S0-AXI-993

a guide to modern + contemporary

ART

in the city

paris

TIDDY ROWAN

Consultant: Christine Macel
Curator, Musée National d'Art Moderne, Centre Pompidou

QUADRILLE

Contents

Introducing Art in the City

*W*hen a modern art collector asked me to give him a tour of London's galleries, I devised a three-day itinerary for him as I was in Paris that week. The paper trail must have been a success because he suggested that I write a book. Encouraged by the idea, I thought, if one city why not others, too?

Paris is a city I know and love, have lived in briefly and visited for more than 20 years. Nevertheless it was a revelation to discover just how much more there was to the art scene than I ever realized. After nearly a year spent researching the book, I learned the importance of putting in some legwork. Staying in the safety zone of a handful of central galleries is indeed one way to experience the heart of the art scene – but it is also rewarding to explore what is happening in places that are more experimental in their programming.

The artists showcased here have been chosen from the broad selection of art to be seen at any one time in Paris. Its art – like that of any city – is made up not only of the work of its home-grown artists but that of others whose work can also be seen here.

In Paris, a great atmosphere is generated when galleries put on new exhibitions and private views – *vernissages*. It provides an opportunity to see in one evening what several galleries are showing as well as to soak up some of the *air de Paris*. This book – both a handbook and a guide – presents a cross-section of artwork, galleries and venues, and at the same time aims to capture something of the compelling atmosphere that surrounds them. It is intended for anyone interested in the current modern and contemporary art scene in this vibrant, culturally diverse city. I hope you will find it a useful companion.

Tiddy Rowan

How to use this guide

A-Z of Artists

The central part of the book is an alphabetical cross-section of artists chosen from the early to mid-20th century (modern) period and the present day (contemporary). They have been selected from across the wide range of disciplines on show in Paris today, and represent painting, drawing, sculpture, photography, video, installation and mixed media.

Each entry illustrates a representative piece of the artist's work accompanied by biographical details, a description of their practice, and details of where their work can be viewed in Paris. Please be aware that the actual work chosen to illustrate an entry may not always be on view – works held in collections and public galleries can be rotated or loaned out, and work in private galleries can be sold. The public art is permanently installed, apart from those locations that feature a changing programme of work.

To include all the modern, contemporary and vibrant emerging artists who have some presence in Paris would fill many volumes. So this is a taste of what lies beyond for those who want to explore further, and it is hoped that each artist featured here will lead the reader to another, whose work will be similarly enjoyed. In addition, many artists not included in this section can be found in the gallery and public art listings in the Directory.

Directory

Galleries and venues highlighted in the Artists section are cross-referenced to the Directory. This lists the public and private galleries, public art, art institutions, art fairs and numerous other sites where art can be seen or resourced in the city. Fifteen feature pages scattered throughout the Directory focus on must-see galleries and organizations in Paris.

The majority of entries are cross-referred to the Maps section (pages 151-71). Also included are significant galleries or artworks that are easily accessible from the city centre but outside the areas covered in the maps, along with relevant transport links.

Maps

A large map of Paris inside the front cover indicates the 10 areas shown in close-up in the Maps section. Every site plotted on the maps is colour-coded to indicate where it is listed in the Directory. See page 151 for a key to the colour coding.

6

Creating your own art tour

The cross-referencing is designed to lead readers on their own spontaneous tours of the Paris art world. Coming out of the Centre Pompidou you will see *Le Pot Doré* by Jean-Pierre Raynaud and on reading about the artist you could be led to the Galerie Pierre-Alain Challier nearby, where you can see a limited edition of another of his trademark pots. While there you might see work by Jean-Michel Othoniel, which will lead you to look at his pearly kiosk over the Palais Royal metro. In the nearby Palais Royal you will find the installation by Daniel Buren. To learn more about Buren you will be led to Galerie Emmanuel Perriton and while there see work by Sophie Calle, which will lead you on an expedition to see the T3 Tramway project, and so on… Opening the Artists section at any page can provide the starting point for such a tour. And, conversely, the Maps section offers the possibility of plotting your own course through the galleries and art sites of any chosen area.

Art in 21st-century Paris: a new deal

*E*arly in the 20th century, Paris took over from Munich to become the undisputed capital of modern art, a position it retained until after World War Two. The city saw the emergence of a number of avant-garde movements, notably those based in Montmartre and its famous Bateau-Lavoir, home to many artists and writers, and later in Montparnasse, location of the artists' studios at La Ruche from 1906, as well as famous cafés including La Rotonde and Le Dôme.

The first of these avant-garde movements was fauvism, a new departure revealed at the 1905 Salon d'Automne with works by Henri Matisse, André Derain, Maurice Vlaminck, Georges Braque and Kees van Dongen. Fauvism takes its name from a comment by the critic Louis Vauxcelles, who described the room in which these pieces were hung as a 'cage of *fauves*' (wild beasts). Picasso moved to the Bateau-Lavoir in 1904. His interest in the African art in the Trocadéro ethnographic museum led him to paint *Les Demoiselles d'Avignon*, which effectively launched the cubist period. The art of collage and assemblage, simultaneously developed by Picasso and Braque, was to prove similarly long-lived. Futurism also spread to Paris, with the manifesto published by Filippo Tommaso Marinetti in *Le Figaro* in 1909.

These currents were followed by the development of the School of Paris, a movement for which many in France continue to feel real nostalgia. Named in 1925 by the critic André Warnod, the term refers to the cosmopolitan, international artistic experience generated in Paris from the mid-1920s to the late 1930s as a result of the many foreign artists then living and working in the city. Artists at the forefront of the School of Paris were Matisse, Braque and Picasso.

Other movements to reach the French capital included Dada, officially born in Zurich in 1916, whose founder, the Romanian Tristan Tzara, moved to Paris in 1920. Meanwhile, in 1913 Paris had seen the creation of the first 'ready-made' sculpture, involving the

transformation of an everyday object into a work of art, when Marcel Duchamp created his *Roue de Bicyclette*, now in the Centre Pompidou (illustrated on page 48). Duchamp, Man Ray and Francis Picabia represented the spirit of Dada in Paris, while surrealism was to reign supreme in the 1920s. The term, used by Apollinaire in 1917 and adopted by André Breton, referred to a revolution in favour of individual freedom, a 'pure psychic automatism' represented by artists such as Salvador Dalí, Max Ernst, Alberto Giacometti, André Masson, Joan Miró and Yves Tanguy. The former advocates of cubism were brought back into line in the 1920s. Working in France, Le Corbusier defined a new style for houses, whose purity reflected a return to simple geometrical order. His concept of a 'machine for living' emerged in 1925 at the International Exhibition of Decorative Arts in Paris.

Paris remained the most important artistic centre throughout the 1930s. When the Nazis closed the Bauhaus the artists fled to Paris. The city retains the legacy of the International Exhibition of 1937 in the famous Palais de Tokyo, which soon became home to the first national museum of modern art along with the Musée d'Art Moderne de la Ville de Paris. When war was again declared in 1939, London and New York became cities of refuge for many artists. After 1945, however, Paris once again attracted international artists who came to study at the École des Beaux-Arts or the Grande Chaumière. Picasso, Matisse, Braque and Fernand Léger were at the height of their glory, and Jean Arp, Frantisek Kupka and Antoine Pevsner still lived in the city.

In 1947 the Musée National d'Art Moderne finally opened in the Palais de Tokyo, with French and foreign artists represented in equal numbers. In 1955 the celebrated gallery owner Denise René, supported from the outset by Victor Vasarely, organized the exhibition *Le Mouvement* around Alexander Calder, who had arrived in 1926, and Duchamp, which included a new generation of young foreign artists such as Yaacov Agam, Pol Bury, Jesús Soto and Jean Tinguely.

The 1960s were marked by the arrival of a movement created by the critic Pierre Restany around artists as diverse as Yves Klein, Arman, César, Tinguely and Martial Raysse, all working '40 degrees above reality' and practising presentation rather than representation. Back in the late 1940s Raymond Hains and Jacques Villeglé had created posters pioneering a style that later emerged as pop art – first in England, and then in New York. However, despite their acknowledged historical importance, the new realists were not well received in New York, and Klein and Tinguely returned to Paris. The year 1960 also saw the foundation of GRAV, a group including François Morellet, which explored a new, interactive relationship between art and audience.

That Paris had lost its position as the most important international centre for art was confirmed in 1964, when the American Robert Rauschenberg won the grand prize at the Venice Biennale. At the same time a new movement, known as narrative figuration, was emerging in France around Hervé Télémaque, Bernard Rancillac and Eduardo Arroyo. The artistic centre shifted to New York and, in 1970, Basel took over as capital of the art market when its new fair was established. The French state took up the challenge, founding the Centre National d'Art Contemporain (CNAC) in Paris, in 1967, while ARC (Animation, Recherche, Confrontation) was established at the Musée d'Art Moderne de la Ville de Paris. A group of artists rebelled with the radical group BMPT, founded by Daniel Buren, Niele Toroni, Olivier Mosset and Michel Parmentier. President Georges Pompidou began toying with the idea of building a national art centre in the late 1960s, while the 1970s saw the birth of the new Support(s)-Surface(s) movement with Claude Viallat, Noël Dolla and Daniel Dezeuze. Meanwhile, highly individual and influential artists such as Michel Journiac, Robert Filliou and Gérard Gasiorowski were developing works whose importance is now widely recognized. The year 1976 saw the institutional affirmation of the Fonds National d'Art Contemporain (FNAC), which became the largest public collector of work by living artists in France and placed its works in many museums.

The Centre Pompidou, designed by Renzo Piano and Richard Rogers, opened in 1977 and was soon surrounded by numerous galleries, many relocating from St-Germain-des-Prés. Orchestrated by the Swedish curator Pontus Hulten, the now legendary opening exhibitions, *Paris-Paris*, *Paris-Berlin* and *Paris-Moscou*, explored the city's international relationships. Artists who moved to Paris during the 1980s and have since gained recognition include Swiss-born Thomas Hirschhorn, Chen Zhen from China and Absalon from Israel. In 1989 the exhibition *Les Magiciens de la Terre* offered an unprecedented opportunity to see work by artists from across the globe, marking the beginning of a more outward-looking view of art and globalization.

During the 1980s, free figuration was at its height, with Robert Combas and Hervé Di Rosa. Bernard Frize was breathing new life into painting and Christo wrapped the Pont Neuf in 1985. Several new institutions were established in the 1990s, once again changing the Paris landscape by providing different kinds of art spaces. The new Jeu de Paume was founded in the 1990s as a centre for image-based art. The Palais de Tokyo opened its doors in 1999 and the same year saw the launch of Le Plateau, the leading space in the TRAM network linking the many art centres in the Paris region, including the MAC/VAL in Val-de-Marne, which exhibits contemporary French art. The founding of the new Ministry of Culture by André Malraux in 1959 had resulted in some major changes in cultural policy. The official creation of the Fonds Régionaux d'Art Contemporain (FRAC) in 1981 ushered in a completely new system. Since 2002 the FRAC Île-de-France has been based at Le Plateau. This dynamic scene is fuelled by the art schools, such as the École des Beaux-Arts, which mounts contemporary exhibitions, while artist residencies have been set up at the Couvent des Récollets, the Cité des Arts and the Pavillon of the Palais de Tokyo.

Traditionally a city of monumental works, Paris has seen a real boom in the creation of public art. Jean Dubuffet's *La Tour aux Figures* (1967-88) was installed in the park at

Issy-les-Moulineaux and Daniel Buren's *Les Deux Plateaux* (1985-86) in the courtyard of the Palais Royal, where it caused a sensation. The metro has commissioned a great many works, including Dominique Gonzalez-Foerster's piece at Bonne Nouvelle station and Jean-Michel Othoniel's sculpture at Place Colette. The T3 Tramway service opened recently in southern Paris with new works by nine artists placed along its route.

During the 1990s Philippe Parreno, Bernard Joisten and Pierre Joseph, all young artists from the École des Beaux-Arts, Grenoble, were working together, soon to be joined by Dominique Gonzalez-Foerster. With their joint piece *Vidéo Ozone* of 1989 they began developing a new form of art that was concerned not so much with the object and space as with a relationship to time and to mechanisms, working with the exhibition's own temporality. These artists of what the art critic Nicolas Bourriaud has termed 'relational aesthetics' are supported by many new magazines such as *Purple Prose* and *Documents sur l'Art*, along with other artists including Maurizio Cattelan, Liam Gillick and Rirkrit Tiravanija. The dynamism of this new generation was reflected in Fabrice Hyber's award at the Venice Biennale of 1997. This was followed by the emergence of young artists such as Mathieu Mercier, Saâdane Afif and Boris Achour, who launched the magazine *Trouble* with the young critic François Piron. In photography we saw through the new eyes of Bruno Serralongue and Valérie Jouve, following on from Jean-Luc Moulène. All of these artists are part of a new and particularly lively young generation – including Xavier Veilhan, Tatiana Trouvé, Adel Abdessemed, Loris Gréaud, Guillaume Leblon and Vincent Lamouroux – which is increasingly gaining international recognition, demonstrating the real change that has occurred in Paris at the dawn of the 21st century.

Today we can see the emergence of a new configuration which, as the idea of an artistic capital is rendered obsolete by the proliferation of artistic centres across the globe, defines Paris as one of Europe's most active sites of exchange and creativity.

Nam June Paik *Olympe de Gourges* (1989) in front of Raoul Dufy *La Fée Électricité* (1937)
Musée d'Art Moderne de la Ville de Paris

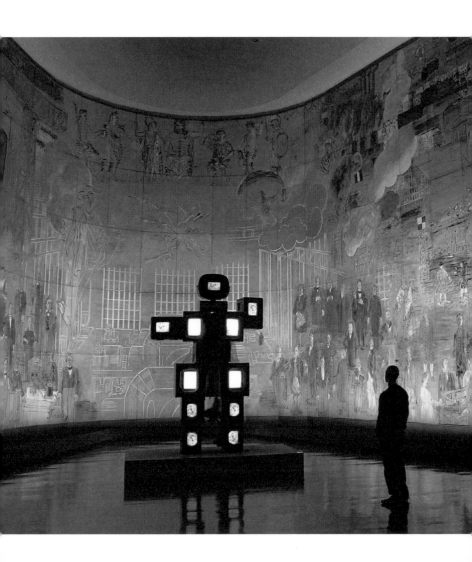

The energy of the galleries, notably those located in rue Louise Weiss, including Air de Paris and the design gallery Kreo, and the recent regeneration of the Marais district with the opening of many new galleries in the tiny rue St-Claude, around heavyweights such as Yvon Lambert, Marian Goodman, Thaddaeus Ropac and Emmanuel Perrotin, not to mention Almine Rech and Chantal Crousel, reflects a new health in the Paris art world. Things are also happening in St-Germain-des-Prés, where there are several very active contemporary art galleries, including Georges-Philippe et Nathalie Vallois, Kamel Mennour, Loevenbruck and Léo Scheer.

14

As the capital of fashion, since the mid-1990s Paris has spearheaded the revival of links between art and fashion. This phenomenon of global marketing has been especially visible in the city, where collaborations between artists and the fashion world have included the recent works commissioned by designer Hedi Slimane for Dior and Chanel, notably from Xavier Veilhan. The opening of exhibition spaces within companies (Magasin and Espace Louis Vuitton exhibitions at the LVMH headquarters) and ultra-hip retail outlets such as the concept-store Colette and the luxurious Bon Marché, have also marked a new stage in the opening up of the business world to work by living artists. The same is true of hotels such as the K, which has been redesigned by Fabrice Hyber, and cafés like Étienne-Marcel, designed by Pierre Huyghe, Philippe Parreno and M/M (Paris).

The revival of the FIAC (Foire International de l'Art Contemporain), which has moved back to the Grand Palais, Annette Messager's success at the Venice Biennale, the annual *Nuit Blanche Parisienne* devoted to contemporary art in early October, the opening of the Grand Palais to major exhibitions of living artists and the reopening of the modernized Centre Pompidou in 2000, are all changing the face of Paris. The renovation of the Musée d'Art Moderne de la Ville de Paris, the planned extension of the Palais de Tokyo – which may well become a 'museum island' – and other

development projects for new centres of contemporary art, are gradually redrawing the map of a city whose wealth of intense creativity is at once individual and collective, public and private.

Visitors to Paris are often left feeling that they have explored a heritage city, endowed with landmark works of art from every period. Lovers of modern art soak up the atmosphere at La Coupole and Le Dôme in Montparnasse, or visit Le Flore and Les Deux-Magots in St-Germain-des-Prés, all of which have long since been abandoned by artists and existentialists. Apart from the Centre Pompidou and the tall towers of La Défense, rising above pieces by Joan Miró and Alexander Calder, contemporary works are not immediately apparent in the planning and architecture of the city. Yet, in the last decade or so Paris has been marked by an unprecedented renewal of creative activity, with the emergence of many new institutions, both public and private, and a new generation of artists, architects, designers and graphic artists, including some who combine the genres. These artists have changed the face of Paris and yet, perhaps surprisingly, their work is not always easily found. This book seeks to help those who would like to experience the art of today in a whole variety of locations, along with the modern works so well represented in private galleries, public spaces and museums throughout the city.

Christine Macel

A-Z of Artists

*Profiling some of the **modern**, **contemporary** and **emerging** **artists** to be seen on **Paris'** **current art scene**. Explore the extraordinary spectrum of talent and discover new names to add to your list of personal favourites. Highlighted names refer to locations and artworks listed in the Directory.*

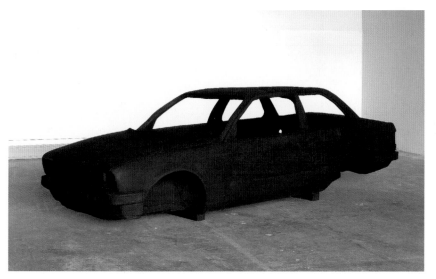

Practice Zero Tolerance (2006) terracotta 140 x 390 x 108 cm

ADEL ABDESSEMED was born in Constantine, Algeria, in 1971. In 1994 he moved to Lyons. Attracted by opposites and despising homogeneity and the sterile atmosphere of consensus, Abdessemed has produced an oeuvre that addresses the contemporary issues of a globalized society in a direct and sometimes crude fashion. In the video *Real Time* (2003) he filmed nine couples making love in the public space of an art gallery, thus blurring the lines between private and public, moral and immoral, while always remaining poetic and sincere. One of his most impressive pieces, *Habibti* (meaning 'darling' or 'sweetheart' in Arabic) from 2006, is a human skeleton of gigantic proportions (approximately 20 metres long) floating in the exhibition space. It is an oversized *vanitas*, illustrating the fears and questions connected to death and passing time, typical of societies in existential turmoil. His sculpture *Practice Zero Tolerance* (above) is a life-size copy of the burnt out carcass of a car, a painful reminder of the riots that occurred in the suburbs of many French cities in autumn 2005, and of the social and political tensions from which these derived. Adel Abdessemed lives and works in Paris. His work can be seen in the collection of the **Centre Pompidou**.

Conatus (Gondwana) detail (2006) mixed media
115 x 90.5 x 363 cm

BORIS ACHOUR was born in Marseilles in 1966. The most striking aspect of his work is the seemingly limitless media in which he expresses himself. Achour shoots videos, creates sculptures and mobiles, takes pictures, makes collages and sound pieces, bringing together all of these elements in vast installations whose sense and order are multi-layered. Each of his pieces draws from new sources and confronts a new theme – with each project a new beginning revolving around Achour's interest in public spaces and in generating a dialogue between art and its environment. Throughout his career Achour has produced work that alters the perception of everyday objects through minimal interventions (the *Actions-peu* series, 1993-97), or adds an inane element to them (*Regarde-moi*; *Artiste Boris Achour*, both 1997). He has also made series of installations with the same title but with greatly varying contents (*Cosmos*, 2001 and *Conatus*, above), using the idea of follow-ups and prototypes, and has tried confronting the visitor with the absurdity of the modern world (*Operation Restore Poetry*, 2005; *Passage*, 2000). Boris Achour lives and works in Paris. His work can be seen in the collection of the **Centre Pompidou**. He is also found at **Galerie Georges-Philippe et Nathalie Vallois**.

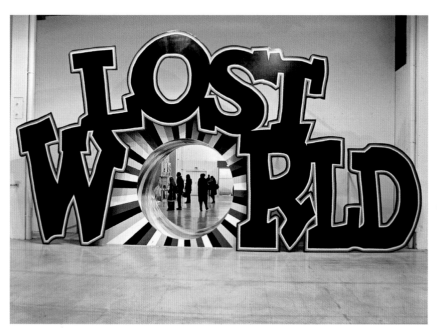

Lost World (2006) mixed media

SAÂDANE AFIF was born in Vendôme in 1970. His artistic production takes multiple forms, working in all kinds of styles and with various media, using found elements, reproducing and copying art, as well as collaborating with other artists in an open and versatile creative process. He travels the world, gathering new materials and inspiration for his pieces. He aims to trigger an interaction between the visitor and his work, to establish links between the art and its surrounding, illustrating social and cultural connections. The installation *Lost World* (above) is both pastiche and reinterpretation of a fairground attraction: a round opening in the wall of an exhibition space is a revolving barrel ironically painted in bland shades of grey, through which the visitor can walk at his or her own risk. *Belvedere (Lyrics)* of 2005 is an installation based on songs written by artist friends about his earlier works, which have, in turn, been interpreted by other artists. By producing different layers of creation, he invites the visitor to experience the work on two different levels – one can choose either to listen to the songs through headphones or to read their lyrics displayed in metal letters on the walls. Saâdane Afif lives and works in Paris and Berlin. His work can be seen in the collections of the **Centre Pompidou**, the **Musée d'Art Moderne de la Ville de Paris** and the **FRAC Île-de-France**. He is also found at **Galerie Michel Rein**.

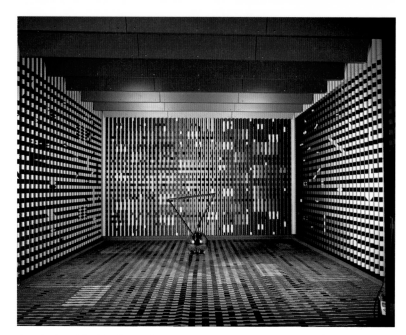

Antechamber of President Georges Pompidou's private quarters in the Palais de l'Élysée (1971)
wood, acrylic, aluminium, paint, lights, metal, Plexiglas 470 x 548 x 622 cm

YAACOV AGAM was born in Rishon-le-Zion (then British mandate of Palestine, now Israel) in 1928. The son of a rabbi, he was raised in a conservative Jewish family and began his training at the Jerusalem School of Art under the guidance of former professors from the Bauhaus. It was through their influence and that of the classes he later followed at the Technical University of Zurich that Agam found an interest in constructivism and colours, which led to his adherence to the principles of kinetic art. On his way to the USA, the artist stopped off in Paris and decided to settle there permanently in 1951. In his works it is not the mobile elements in the piece itself that create movement, as is the case with most kinetic art, but rather the progression of the spectator that engenders the optical illusion of a moving piece. The association of brightly coloured stripes with three-dimensional prismatic bars is characteristic of his sculptures and paintings, as well as of his many outdoor monuments. Yaacov Agam still lives and works in Paris. One of his most famous pieces, the antechamber of the private quarters in the French presidential residence, commissioned by then president Georges Pompidou in 1971 (above), can be seen in the **Centre Pompidou**, while his musical *Fountain* of 1975-77 stands in the heart of the esplanade of **La Défense**. He is also found at **Galerie Denise René**.

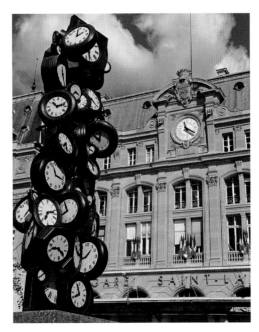

L'Heure de Tous (1985) mixed media

ARMAN was born Armand Fernandez in Nice in 1928. As a homage to Vincent van Gogh, who signed his paintings Vincent, he decided to be known by his first name only. After a printing error on the invitation card for an opening in 1958, he dropped the final 'd' of his name. Arman grew up in the artistic circles of Nice, meeting Yves Klein and Serge Poliakoff, and experimented with various creative processes, including happenings, prints and surrealist and abstract painting. In 1960 he signed the new realism manifesto in Paris, alongside his friends César, Yves Klein and Raymond Hains. From around this time Arman created sculptures made from found objects, including old household appliances and musical instruments, which he combined in great numbers to form 'accumulations', burning or even destroying them, sometimes with great violence, before re-assembling the dismantled pieces in a new order. Two of his best-known pieces – a towering accumulation of clocks, *L'Heure de Tous* (above), and another of suitcases, *Consigne à Vie*, both from 1985 – are located in front of Gare St-Lazare. Arman died in New York in 2005. The **Centre Pompidou** is home to one of his first destroyed pieces from the *Colère (Rage)* series, *Chopin's Waterloo* (1962), and the collection of the **Musée d'Art Moderne de la Ville de Paris** holds his *Murex* accumulation of spare car parts from 1967.

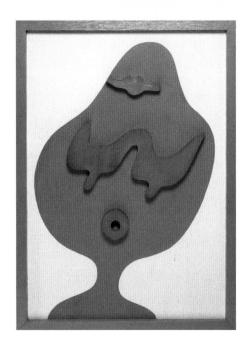

Femme (1927) oil on wood 136 x 100 x 3.8 cm

JEAN ARP was born Hans Arp in the Alsatian capital of Strasbourg, then part of Germany, in 1886. When the region returned to France after World War One his first name was changed to Jean. Arp's work is characterized by movement and change. He worked in Germany, France and Switzerland, wrote poetry, sculpted and painted, and became involved in various avant-garde artistic styles. One of the main members of Dada in Zurich and Cologne in the 1910s and '20s, he collaborated with Wassily Kandinsky and his Munich-based expressionist Blue Rider group, before working with the Parisian surrealists. He eventually settled in the Parisian suburb of Meudon (now Clamart), where he dedicated himself to the abstraction/creation movement with his wife and fellow artist, Sophie Taeuber. Nowadays he is most famous for his collages and sculptures, which illustrate an organic and abstract vocabulary based on the idea of metamorphosis and playful evolution. Jean Arp died in Basel in 1966. His large bronze mural sculpture *Constellation Unesco*, commissioned in 1958 for the Parisian headquarters of **UNESCO**, can still be seen at its original location, while the collection of the **Centre Pompidou** holds a great number of his works, including *Femme* (above). One can also visit the Clamart house and atelier that he built, lived and worked in with Sophie Taeuber, and which is now **La Fondation Arp**.

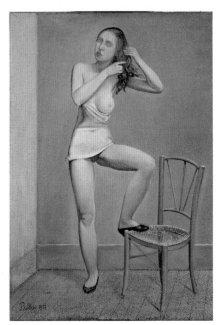

Alice (1933) oil on canvas 162.3 x 112 cm

BALTHUS was born Balthazar Klossowski de Rola in Paris in 1908. His father was an art historian and stage designer, his brother Pierre became a famous philosopher, while his mother befriended many artists and writers, including the German poet Rainer Maria Rilke, who gave Balthazar his nickname. After travelling extensively both in Europe and the French colonies, Balthus, who remained a very private and obscure character throughout his life, returned to Paris where he studied the academic paintings in the Louvre and those of family friends Pierre Bonnard and Maurice Denis. Drawing on these classical influences, he developed a unique style, in stark contrast to that of the established art scene of his time. He mainly painted portraits and genre scenes in a figurative, highly constructed, academic fashion, which some branded anti-modern. The themes of his paintings, often barely clad or nude adolescent girls in sometimes explicit sexual poses, were also a source of controversy. Balthus did not deny this awkward dimension in his work, explaining that he viewed the adolescent girl as a symbol of the possibilities of the future and of the mystery of the transformations to come. Balthus died in Rossinière, Switzerland, in 2001. He is one of the rare artists whose works entered the collection of the **Musée du Louvre** during their lifetime. He is also found in the collections of the **Musée Picasso** and the **Centre Pompidou** (above).

90-91 126 x 126 C (1990-91) acrylic on canvas 126 x 126 cm

MARTIN BARRÉ was born in Nantes in 1924. To this day he remains one of the more obscure undiscovered figures of French abstract painting, even though he is also hailed as one of the artists who led French art into the contemporary era. His graceful pictures, balancing mass, colour and line in harmonious ensembles, vibrate with a minimalist light energy. Many of his most famous works were sprayed on rather than painted in an effort to illustrate the possibility of painting without directly touching the surface of the canvas, thereby reducing the gesture and thus the interference of the artist to a minimum. Throughout his life Barré struck art connoisseurs with the sheer contrast between the often colourful, radiant quality of his works and his austere, structured and obsessive working method. He remained a mysterious, discreet artist who furthered the riddle with the titles of his works, which are mostly combinations of numbers and letters. Martin Barré died in Paris in 1993. His work can be seen in the collections of the **Centre Pompidou**, which owns a number of his series, and the **FRAC** Île-de-France. He is also found at **Galerie Nathalie Obadia**.

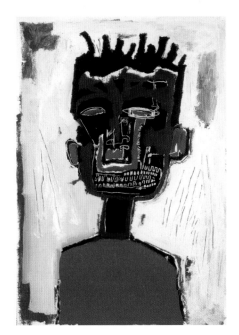

Autoportrait (1984) acrylic, wax crayon, paper, canvas
100 x 70 cm

JEAN-MICHEL BASQUIAT was born in New York in 1960. He is the most illustrious, or infamous, incarnation of the shooting-star artist. Half Puerto Rican and half Haitian by descent, and raised in Brooklyn, the 17-year-old Basquiat started out by tagging the walls of Manhattan squats with mysterious graffiti phrases. He taught himself how to paint and soon developed the style that was to make him into one of the most sought-after painters of the 1980s, recognizable by his characteristic signature: a three-pointed crown. Obsessed with the themes of death and the divine, his Caribbean and African heritage and the urban environment in which he grew up, he frenetically produced works of a brutal strength, emanating from an ambivalent angst and yearning. His figurative paintings, in which thick layers of paint contrast with empty patches of canvas, are the erratic and powerful legacy of an artist who threw all of his energy and fears into his art, as though sensing that he had but little time. In 1988 Jean-Michel Basquiat died from a drug overdose in New York. His work can be seen in the collection of the **Centre Pompidou** (above). He is also found at **Galerie Jérôme de Noirmont**.

Le Magasin de Ben (1958-73) mixed media 350 x 500 x 350 cm

BEN was born Benjamin Vautier in Naples in 1935. He started off as a record salesman in Nice in the 1960s, before deciding to turn his shop into a work of art by accumulating heaps of objects and cramming these into this confined space. He befriended Yves Klein along with other members of the new realism and was also attracted to the ideas of the fluxus movement. However, he felt the strongest connections with Marcel Duchamp, orientating his work more into the direction of minimal interventions, mainly by applying his signature to already existing products and artefacts. He has described himself as a copyist who tries to make as many things as possible his own. Throughout his career Ben has delved into performance art, sculpture, video, installations, texts and mail art, but the works for which he is most widely recognized are the numerous simple phrases scribbled in white acrylic paint on black canvas: in these he mocks many aspects of contemporary society, the art world, modern obsessions and fears, as well as himself as a person and as a creator. Ben lives and works in Nice. His work can be seen in the collections of the **Centre Pompidou** (above) and the **Musée d'Art Moderne de la Ville de Paris**, and at Place Fréhel (*Il Faut se Méfier des Mots*). He is also found at **Galerie Daniel Templon** and **Galerie Jérôme de Noirmont**.

En Suivant la Main Droite de... Marilyn Monroe in 'Some like it Hot' (2006) ink jet print on wallpaper
400 x 720 cm

PIERRE BISMUTH was born in Paris in 1963. He produces collages, mural paintings, videos, photos and installations, and was co-awarded an Academy Award for his contribution to the screenplay of the movie *Eternal Sunshine of the Spotless Mind*. Most of his artworks are assembled or re-assembled from everyday objects whose context disappears as the art piece is created, the objects becoming mere materials in the creative process. In the *Origami* series from 2003, he uses posters – from films, of wildlife, tourist advertisements – and folds them in the Japanese tradition, only to unfold them again, with just the creases as a reminder of their past state. The *En Suivant la Main Droite de...* (*Following the Right Hand of...*) series (2005-06) emanates from a more complex procedure: Bismuth aimed to create a connection with the inaccessible female stars of classical Hollywood by drawing the line that would have appeared had these actresses held a pen in their right hand in some of the most epic scenes of their career. As is the case in these two series, his pieces always contain a healthy dose of humour and allow the viewer to experience a new take on ordinary situations. Pierre Bismuth lives and works in Brussels and New York. His work can be seen in the collection of the **Centre Pompidou**, which owns one picture from the series *En Suivant la Main Droite de...*. He is also found at **Cosmic Galerie**.

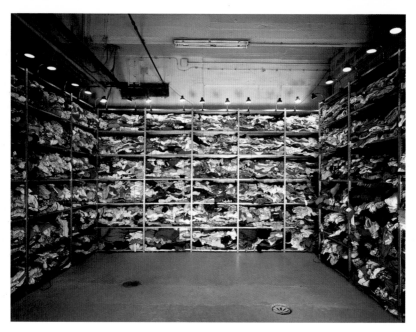

La Réserve du Musée des Enfants (1989) clothes, metal shelves, lights

CHRISTIAN BOLTANSKI was born in Paris in 1944 to a Jewish family of Polish descent. He has remained concerned with the idea of the Holocaust – from which he derives his fascination with memory, bygone childhood and death – throughout most of his career. An aura of nostalgia and intimate sadness emanates from many of his works that often comprise elements from, and illustrate chapters of, his biography – whether real or fictitious. Boltanski started painting at a young age before beginning to write texts and letters to other artists. He eventually began creating installations in which he accumulated found objects, telling personal stories in detail, inviting the onlooker to identify with universal signs and codes. These monuments to the past and to memory generate what he calls an 'individual mythology'. Later on he started to use photography and video, both as a documentation of his installations and as independent art forms. Christian Boltanski lives and works in Malakoff. The cellars of the **Musée d'Art Moderne de la Ville de Paris** hold a specially commissioned piece, *Réserve du Musée des Enfants* (above), which Boltanksi created *in situ*. Other works can be seen in the collections of **MAC/VAL** and the **Centre Pompidou**. He is also found at **Galerie Marian Goodman**. An interactive sound piece (*Les Murmures*) installed around benches in Parc Montsouris is part of the **T3 Tramway** project.

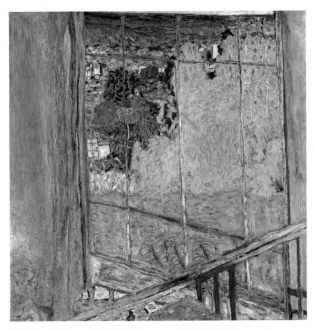

L'Atelier au Mimosa (1939-46) oil on canvas 127.5 x 127.5 cm

PIERRE BONNARD was born in Fontenay-aux-Roses in 1867. A trained lawyer, he started painting in the early 1890s, having struck up friendships with Édouard Vuillard and Toulouse-Lautrec. However, it was the Parisian group the Nabis (prophets) who had the strongest influence on the genesis of his style. Their interest in spiritual matters and Japanese art had a lasting impact on his paintings. The perception of space and depth in Japanese wood-block prints and the mystic qualities attributed to colour by the Nabis are visible in his works: his canvases are covered in bright colour fields, whose flat surfaces project a two-dimensional, almost abstract, depth. Bonnard turned his talent to different media, being one of the first recognized artists to paint commercial posters; he also printed lithographs, illustrated books and created stained-glass windows. He worked mostly in his studio, making sketches and sometimes taking photographs of his subjects. In 1925 Bonnard moved to the French Riviera with his wife Marthe, who was one of his main sources of inspiration and who appears in many of his works. His work is revered today for its radiant colourful qualities. Pierre Bonnard died at Le Cannet in southern France in 1947. Some of his most emblematic works can be seen in the collections of the **Centre Pompidou** (above), the **Musée d'Art Moderne de la Ville de Paris**, the **Musée d'Orsay** and the **Petit Palais**.

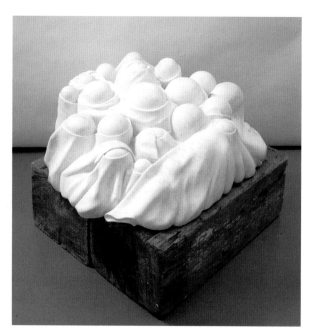

Cumul 1 (1968) white marble and wood 51 x 127 x 122 cm

LOUISE BOURGEOIS was born in Paris in 1911. With a career spanning more than seven decades, she has created a vast and varied oeuvre and is one of the most respected figures in contemporary art. She started out as a painter, becoming an assistant to Fernand Léger in Paris in the 1930s, before meeting the many surrealist exiles in New York and dedicating herself to sculpture. She has worked in numerous media, creating huge structures in metal, wood or marble, and using fabric, wax or paper. Her sculptures take different shapes: sometimes abstract spatial constructions, sometimes architectural designs, cage-like wooden crates or monstrous creatures with over-sized limbs. The human figure also plays a key role in her work: she has produced oversized body parts and set whole bodies of wax into narrative choreographies. The sexual energy emanating from some of these works is directly linked to Bourgeois' interest in feminism, sexuality and violence, as well as the traumas that have haunted her since her childhood. Louise Bourgeois has lived in New York since 1938, where she moved with her art-historian husband Robert Goldwater. Her work can be seen in the collections of the **Centre Pompidou** (above), the **Musée d'Art Moderne de la Ville de Paris**, the **Bibliothèque Nationale de France** and in the **Jardin des Tuileries** (*The Welcoming Hands*). She is also found at **Galerie Karsten Greve**.

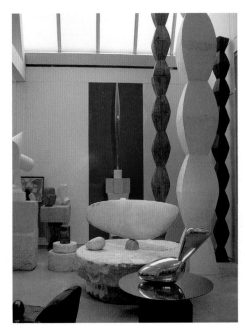

Brancusi's Studio (replicated in Atelier Brancusi)

CONSTANTIN BRANCUSI was born in Hobita, Romania, in 1876. The gifted son of poor Romanian peasants, he managed to attend art schools successively in Craiova, Bucharest and finally in Paris, where he moved in 1904. He started out in the atelier of Auguste Rodin but left after only two months, frustrated to be in the shadow of the great master and eager to develop his own formal vocabulary away from the then prevailing romantic naturalism. Always conscious of, and attached to, his peasant roots, Brancusi was a hard worker and an admirer of folkloric art as well as of the mystic dimension present in almost every aspect of rural life. Moving away from figurative work, he gradually simplified his forms down to clear lines and volumes, eventually producing abstract, geometrical objects that none the less remained evocative, both through their shape and title, like the famous *Princess X* of 1920, which caused a stir because it was deemed phallic and thus obscene. Constantin Brancusi died in Paris in 1957. He bequeathed his works to the French state on condition that they be exhibited in exactly the same way as in his Paris studio. This condition was fulfilled with the construction *Brancusi's Studio* in the Atelier Brancusi (above), a building by Renzo Piano outside the **Centre Pompidou**. One of his first commissioned sculptures, *The Kiss* (1910), can be seen at his tomb in the Cimetière de Montparnasse.

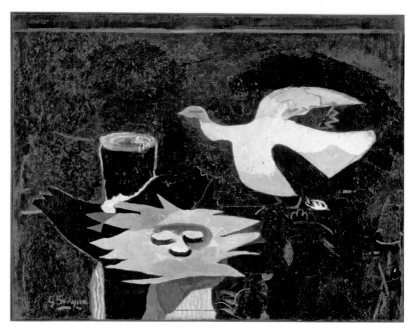

L'Oiseau et son Nid (1955) oil on canvas 130.5 x 173.5 cm

GEORGES BRAQUE was born in Argenteuil in 1882. He is most famous today for having created the cubist movement with Pablo Picasso in the 1900s and was therefore one of the avant-garde artists who turned the art world upside down in the early 20th century. Braque was a trained craftsman and started his artistic career under the influence of first impressionism and then fauvism. After seeing a Cézanne retrospective, Braque began to focus exclusively on the shape and structure of objects, reducing his subjects to geometrical, often cube-like, forms in shades of grey and brown, hence the name that was given to this new style. However, Braque quickly wearied of distancing himself from reality in his art and began adding real-life objects such as newspaper cuttings and wallpaper to his paintings, resulting in cubist collages. After World War One, during which he was seriously wounded, Braque returned to a more figurative approach in painting. Although he at first composed his works in predominantly dark shades, he gradually returned to a more colourful and lively palette, and to more classical genres like still lifes and landscapes. Georges Braque died in Paris in 1963. His work can be seen in the collections of the **Centre Pompidou** (above), the **Musée d'Art Moderne de la Ville de Paris** and the **Musée Picasso**. The ceiling of the Henri II room at the **Musée du Louvre** is adorned with *Les Oiseaux* (1949-51).

Graffiti, from the series *IX Images Primitives* (before 1933)
gelatin silver print 49.1 x 39.6 cm

BRASSAÏ was born Gyula Halász in Brasso, Austro-Hungary (now Brasov, Romania) in 1899. He took the pseudonym Brassaï (meaning 'from Brasso' in Hungarian) in 1923. Brassaï moved to Paris in 1924 after living for some time in Berlin, where he had started working in journalism, which he continued doing in Paris and which eventually led him to start taking pictures. He used his camera to capture the city he lived in, and which he loved, catching the very essence of Paris, its beauty and ugliness, its architectural magnificence and oddities, its seedy underworld and magical nightlife. It was his fascination with the appearance of the city at night that generated some of his most famous works depicting deserted streets or lively boulevards filled with passers-by in the pale light of street lamps. His work is so evocative of all that the 'City of Light' stands for that his friend Henry Miller called him the 'eye of Paris'. He also made some of the most memorable portraits of the leading artistic figures of his time: among them Salvador Dalí, Pablo Picasso and Jacques Prévert. Brassaï died in Eze, on the French Riviera, in 1984. His photographs can be seen in the collections of the **Centre Pompidou** (above), the **Musée d'Art Moderne de la Ville de Paris**, and the **Musée Carnavalet**, the museum dedicated to the history of Paris.

Reconstruction of wall from André Breton's studio (1922-66) mixed media

ANDRÉ BRETON was born in Tinchebray, Normandy, in 1896. A poet, writer and theorist, influenced by themes and theories as varied as nihilism, psychic science, communism and Dada, he was also a great admirer of the writings and thoughts of Arthur Rimbaud. In 1924 Breton wrote the *Surrealist Manifesto*, calling for a free expression of the mind, without the constraints of reason or morals, and insisting on the importance of dreams and the subconscious. What started off as the guidelines for a literary group, including among others Louis Aragon and Paul Éluard, quickly became, under the guidance of its founder, a theory that would flourish in each artistic discipline, most notably in the visual arts of the Paris avant-garde scene of the 1920s and '30s. Breton influenced many artists and travelled extensively – to Mexico where he visited Trotsky, Frida Kahlo and Diego Rivera, and to the USA to escape Vichy France. On returning to Paris in 1946, Breton started compiling and classifying his sources and documents in his studio. He adorned one of the walls with various objects: found ornaments, his own collages and drawings, letters and souvenirs, as well as various objects given to him by his artist friends. This treasure-box, or cabinet of curiosities, can now be seen in the **Centre Pompidou** (above). André Breton died in Paris in 1966.

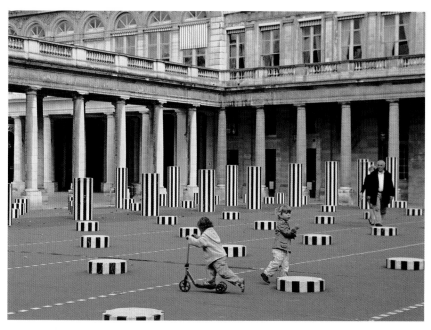

Les Deux Plateaux (1985-86) concrete, paint

DANIEL BUREN was born in Boulogne-Billancourt in 1938. Winner of the Golden Lion at the Venice Biennale in 1986 and curator of the French Pavilion in 2007, he is one of the most respected of French contemporary artists. From the beginning of his career he set out to reduce his artistic expression to a minimum, resulting, in 1965, in the creation of a pattern of vertical stripes, each 8.7 centimetres wide, alternating coloured and white stripes. This grid remains his signature to this day and he has applied it to all sorts of materials – fabric, wood, concrete, glass, paper – and reproduced it in all colours and sizes. Buren has created a vast oeuvre of interventions, sculptures and installations, always produced *in situ*, to ensure that despite its repetitive, near-industrial appearance, his work enters into a harmonious dialogue with its surroundings. Daniel Buren lives and works in Paris. The **Centre Pompidou** and **Musée d'Art Moderne de la Ville de Paris** hold many of his pieces in their collections; yet, to admire their site-specific qualities, visit the cour d'Honneur of the **Palais Royal** which contains *Les Deux Plateaux* (above), the **Musée du Louvre** where he decorated, with Jean-Pierre Raynaud, the Café Richelieu in 1993, and the **Parc de la Villette**, where he created a scenic path, a dialogue between his stripes, nature and architecture: *Diagonale pour des Bambous* (1987). He is also found at **Galerie Kamel Mennour**.

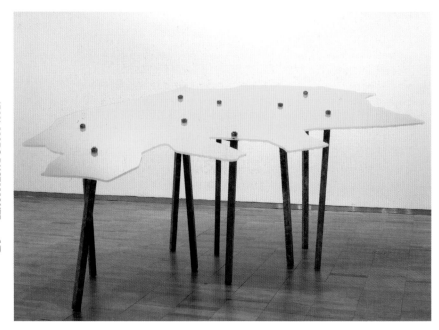

Contra Posto (2002) galvanized steel, ink on Plexiglass 110 x 250 x 145 cm

JEAN-MARC BUSTAMANTE was born in Toulouse in 1952. Since his first series of photographs, dating from the late 1970s, which he provocatively named *Tableaux* (*Paintings*), Bustamante has been concerned with the unfinished, the transient. These first large-format pictures were taken in the suburbs of a then rapidly changing Barcelona, and in them he tried to capture the moment and the place where change was taking place, where the periphery of a city was mutating into a new geographic entity. In the mid-1980s he formed the BazileBustamante duo with the French sculptor Bernard Bazile – a time when his work began including a wider variety of materials and shapes – yet he remained focused on the idea of representing transition. Bustamante continued taking pictures of incomplete spaces throughout the world, but in the 1990s he also began working with Plexiglas and bright colours, creating works that blur the notions of sculpture and painting. Among these is his *Trophée* series: large transparent sheets of Plexiglass seemingly floating in front of the wall, whose inner layer of paint has been partially scraped off to create a new pattern of voids and colourful surfaces. Jean-Marc Bustamante currently lives and works in Paris. His work can be seen in the collections of the **Centre Pompidou**, the **Musée d'Art Moderne de la Ville de Paris** and the **FRAC Île-de-France**. He is also found at **Galerie Thaddaeus Ropac**.

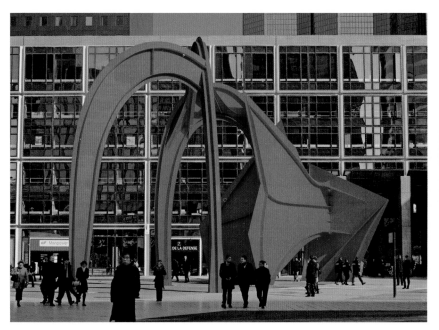

L'Araignée Rouge (1976) steel plate, bolts, paint

ALEXANDER CALDER was born in Philadelphia, the son and grandson of sculptors, in 1898. An engineer by training, Calder soon changed his career plans, becoming an illustrator and painter. Fascinated by the world of the circus, he made his first three-dimensional piece in Paris in 1926: the *Cirque Calder* was made mostly from wire, a material he would continue using in subsequent years to create spatial 'drawings'. Associated with most of the Paris art movements of the 1930s, Calder slowly moved away from sculptural figuration and towards a more abstract practice, inventing two distinct types of works for which he is still revered today: the stabile and the mobile. His engineering skills enabled him to develop these graceful, apparently light and simple structures: to evoke the sturdy stability of the former and the elegant, playful movement of the latter in fact required great skill and precision. He also painted and drew, and designed tapestries and the decor for three aeroplanes. Alexander Calder died in New York in 1976. Paris is home to three of his outdoor structures: *La Spirale* (1958), a black steel mobile commissioned for the UNESCO building, *Les Cinq Ailes* (1967) in the Bois de Vincennes and *L'Araignée Rouge* (*Red Spider* – above), a stabile at La Défense. The collection of the Centre Pompidou has works spanning his entire career, including works on paper and tapestries.

Le Téléphone with Frank Gehry (2006) mixed media

SOPHIE CALLE was born in Paris in 1953. Both a voyeuristic and an exhibitionist artist, she uses photographs, letters, sound recordings, videos and testimonies to unveil personal stories and draw the spectator into a normally private world, framed by a myriad of documents. She sometimes uses her own experiences, giving away details of her love life (*Prenez Soin de Vous*, for the French Pavilion of the Venice Biennale, 2007), the emotional and personal dramas afflicting her, or those of strangers whom she decides to follow in the street (*Suite Vénitienne*, 1980). She stages her life in an auto-fictional narration, inventing and documenting events that have never occurred, or creates odd and inspiring events, recording and documenting the reaction these situations might trigger in passers-by. For example, with the *Chambre avec Vue* project (2003) she spent an entire night in a bed on the highest level of the Eiffel Tower and invited people to keep her awake by telling her bedtime stories. *Le Téléphone* (above), part of the **T3 Tramway** project and a collaboration with the architect Frank Gehry, consists of a flower-shaped phonebooth where one cannot make any calls – only answer the phone when it rings, to listen to one of Calle's stories. Sophie Calle lives and works in Malakoff. Her work can be seen in the collection of the **Centre Pompidou**. She is also found at **Galerie Emmanuel Perrotin**.

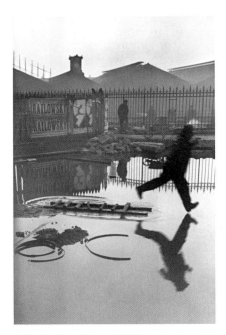

Behind the Gare St-Lazare (1932) gelatin silver print
44.4 x 29.7 cm

HENRI CARTIER-BRESSON was born in the Brie region of France in 1908. He is universally acknowledged as one of the great photographers of the 20th century and is a central figure in the history of photography. He helped develop the field of photojournalism and co-founded the Magnum Agency in 1947 with his friends Robert Capa and David Seymour. HCB, as he liked to refer to himself, started out as a painter and was associated with the Paris surrealists. In 1931, he began taking pictures during his perilous travels in the Côte d'Ivoire, and on returning to France decided that it was with this tool that he could best express his artistic aspirations. He roamed the world, capturing events that would change the course of history along with the much more intimate details of people's everyday lives. His genius was the ability to take the picture at precisely the right moment, capturing a fraction of eternity in a perfect composition. He photographed many of the intelligentsia and artistic avant-garde of his time: his portraits of Jean-Paul Sartre and Henri Matisse remain world-famous. Henri Cartier-Bresson died in Montjustin, in the French Alps, in 2004. Shortly before his death he inaugurated the **Fondation Henri Cartier-Bresson**. Other works can be seen in the collections of the **Centre Pompidou**, the **Musée Carnavalet** and the **Maison Européenne de la Photographie**. He is also found at **Galerie Esther Woerdehoff**.

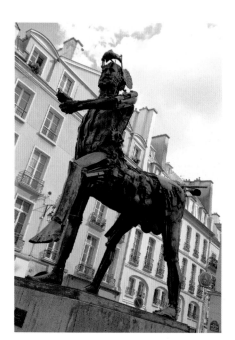

Le Centaure (1983) soldered bronze 450 cm tall

CÉSAR was born César Baldaccini in Marseilles in 1921. Like many of his friends from the new realism movement, the French sculptor is known by his first name only. Starting off as a poor young artist, he worked with cheap materials he found on waste sites, such as wire, pipes from old plumbing and discarded car parts. Throughout his career he was to remain faithful to these first materials, respecting their aesthetic in his finished works. He used them to create agglomerations, sometimes generating figurative sculptures, sometimes purely abstract compact masses. From the 1960s he also made compressions, flattening and smashing metal structures (often, but not exclusively, cars) with the help of a hydraulic press, giving them new shapes. He also worked with chemical resins from which he realized a series of *Expansions* and produced classical sculptures out of cast metal, like his famous, 6-metre tall *Le Pouce*, a copy of his thumb, which stands in **La Défense**, along with *Icare* (1980). Furthermore, *Le Centaure* (above), a homage to Pablo Picasso, stands atop the former entrance of the now defunct metro station Croix-Rouge, on the square of the same name. César died in Paris in 1998. The **Centre Pompidou**, the **Musée d'Art Moderne de la Ville de Paris** and **MAC/VAL** all hold substantial collections of his works.

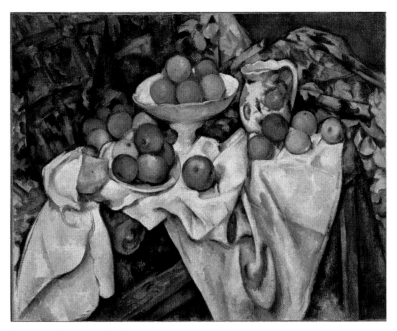

Pommes et Oranges (1900) oil on canvas 74 x 93 cm

PAUL CÉZANNE was born in Aix-en-Provence in 1939. His work had one of the strongest influences on the genesis of the revolutionary art movements that came into existence in the early 20th century (most notably cubism, fauvism and abstraction). Son of a rich banker, Cézanne initially trained as a lawyer but he decided to pursue an artistic career in Paris, against the will of his parents, on the advice of his good friend the prominent author Émile Zola. Originally close to the impressionists (particularly Camille Pissarro whom he considered his mentor), Cézanne gradually evolved his own style of painting, finally leaving Paris in the mid-1880s to return to his cherished home of Provence, where he was to spend the rest of his life painting his characteristic landscapes, still lifes and portraits, as well as the famous *Bathers* series. Cézanne's obsession with rendering the most truthful version of his visual perception, rather than reality, led him to paint his works in small, visible brushstrokes, presenting his subjects in near-monochrome planes with a vivid sense of depth and volume. It is these sharp and almost architectural, geometric volumes and colours that contributed to his direct influence on the generation of artists that was to follow him, such as Georges Braque and Henri Matisse. Paul Cézanne died at Aix-en-Provence in 1906. His work can be seen in the collections of the **Petit Palais** and the **Musée d'Orsay** (above).

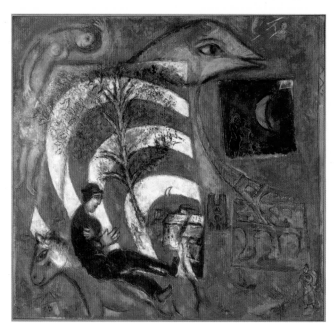

L'Arc-en-Ciel (1967) oil on canvas 160 x 170.5 cm

MARC CHAGALL was born in Vitebsk, Belarus, in 1887. He left for Paris, then the heart of the art world, in 1910. His style draws from many different sources, combining figuration with a very free line and absence of rational perspective, while his formal language brings together cityscapes from his happy Yiddish childhood with the marvels of Paris and the lush countryside of southern France. Typically, his works depict dreamy scenes from everyday life, incorporating lovers, musicians, farm animals, bouquets, mythical figures and characters from legends and fairy-tales. After the Holocaust and the creation of Israel, Chagall added religious themes to his oeuvre, painting numerous biblical scenes and pictures of religious rituals. His palette remained bright and varied throughout his life, even during the dark years of mourning and exile. In 1964 Chagall was invited to decorate the *Ceiling* of the Opéra Garnier by the minister of culture, André Malraux. This sumptuous composition, depicting scenes from ballet and opera, is filled with dancers, animals and benevolent divinities, complementing the rich gold and velvet decorations of the opera house. Marc Chagall died in St-Paul-de-Vence, near Nice, in 1985. His work can be seen in the collections of the **Centre Pompidou** (above), the **Musée d'Art et d'Histoire du Judaïsme** and the **Musée d'Art Moderne de la Ville de Paris**.

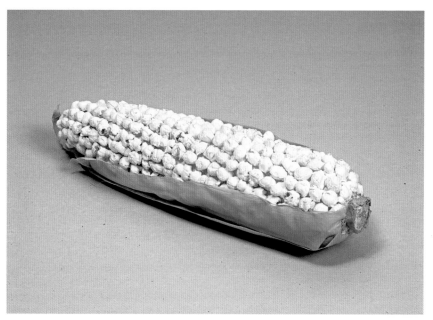

Big Corn (2007) freeze-dried popcorn, polystyrene, resin, paint, plastic 10 x 40 x 10 cm

FRANÇOIS CURLET was born in Paris in 1967. He is a versatile artist, making use of every available material and style to convey his humorous and ironic messages. Even though one might describe some of his works as the by-product of idle musings, Curlet staunchly refuses to let his art descend into superficiality – all of his pieces tell a story or make a point about the many, at best awkward, aspects of modern life. Curlet has created Rorschach tests made from tandoori-mix boxes, neon signs hailing the spirit of all things Belgian, and has installed three oversized peas (over 2 metres in diameter) in the classical rooms of a Paris exhibition space. He is currently awaiting the patent for a 'lazy' concrete that he invented and which takes all the time in the world to dry, thus creating haphazard, organic shapes strongly contrasting with the brutalist, smooth and slick surface generally associated with this material. François Curlet lives and works in Brussels. His work can be seen at **Air de Paris**.

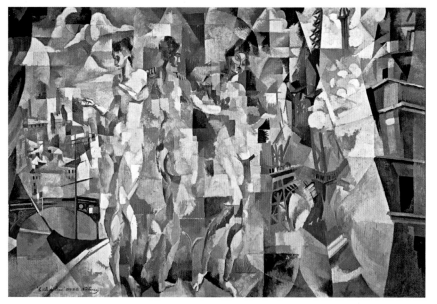

La Ville de Paris (1910-12) oil on canvas 267 x 406 cm

ROBERT DELAUNAY was born in Paris in 1885. He was initially influenced by late impressionism and colour was to remain crucial throughout his career. Following his marriage to Sonia in 1910, the pair worked together on numerous projects, always continuing to produce their own art. Delaunay painted many views of Paris, and it is through these repetitive works, and his insistence on certain details, that he gradually started deconstructing images, eventually painting abstract forms. Before World War One he was associated with Wassily Kandinsky and other members of the Blue Rider group, developing his own version of abstraction at the same time as the German avant-garde movement. His paintings became radiant and geometrical, but also increasingly colourful and rhythmical, owing to his near-metaphysical obsession with light, particularly the sun's ability to generate colour and to set it in motion. During this period, vast concentric circles of colour cover large canvases. Later, he returned to figurative painting, incorporating elements of popular culture in his works, but mostly he continued to develop his geometric, abstract vocabulary in a varied palette. Robert Delaunay died in Montpellier in 1941, fleeing the Nazi occupation. His work, as well as that of Sonia Delaunay, can be found in the collections of the **Centre Pompidou** and the **Musée d'Art Moderne de la Ville de Paris** (above).

Trois Personnages Assis sur l'Herbe (1906) oil on canvas 38 x 55 cm

ANDRÉ DERAIN was born in Chatou, on the Seine near Paris, in 1880. He initially painted in the neo-impressionist style, before meeting Henri Matisse and Maurice de Vlaminck in the early 1900s. Together they explored the landscapes of southern France from which they drew the energy and intense colours that were to characterize the fauvist movement. It is Derain's work from this period, with its colourful palette and simplification of the subject to a pure representation of light, with which he is most associated today. Until the onset of World War One, Derain remained at the centre of the French avant-garde. His style evolved as he made new friends and travelled through Europe: trying out early cubism with Pablo Picasso and collaborating with Wassily Kandinsky's Blue Rider group. He was also influenced by the African art he saw while visiting London. Following a three-year period of military service Derain returned to a more classical, austere and traditional style of painting, which made him a very popular artistic figure in the 1920s. During this period he designed costumes and sets for operas and ballets, illustrated books for André Breton, Oscar Wilde and Guillaume Apollinaire, and made sculptures. André Derain died in a car crash in Garches, in 1954. His work can be seen in the collections of the **Centre Pompidou** (above) and the **Musée d'Art Moderne de la Ville de Paris**. He is also found at **Galerie Fanny Guillon-Laffaille**.

Les Pains de Picasso (1952) gelatin silver print 40.6 x 30.5 cm

ROBERT DOISNEAU was born in Gentilly, south of Paris, in 1912. Starting out in the 1930s as the official photographer of the vast Renault industrial plant of Boulogne-Billancourt, near Paris, Doisneau went on to record the ordinary daily lives of the inhabitants of the city. In his portraits of children playing in the streets, scenes of bustling cafés and brasseries, elderly craftsmen at work, or the animated shopping streets in the working-class districts of eastern Paris, he managed to capture not only the way Parisians perceive themselves and their city, but also how the foreign visitor idealizes the romantic, traditional aspects of the French capital. His works are so much a part of the subjective common heritage that in 2005 one of his most iconic pieces, *The Kiss by the Hôtel de Ville* (1950), portraying two lovers in the optimistic atmosphere of post-war Paris, secured one of the highest prices ever paid in France for a photograph at auction. Today, Doisneau's black and white photographs remain some of the most quintessential visual witnesses of a bygone era. He also worked for *Life* magazine, for which he shot portraits of some of the most illustrious Parisian artists, most notably Pablo Picasso (above). Robert Doisneau died in Montrouge, near his birthplace, in 1994. His work can be seen in the collections of the Musée Carnavalet and the Centre Pompidou. He is also found at Galerie Claude Bernard.

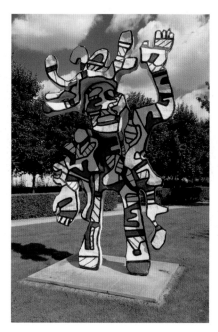

Le Bal Costumé (1973) epoxy paint, resin

JEAN DUBUFFET was born in Le Havre in 1901. He attended the Académie Julien in Paris but became disenchanted and abandoned his studies to run the family shop. He returned to painting in the 1930s, dedicating himself to art from 1942. Dubuffet was inspired by art brut, work produced by those outside generally accepted boundaries of high art, such as children, prisoners or the mentally ill. He attempted to re-create this kind of art, emancipated from the intellectual pressures of the cultural world and the established taste of the bourgeoisie, entities he thoroughly distrusted. Until the 1960s he produced paintings of naïve appearance, incorporating odd materials (such as tar or hay) to create a thick and lively texture on the surface of the canvas. In 1962 his *L'Hourloupe* series marked a different style: interconnected cells with black frames on a white background, filled with blue or red colour fields or with parallel hatched lines. He applied this cannon to drawings, paintings and resin and polystyrene sculptures. Jean Dubuffet died in Paris in 1985. His work can be seen in numerous locations including the collections of the **Centre Pompidou**, the **Musée des Arts Décoratifs**, **MAC/VAL** and the **Fondation Dubuffet**. He is also found at the **Jardin des Tuileries** (*Le Bal Costumé* – above), Issy-les-Moulineaux (*La Tour aux Figures*), Caisse des Dépôts (*Le Réséda*) and Hôpital Robert Debré (*L'Acceuillant*).

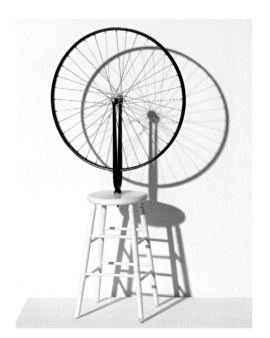

Roue de Bicyclette (1913) metal and painted wood
126.5 x 63.5 x 31.5 cm

MARCEL DUCHAMP was born in Blainville, Normandy, in 1887. One of the most influential figures of 20th-century art, Duchamp helped establish the philosophy and the theory of many contemporary art practices. Born into an artistic family, Duchamp studied at the Académie Julien in Paris but left after a year, preferring to draw inspiration from older brothers, friends and other artists. His early paintings show the influence of both cubism and futurism. However, he quickly felt that the possibilities offered by painting, and by what he called 'retinal' art, were not sufficient tools to achieve his artistic aims. From 1913 onwards Duchamp frequented Dada groups and while living in the USA during World War One he established the concept of the 'ready-made': a found object that acquires its artistic propriety by the fact that it has been chosen and signed by the artist. Over the years Duchamp created more 'ready-mades', as well as composite collages, films and photographs. He created a fictional, transvestite character to narrate stories and include in artworks, and curated revolutionary exhibitions. In later life he dedicated himself to his other great passion, chess, but remained in touch with the art world as a critic, theorist and mentor to younger artists. Marcel Duchamp died in 1968 at Neuilly-sur-Seine. His work can be seen in the collections of the **Centre Pompidou** (above) and the **Musée d'Art Moderne de la Ville de Paris**.

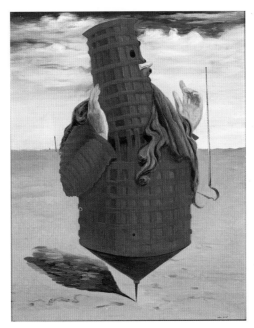

Ubu Imperator (1923) oil on canvas 81 x 65 cm

MAX ERNST was born in Brühl, near Cologne, in 1891. He studied philosophy, history of art and psychology in Bonn, yet after discovering the paintings of German expressionist artists, he began his career as a self-taught painter and craftsman in 1910. Ernst was one of the founding members of the Cologne branch of the Dada movement in 1918, where he met Jean Arp. After moving to Paris in 1922, his works became influenced by surrealism. From this time onwards his drawings, paintings, collages and even poems, revolved around the interpretation of his dreams and memories of his childhood. One example was the characteristic half-bird, half-human creature, supposedly an avatar, which derives from an incident involving his childhood pet parrot, which died on the night one of his sisters was born. Fleeing Nazi persecution in occupied France, Ernst settled in New York and, later, Arizona, where, encouraged by the art collector Peggy Guggenheim, he experimented with sculpture. Returning to Europe in the early 1950s, Ernst enjoyed popularity until his death, respected for his poetic work in a range of media: drawing, sculpture, painting and print. Max Ernst died in Paris in 1976. All aspects of his work can be seen in the collections of the **Centre Pompidou** (above) and the **Musée d'Art Moderne de la Ville de Paris**. He is also found in the place Georges Pompidou (*Le Grand Assistant*).

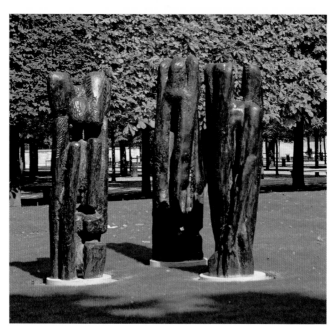

Personnages III (1967) bronze

HENRI ÉTIENNE-MARTIN was born in Loriol-sur-Drôme in 1913. He trained as a sculptor at the École des Beaux-Arts in Lyons and at the Académie Ranson in Paris. Unlike many abstract artists, his works do not derive from studies of form and shape but are the result of his psychological and spiritual researches. He believed that every material had a soul and a story to tell, and his works took on very different forms depending on whether they were made from wood, marble or metal. The void is a palpable element of his works, conveying feelings of loss and absence, along with influences from Eastern philosophies – Taoism and Buddhism – to which the concept of non-being and emptiness are crucial. For example, a series of sculptures entitled *Demeures* (*Dwellings*), constructed as vast shelters, was inspired by the sadness he felt when his childhood home was sold, and the sense of separation and psychological homelessness he subsequently experienced. His oeuvre speaks to the onlooker with its profoundly lyrical qualities, evoking emotions of generosity and sensitivity. Henri Étienne-Martin died in Paris in 1995. His work can be seen in the collections of the **Centre Pompidou** and the **Musée d'Art Moderne de la Ville de Paris**, as well as in the **Jardin des Tuileries** (*Personnages III* – above), the **Musée de Sculpture en Plein Air** (*Demeure no. 1*) and Parc de Bercy (*Demeure no. 10*).

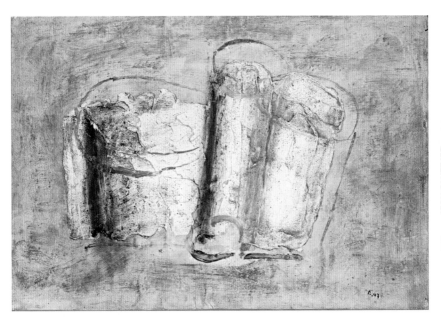

Les Boîtes de Conserve (1947) oil on paper 50 x 73 cm

JEAN FAUTRIER was born in Paris in 1898. He is one of the few French artists of his time to be trained abroad, first at the Royal Academy (which he entered aged 14) and later at the Slade School of Art, both in London. Disappointed, however, by the overly academic approach of these institutions, he returned to Paris, finishing his education by himself. His paintings and sculptures are powerful, figurative expressions of a sensitive mind. His earlier works were mainly series of nudes, landscapes and still lifes rendered with minimal, dark colours and tentative but heavy lines. Later in life his work became increasingly political, most famously those recalling the German occupation and its hardships (he himself had to flee from the Gestapo) and a series of paintings denouncing the lack of freedom in Eastern Europe, executed after the crushing of the 1956 revolution attempt in Hungary. Fautrier experimented with different techniques, inventing a process combining painting and copying, which allowed him to create a number of 'original multiples'. Influenced by the lush English gardens he had visited as a student, he created a carefully tended 'wild' garden in the Paris suburb of Châtenay-Malabry, where his studio is located and where he died in 1964. His work can be seen in the collections of the **Centre Pompidou**, the **Musée National de l'Orangerie** and the **Musée d'Art Moderne de la Ville de Paris** (above).

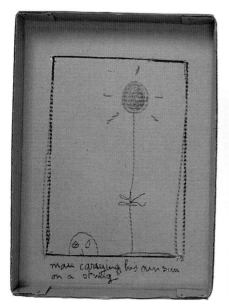

Man Carrying his own Sun on a String (1973) cardboard boxes, pastel, photograph 45 x 33.5 x 5.6 cm

ROBERT FILLIOU was born in Sauve, the Midi, in 1926. He originally studied economics at UCLA in Los Angeles, and worked as mechanic in a Coca-Cola plant and as a special UN envoy before returning to France and becoming an artist. He travelled extensively throughout his life, settling in France, the USA, Korea, Denmark and Germany, wherever work or friendship took him. He is associated with the fluxus movement, which called for the integration of all forms of art into every aspect of life. Filliou's oeuvre, comprising innumerable performances as well as videos, sculptures and agglomerations of the most varied objects and installations, is characterized both by a benevolent sense of humour (he opened a 'non-shop' in Nice and founded a 'genial republic') and a genuine interest in social issues and the way humans interact. Furthermore, he pursued his passion for the spoken and written word as a poet and a teacher at various art schools throughout Europe. One of his most famous sentences sums up the way he perceived life and his work: 'Art is what makes life more interesting than art....' Robert Filliou died in 1987 at Les Eyzies in the Dordogne. His work can be seen in the collections of the Centre Pompidou and the Musée d'Art Moderne de la Ville de Paris. He is also found at Galerie Nelson Freeman.

Opa (2007) acrylic and resin on canvas 240.5 x 310 cm

BERNARD FRIZE was born in St-Mandé, just outside Paris, in 1954. His approach to his own creation and to art itself has always been quite radical, despite the apparently seductive colourfulness of his paintings. He rejects the idea of artworks carrying a message or serving as a means to express emotion, thought or theory. His interest lies solely in technique, which he reinvents in each of his series of paintings until he feels he has exhausted all the possibilities of the process he is employing. Frize also doubts any notions of originality and uniqueness of the artist, allowing anonymous collaborators to contribute to his works. He focuses his efforts on creating 'automatic paintings', a haphazard way of applying paint onto canvas, intent on highlighting the most inherent character of this medium: its flatness. The results of this highly practical approach are paintings of widely varying scale, in which seemingly methodical, yet in fact coincidental, geometrical and colourful lines or independent brushstrokes create a rhythmic, two-dimensional pattern on a slick, neutral white background. Bernard Frize lives and works in Paris. His work can be seen in the collections of the Centre Pompidou and the Musée d'Art Moderne de la Ville de Paris. He is also found at Galerie Emmanuel Perrotin.

En Chine, à Hu-Xian (1974) oil on canvas 200 x 300 cm

GÉRARD FROMANGER was born in Pontchartrain, west of Paris, in 1939. He trained at the École des Beaux-Arts in Paris and early on rejected the trend toward austere abstraction, which dominated painting in his youth. Instead, he focused on the representation of the realities and the visual codes of the world around him. He was therefore viewed as a representative of the French version of pop art – narrative figuration. He became a protégé of the sculptor César, who lent him his studio for a period of two years and encouraged him to pursue his own style of painting. His works range from portraits painted in continuous lines, reproductions of photographs painted over large Plexiglas sculptures, Paris street scenes and giant billboard-like adverts for non-existent products. Through these varied media and bright colours he reinterprets popular culture and the visual signs of his time with an ever-present, typically French, sense of caustic humour and subtle political statement, both of which add depth to his exposure of the ways in which consumerist society perceives itself. Gérard Fromanger lives and works in Paris and Siena. His work can be seen in the collection of the **Centre Pompidou** (above). He is also found at **Galerie Claude Samuel**.

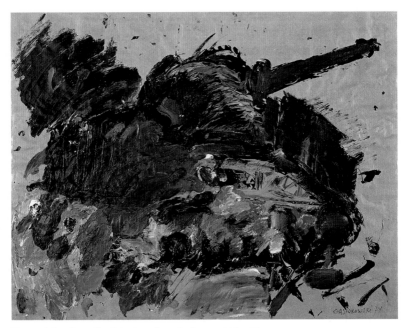

Champ de Bataille et Char (1974) acrylic on kraft paper 49.5 x 65 cm

GÉRARD GASIOROWSKI was born in Paris in 1930. He trained at the École des Arts Appliqués in Paris before working in an insurance company and as a photographer's assistant. He discovered American pop art in the 1960s and resumed painting with a series of hyper-realistic works influenced by, though contrasting with, his former photographic work. Gasiorowski subsequently confronted the traditional Western perception of art on a theoretical level, attempting to 'kill' art, and later in a more formal translation of this conflict on canvas, with a series of abstract black shapes on white backgrounds and with simple, seemingly unfinished, acrylic paintings. He furthered his critique of art and of the money-obsessed market by dispensing with picture frames and later by giving up painting altogether. Instead, he focused on creating vast violent and complex accumulations of cut paper and toys spattered with paint: landscapes of war and fear. Before returning to painting for one final series, he invented a fictitious *alter ego*, a sadistic art school director, whose imaginary academy produced mysterious 'hat drawings', and he reappeared in the public sphere only after staging the director's murder. Gérard Gasiorowski died in Lyons in 1986. His work can be seen in the collections of the **Centre Pompidou**, the **Musée d'Art Moderne de la Ville de Paris** and the **FRAC Île-de-France**. He is also found at **Galerie Maeght**.

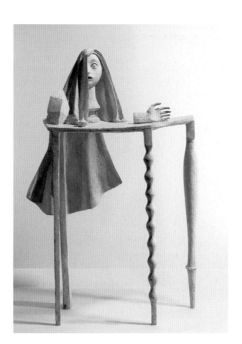

La Table Surréaliste (1933) plaster 148.5 x 103 x 43 cm

ALBERTO GIACOMETTI was born in Borgonovo, Switzerland, in 1901, into a family of artists. After training at the École des Beaux-Arts in Geneva, he moved to Paris in 1922, where he became the pupil of the sculptor Antoine Bourdelle at the Académie de la Grande Chaumière in Montparnasse. Noted as a draughtsman, painter and most famously as a sculptor, Giacometti's oeuvre is among the most recognized of the 20th century. He initially worked in close collaboration with the surrealist movement, befriending Joan Miró and Max Ernst, creating violent, intense sculptures of the human form and highly structured portraits, as well as a series of cubist works. Disenchanted with the surrealists and socially isolated in the 1930s, he destroyed most of his work from this period. From 1945 he embarked on a more fruitful phase, after meeting his future wife, Annette, and the philosopher Jean-Paul Sartre, who remained his friend until his death. In his last 20 years, Giacometti produced figurative metal sculptures, reducing human and animal forms to their most basic elements to create tall, emaciated statues, standing sturdily on heavy foundations. Alberto Giacometti died of a heart failure in 1966, aged 65, at Chur, Switzerland. Many of his works on paper can be seen in the collections of the **Centre Pompidou** (above) and the **Musée d'Art Moderne de la Ville de Paris**. His sculptures can be found at **UNESCO**.

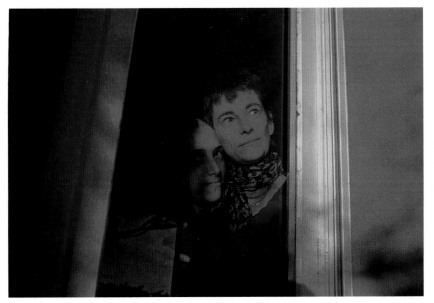

Charlotte and Marie-Anne Watching the Sunset, Christmas Eve, Sète (2003) cibachrome 101.5 x 152.5 cm

NAN GOLDIN was born in Washington DC in 1953. Raised in the suburbs of Maryland and Boston, Goldin was profoundly shaken by the suicide of her older sister in 1965, becoming estranged from her family and living in foster homes from the age of 14. She studied at Tufts University, Boston, where she started taking documentary photographs, capturing in black and white the lives of her friends and roaming the local gay scene with her camera. She moved to New York in 1978 and established a close network of friends who became both a substitute family and an endless source of artistic inspiration. Turning to colour photography, Goldin openly documented her life and that of her friends, never shying away from the crass, shocking or sad, nor the genuinely poetic, romantic and sincere. Her vast collection of snapshots shows scenes from the intimacy of lovers' bedrooms, drag queens getting ready for their act, drug-fuelled parties and the enticing night streets of the metropolis. She documented her own and her friends' sufferings, sometimes from drugs or Aids. Her work is both documentation and testimony, a mirror and photo album, capturing all the people, things and events in her life. Nan Goldin lives and works between Paris and New York. Her work can be seen in the collections of the **Centre Pompidou** and the **Fondation Cartier pour l'Art Contemporain**. She is also found at **Yvon Lambert**.

BUCKY, the Intergalactic Draw (2007-08) super 16 mm transferred to 35 mm film, 6 min 50 sec

LORIS GRÉAUD was born in Eaubonne, north-west of Paris, in 1979. One of the most prolific figures of the young French contemporary art scene, Gréaud briefly studied filmmaking and graphic design, before being expelled from the Paris Conservatoire and completing a degree at the École Nationale Supérieure d'Arts Paris-Cérgy. His installations draw on various sources, including references to Le Corbusier, William Burroughs and David Lynch. He stimulates all the senses in his work, especially by his use of sound, which is present in many of his pieces, and incorporates mysterious riddles in both the titles of his works and the encrypted, highly subjective explanation of their meaning, frequently interacting with other visual artists, musicians, filmmakers, scientists, architects and writers. Formally, many of his works offer slick, sharp surfaces and elements reminiscent of contemporary design, although sometimes only deceitfully so, such as in his giant, sculptural hot air balloon (*A Prophecy*, 2006), and he is unafraid to include organic matter, such as a stuffed duck or a bed of watercress, in his work. His interdisciplinary approach is like an echo of empirical perception and as varied as the sources and memories the mind draws from. Loris Gréaud lives and works in Paris. His work can be seen in the collections of the **Centre Pompidou** and the **FRAC Île-de-France**. He is also found at **Yvon Lambert**.

Saffa (1964) paint, wood 130 x 100 cm

RAYMOND HAINS was born in St-Brieuc, Brittany, in 1926. He studied at the École des Beaux-Arts, Rennes, where he met Jacques Villeglé, with whom he later joined the new realism movement in the 1940s, before becoming a photographer's assistant. His first works are abstract photographs, but, like Villeglé, he began exhibiting political posters found on city walls, haphazard but evocative creations by anonymous individuals who ripped the topmost posters apart revealing parts of the ones beneath. This marked the beginning of his interest in the intervention of the anonymous city-dweller in the public space and the subsequent appropriation of the result by the artist as a by-product of popular culture. Hains is known for his word-games and his typically French affection for *bons mots*, illustrating both his sense of humour and his erudition. These characteristics are apparent in his later installations, sculptures and interventions, into which he frequently integrated the innovations of the day (CCTVs, laptops, the internet), and through which he illustrated his great interest in people and their environment. Raymond Hains died in 2005 in Paris. His work can be seen in the collections of the **Centre Pompidou**, the **Musée d'Art Moderne de la Ville de Paris** (above), the **FRAC Île-de-France** and the **Fondation Cartier pour l'Art Contemporain**. He is also found at **Galerie Daniel Templon**.

Peinture (Ecriture Rose) (1958-59) coloured ink and gold leaf on canvas 329.5 x 424.5 cm

SIMON HANTAÏ was born in Biatorbágy, Hungary, in 1922. After studying at the Academy of Fine Arts in Budapest, he moved to Paris in 1949, obtaining French citizenship in 1966. He collaborated with the surrealists, creating intricate figurative paintings, but broke with the movement in the 1950s, becoming influenced by the impulsive painting technique of Jackson Pollock and American abstract expressionism. He began working directly onto canvas in the 1960s, with series of works in which he folded and crumpled the canvas, sometimes allowing the colour to rest freely on the resulting landscape or filling the haphazard pattern with monochrome colour fields. This technique allowed him to move away from any sort of pre-established composition. Hantaï gave increasing importance to the blank canvas, associating the white surface with notions of freedom, purity, silence and memory. His interest in the metaphysical and his Catholicism, combined with a devotion to the formal possibilities of abstraction, precise use of techniques and materials, result in lyrical works whose visual depth triggers emotional reflection. Simon Hantaï lives and works in Paris. His work can be seen in the collections of the **Musée d'Art Moderne de la Ville de Paris**, the **Centre Pompidou** (above) and the **Fondation Cartier pour l'Art Contemporain**. He is also found at **Galerie Larock-Granoff**, **Galerie Brimaud** and **Galerie l'Or du Temps**.

Outgrowth (2005) wood, cardboard, brown adhesive tape, 131 globes, printed matter 350 x 620 x 30 cm

THOMAS HIRSCHHORN was born in Bern, Switzerland, in 1957. He grew up in Davos and studied at the School of Design in Zurich. Hirschhorn is a politically engaged artist, who presents his theories about the happenings and social evolutions of the world in large-scale, mostly *in-situ* installations. He uses the humblest of materials: newspaper cuttings, aluminium foil, cardboard, small found objects, plywood and vast amounts of duct tape, an omnipresent element that both holds together many of the various materials but also constitutes a clear visual element of the whole piece. He abhors perfection and distances himself from the cosy confinement of the artistic elite. On the contrary, he often invites viewers to interact with his works, to walk inside his installations, which in some cases fill whole houses, and he takes his art to socially tense urban areas, most famously the north-eastern suburbs of Paris where his studio is located. In his exuberant, overflowing installations he has illustrated his version of the origins of the September 11 attacks, presented key people and events of the 20th century, and illustrated the ambiguous attitude of the Swiss state towards controversial contemporary issues. Thomas Hirschhorn has lived and worked in France since 1984 and is now based in Aubervilliers and Paris. His work can be seen in the collection of the **Centre Pompidou**. He is also found at **Galerie Chantal Crousel**.

Carte du Monde 2000-2046 (2000-07) brass arrows, card on wood, globe 304.8 x 94 cm

HUANG YONG PING was born in Xiamen, China, in 1954. In 1989 he took part in the renowned exhibition *Les Magiciens de la Terre* at the Centre Pompidou. Huang has since become an important figure in the contemporary art scene, representing France at the 1999 Venice Biennale. His work reflects his dual cultural links and is influenced both by the Dada movement in its choice of materials and playful sense of humour (he was the founder of the Xiamen Dada group in China in the 1980s) and by Chinese numerology traditions, Taoist philosophy and geomancy. Huang's monumental installations often involve live animals, for which they have been censored, and combine references to oriental mythology and Chinese symbolism as well as to the chaotic state of current world events. For an exhibition in 2006 the artist displayed animals with religious symbolism: for example, *List of Gifts* comprised a huge bat carrying in its mouth a scroll covered with drawings of pagan altars and transparent bodies, and *The Hands of Buddha* depicted a giant squid with rosary beads entwined in its tentacles. Like a cabinet of curiosities, the works offered no clues as to their meaning, leaving the viewer to decipher their symbolism. Huang Yong Ping lives and works in Paris. His work can be seen in the collections of the **Centre Pompidou** and the **Fondation Cartier pour l'Art Contemporain**. He is also found at **Galerie Anne de Villepoix**.

This is not a Time for Dreaming (2004) puppet play and super 16 mm film transferred to video, 24 min

PIERRE HUYGHE was born in Paris in 1962. Throughout his career he has been involved in multimedia collaborations with other artists. In 1995 he orchestrated a work called *Mobile TV*, a television station showing programmes by various artists. He collaborated with Philippe Parreno on the work *L'Histoire d'un Sentiment*, a deliberately unfinished film script with a character named Anna Sanders, and on *Anna Sanders*, a fake magazine for a woman who is never shown and thus becomes a sort of phantom demographic. In 1999 they devised *No Ghost Just a Shell*, in which AnnLee, a Japanese Manga cartoon character, was bought and licensed by the artists, then 'shared' with other artists for their own projects, before finally being given the rights to herself. In the late 1990s Huyghe was an innovator of the 'post-production' technique, re-using existing mass media, such as films, to create new art. In the triple-screen projection *L'Ellipse* (1998), he slowed a jump cut from Wim Wenders's film *The American Friend* and added his own footage of Bruno Ganz acting out a scene skipped in the film – the walk across a city between phone calls. This 'lost' scene draws our attention to the temporal gaps in fiction films and the viewer's role in completing the work of narrative art. Pierre Huyghe lives and works in Paris. His work can be seen in the collection of the **Centre Pompidou**. He is also found at **Galerie Marian Goodman**.

Artère (2006) ceramic tiles 1,001 square metres

FABRICE HYBER was born Fabrice Hybert in Luçon, Vendée, in 1961, and erased the 't' from his last name in May 2004. He studied at the École des Beaux-Arts in Nantes and produces works based on a process of accumulation, proliferation and hybridization, constantly moving between drawing, painting, sculpture, installation and video as well as commerce. He describes his work as a gigantic rhizome, which develops according to a system of exchange and association. His drawings and paintings play a key role in this creative process, the rapidity of their execution allowing for constant corrections and analogies. Thought is perceived as an organic process, intrinsically linked to the physiological functioning of the body. His series of layered, hybrid *Homeopathic Paintings*, started in 1986 and which now number over 20, lies at the core of his work. The title refers to the medicinal distillation of a huge amount of information into small doses. He is known for his *POF* (*Prototypes of Objects in Function*), in which everyday objects are adapted to the user's needs: a swing incorporates a phallic protuberance; a diver's mask becomes a mirror reflecting the wearer's eyes and is entitled *Deep Narcissus*. Fabrice Hyber lives and works in Paris. His work can be seen in the collection of the **Centre Pompidou** and in the **Jardin du Luxembourg** (*Le Cri, l'Écrit*) and **Parc de la Villette** (*Artère*, above). He is also found at **Galerie Jérôme de Noirmont**.

Le Déjeuner sur l'Herbe (1964) acrylic and screenprint on canvas 172.5 x 196 cm

ALAIN JACQUET was born in Neuilly-sur-Seine, outside Paris, in 1939. After visiting the University of Grenoble, Jacquet took architecture classes at the École des Beaux-Arts in Paris and exhibited for the first time in 1961, before moving to New York in 1964. There he discovered pop art, which would constitute a lasting influence on his work. However, he did not find a place for himself in the American art scene or in this intrinsically American art movement. Indeed, Jacquet had issues with the exclusive concentration of pop art on the most banal elements of popular culture, and he returned to France where he could focus on his own style. His paintings are large-scale screenprints, close to those of Roy Lichtenstein but technically much more elaborate in that Jacquet makes use of a mechanical process to print his works. He often superimposes a pattern of colourful dots onto reproductions of masterpieces such as Manet's *Déjeuner sur l'Herbe* (above), Ingres' *La Source* and Jasper John's *Three Flags*. The optical illusion of colour fields generated by this systematic technique remains a key feature of his work and he continues to develop the process further, printing on new materials and magnifying details from paintings until they become abstract. Alain Jacquet lives and works in Paris and New York. His work can be seen in the collection of the **Centre Pompidou** (above). He is also found at **Galerie Daniel Templon**.

L'Inceste (1975) gelatin silver prints 30.5 x 40.5 cm each

MICHEL JOURNIAC was born in Paris in 1935. An exceptional artist, he used his body as the subject of his work and as a means of questioning society. The body is mutilated, staged, travestied and exposed in order to retrieve what Journiac termed 'man's truth', freedom from the consumer society that renders everyone passive. His childhood was marked by the tragic death of his younger brother from septicaemia, perhaps informing his key themes of death, religious ceremony, ritual and blood. Discovering his homosexuality at the age of 17, Journiac lived a troubled existence, moving from one teaching job to another, painting tortured expressionist paintings in the 1960s before plunging solely into performance art, which has variously been described as provocative, scandalous and outrageous. In the performance *Mass for a Body* (1969) he dressed as a priest and offered up the artist's body in the form of a sausage made from his own blood. He used photography to keep track of his performances and it became one of his principal media. In the 1972 series *Hommage à Freud* he re-enacts 24 hours in the life of a woman, taking on different, incestuous roles in a critique of a society that uses and abuses Freudian theory. Journiac's work is not for the sensitive, yet it captivates by its sincerity and intensity. Michel Journiac died in 1995 in Paris. His work can be seen in the collection of the **Centre Pompidou** (above).

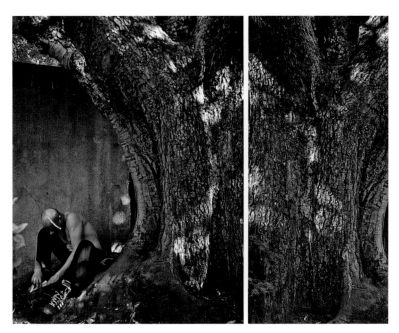

Untitled (Les Arbres) (2006) C-print diptych 150 x 193 cm

VALÉRIE JOUVE was born in St-Étienne in 1964. Originally trained as a sociologist, she has been practising photography for the past 15 years, using the medium as a means of capturing individuals, usually within an urban setting. Often formatted like portraits, her works reflect a certain poignancy, the faces of her subjects imprinted with their experience, the traces of their lives and surroundings. The series of works entitled *Les Passants* focuses on the movement of human bodies within the architectural framework of the city. The rhythmic mobility of arms and legs seem both to harmonize and contrast with the rigid curves and angles of the buildings that rise up around them. Jouve has also made several films. *Time is Working around Rotterdam* (2006) is conceived as a kind of road movie, travelling alternatively through industrial zones, busy streets and the calm mirroring surfaces of skyscrapers. Successive landscapes seem to merge into what becomes a visually abstract composition, passing from one temporality to another, accelerating and decelerating in pace, moving from a grainy to a smooth texture. People emerge and are submerged in the endless flux of space and time. Valérie Jouve lives and works in the Parisian suburb of Montreuil. Her work can be seen in the collections of the **Centre Pompidou,** the **Musée d'Art Moderne de la Ville de Paris** and **MAC/VAL.** She is also found at **Galerie Xippas.**

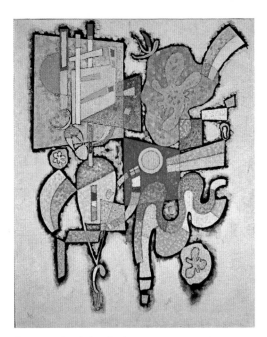

Complexité Simple (1939) oil on canvas 100.5 x 82 cm

WASSILY KANDINSKY was born in Moscow in 1866. He trained as a lawyer before moving to Munich in 1896, where he studied at the Academy of Fine Arts under the German symbolist painter Franz von Stuck. He was the main proponent of the Neue Künstlervereinigung group whose art was a synthesis of expressionism and symbolism, influenced by theosophy and mysticism as well as synaesthetics (the notion that one can perceive things with all senses at the same time). His paintings from this period comprise alpine landscapes, idealized visions of rural life and Saint George, patron saint of Moscow. Often considered to be the first abstract painter, in 1911 he co-founded the Blue Rider group, extending his studies on abstraction with a spiritual approach to colour and pure form. He gave his works generic names, such as *Compositions* and *Improvisations*, titles borrowed from music. During World War One Kandinsky returned to Russia, but left after the Revolution. He taught at the Bauhaus before settling near Paris after the seizure of power by the Nazis in Germany. His abstract style, focusing on the interaction of colour fields, veered between the analytical, geometrical and even biomorphic. Wassily Kandinsky died in 1944 in Neuilly-sur-Seine. His wife, Nina, donated his collection to the **Centre Pompidou** (above). He is also found in the collections of the **Musée d'Art Moderne de la Ville de Paris** and **Musée Maillol**.

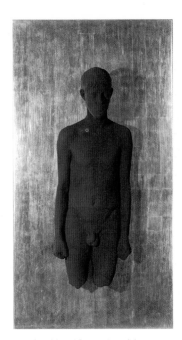

Portrait Relief de Martial Raysse (1962) bronze, pigment,
resin mounted on panel with gold leaf 176 x 94 cm

YVES KLEIN was born in Nice in 1928. Despite his short artistic career of only eight years, he is considered one the most important and influential figures of the avant-garde. He grew up in a bohemian atmosphere with artist parents, but as a young man he was more interested in practising judo. At his first lesson he met Armand Fernandez, the future Arman, with whom he later founded the new realism movement. He turned to art, which he saw as a means of spiritual existence, with monochrome paintings influenced by the mystical writings of the Rosicrucian leader, Max Heindel. In 1955 Klein held his first exhibition at the Club des Solitaires where he met the art critic Pierre Restany who helped launch his artistic career. Klein began his famous Blue Period in 1957, after a trip to Assisi in Italy, where the blue skies in Giotto's frescoes left a lasting impression on him, convincing him of the spiritual qualities of this colour. His used the colour, which he named IKB (International Klein Blue), in painting, sculpture and performances, taking out copyright on the name in 1960. In the same year, Klein introduced gold and pink into his colour palette. An *ex voto* triptych, dedicated to Saint Rita, decorates his wedding invitation to Rotraut Uecker in 1962, the year of his death from a heart attack in Paris. His work can be seen in the collections of the **Centre Pompidou** and the **Musée d'Art Moderne de la Ville de Paris** (above).

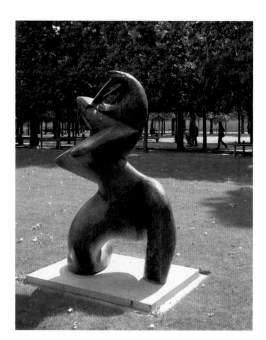

La Grande Musicienne (1937) bronze

HENRI LAURENS was born in Paris in 1885. One of the most important sculptors of the 20th century, he is best known for his cubist sculptures, which exalt feminine sensuality. Born into a working-class family, Laurens learned to sculpt during the day and took drawing lessons in the evening. Illness led to one of his legs being amputated, causing him constant pain. Working in the Montparnasse studios of La Ruche, he became a part of the Parisian avant-garde, meeting writers, sculptors and painters such as Marc Chagall. His first exhibition dates from 1911 at the Salon des Indépendants, where his work caught the eye of Auguste Rodin and Georges Braque. Numerous commissions enabled him to earn a living decorating public institutions, such as the school at Villejuif, and working for private collectors such as Jacques Doucet and Helena Rubinstein, and with Le Corbusier. In 1910 Laurens produced an eclectic series of works, assembling disarticulated and abstract forms, employing collage and sculptural supports including wood, plaster, metal and clay. The next ten years were characterized by small rounded sculptures of women in stone that became bigger and more harmonious in time. Henri Laurens died in Paris in 1954. His work can be seen at his tomb in the Cimetière de Montparnasse (*La Douleur*) and in the **Jardin des Tuileries** (*La Grande Musicienne* – above). He is also found at **Galerie Bernard Bouche**.

Empress of India II (2005) neon tubes 196 x 580 cm

BERTRAND LAVIER was born at Châtillon-sur-Seine in 1949. A self-taught artist, with a degree in landscape gardening, his interest was awakened by the galleries that he passed each day. He developed his talent through observation and practice, concentrating on the relationship between art and reality and questioning the status of art in society. In his first works from the 1970s he modified everyday objects in a similar vein to Marcel Duchamp's 'ready-mades'. In the 1980s he adapted advertising posters and road signs, knocking the object's status sideways. A fridge repainted in its original colour becomes at once an image of the object and the object itself; an anvil on a chest of drawers a sculpture whose aesthetic value replaces the object's functionality. In *Giulietta* (1983) the emotional impact of a crashed Alpha Romeo evokes the automobile as a consumerist icon and a history of car crashes from James Dean to Jean-Luc Godard; César's compressions to Andy Warhol's *Crashed Cars*. In *Walt Disney Productions* (1990s) high and low culture are mixed, with cartoon characters reproduced in sculptures reminiscent of Henry Moore. In 2006 he created *La Bocca*, a porcelain copy of Dalí's red lips sofa. Bertrand Lavier lives and works in Aignay-le-Duc. His work can be seen in the collections of the **Centre Pompidou**, the **Musée d'Art Moderne de la Ville de Paris** and in the **T3 Tramway** project. He is also found at **Yvon Lambert**.

L'Arbre (2005) wood, paint, polyester 600 x 300 cm

GUILLAUME LEBLON was born in Lille in 1971. An upcoming figure among the younger generation of French artists, he graduated from the École des Beaux-Arts in Lyons and was resident at the Rijksakademie in Amsterdam from 1999 to 2000. Leblon's sculptural work is indebted to a minimal and conceptual art, employing pure line and volume. His work attempts to capture traces of the real but questions the notion of representation. For example, in his sculpture *Contours* (2001-04) he uses neon light to sketch the outline of a stylized chandelier, hung from the ceiling as a ghostly decoration for a bourgeois interior. In *L'Arbre* (above) he plays with scale and reproduces a life-size tree of the type used in architects' models. His films are imbued with a sense of nostalgia and concerned with ideas of loss, memory and permanence. In *Villa Cavrois* (2000) he takes as his subject a once elegant building by the architect Robert Mallet-Stevens, which has now fallen into ruin, filming slowly for nine minutes to reveal its lost beauty. The devastating effects of nature are also present in *April Street* (2002), which shows a town half submerged in floods, subdued, deserted and captured in a melancholic film shot from a boat. Guillaume Leblon lives and works in Paris. His work can be seen in the collection of the **Centre Pompidou**. He is also found at **Galerie Jocelyn Wolff**.

Ruins of Love 1 (2005) photograph on aluminium 91 x 220 cm

ANGE LECCIA was born in Minerviu, Corsica, in 1952. His work is renowned for its emotional impact and has influenced a generation of younger French artists such as Dominique Gonzalez-Foerster and Philippe Parreno. In the 1980s Leccia worked mainly with objects, which he often confronted using a mirror effect and endowed with human feeling. *Le Baiser* (*The Kiss*, 1985) incorporates two cars whose touch is limited to the mingling of their headlight beams. This form of expression comes to an end with the film *Explosions* (1994) whose saturated images of war seem to transform his art into immaterial energy. Cinema became the principal source and subject of his work. From the poetry of objects, Leccia moved on to the poetry of image, which he explores through the elements. Fire explodes from a plummeting aircraft (*Pacifique,* 1997), waves rolling onto the beach are filmed at 90 degrees to form perpetual snowy summits (*Mer*, 1991), lightning streaks the night sky in violent scrawls (*Orage*, 2000). In each, the image is treated as an organic process, constantly shifting our comprehension of the real. Ange Leccia lives and works in Paris where he runs the Pavillon artists' residency at the **Palais de Tokyo**. His work can be seen in the collections of the **Centre Pompidou**, the **Musée d'Art Moderne de la Ville de Paris** and the **Fondation Cartier pour l'Art Contemporain**. He is also found at **Galerie Almine Rech**.

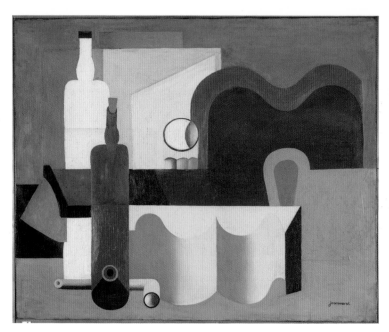

Nature Morte Léonce Rosenberg or *Nature Morte 'L'Effort Moderne'* (1922) oil on canvas
65 x 81 cm

LE CORBUSIER was born Charles-Édouard Jeanneret in La Chaux-de-Fonds, Switzerland, in 1887. Corbu, as he was later known, is universally recognized as one of most prominent architects of the 20th century, the father of modernist architecture, a brilliant theoretician, teacher and extraordinary urban planner, whose works and writings had a profound impact on 20th-century architecture. Le Corbusier was not only an architect; he also designed furniture and was a prolific draughtsman, painter and sculptor, making prints, collages and ceramics. Originally influenced by cubism, Le Corbusier and his friend and fellow architect Amédée Ozenfant created their own movement, which they called purism. This style broke from the overly schematic and decorative aspects of cubism and aimed to depict universal, pure forms through the combination of logic, mathematics and order. This process, inspired by the efficiency and simplicity of machines and their productions, called for the elimination of the personal or emotional in painting. Le Corbusier died during a swimming accident in Roquebrune-Cap-Martin, on the Côte d'Azur, in 1965. The **Fondation Le Corbusier**, his former house and studio, which he also built, is now home to the largest collection of his plans, models, paintings and drawings. His visual art can also be seen in the collection of the **Centre Pompidou** (above).

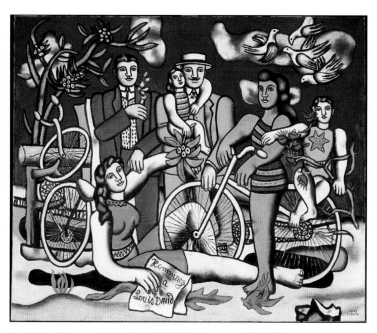

Les Loisirs – Hommage à Louis David (1948-49) oil on canvas 154 x 185 cm

FERNAND LÉGER was born in Normandy in 1881. After working as an architect's apprentice in Caen, he settled in Paris in 1900 and supported himself as a draughtsman. He was refused admittance to the École des Beaux-Arts, but attended classes there and also at the Académie Julien from 1903. His early works were impressionistic, but his discovery of Paul Cézanne in 1907 triggered an emphasis on drawing and geometry. The early cubism of Pablo Picasso and Georges Braque also had an impact on his style. From 1911 to 1914 his work became increasingly abstract, his palette limited to primaries and black and white, and a focus on cylindrical forms in a style the critics dubbed 'tubism'. Influenced by the rise in mechanical production, his works from 1918 were criticized for their lack of humanity. His figures are expressionless and robotic, his environments employing formal purity and rigour. In his *Paysages Animés* (1921) figures and animals exist harmoniously in landscapes made up of streamlined forms. Léger is also known for his theatre designs, notably the iconic futurist film *Ballet Mécanique*. He lived in the USA for five years during World War Two, returning to France in 1945, where he spent the next ten years producing illustrations, paintings, murals, stained-glass windows and costume designs. Fernand Léger died in 1955 in Gif-sur-Yvette. His work can be seen in the collection of the **Centre Pompidou** (above).

Flowers of Romance (2007) neon tubes 85 x 130 cm

CLAUDE LÉVÊQUE was born in Nevers in 1953. He moved to Paris in the late 1970s, where he was influenced by the work of Christian Boltanski. Designing window displays during the day, he developed a talent for installations. Caught up in the punk scene of the 1980s, he frequented the nightclub Palace, a hangout for artists, designers and musicians. Punk iconography and attitudes were to remain dominant features of his work. Lévêque uses light, sound and neon signs to create a hyper-tense atmosphere, bordering on the antisocial, in which the viewer is suspended between hypnotic dream and a harsher reality, implying pain and anxiety. In *Grand Hôtel*, an installation from 1982, he played with the idea of a hotel as an altar and the image as sacred, displaying photos of friends in kitsch frames on red velvet, surrounded by glass shards to prevent anyone from approaching. His installations are typically theatrical, ceremonial, even magical, often with references to childhood, though some are provocative: a work from 2001 inscribes '*Je suis une merde*' in blue neon. He has a capacity to find beauty in everyday violence in a way that is both unbearable and fascinating. Claude Lévêque lives and works in Paris. His work can be seen in the collections of the **Centre Pompidou**, the **Musée d'Art Moderne de la Ville de Paris**, the **FRAC Île-de-France** and in the **T3 Tramway** project. He is also found at **Galerie Kamel Mennour**.

Grand Aliment Blanc (1962) marble, wood, cardboard, electric motor 251 x 150 x 76 cm

ROBERT MALAVAL was born in Nice in 1937. Almost forgotten to the art world, his importance as a painter and forerunner of French pop art influencing today's generation of electronic musicians was revived in 2005 following retrospectives at the Palais de Tokyo and Lyons Biennial. With their atmosphere of depression interspersed with moments of euphoria, restlessness and a constant desire for renewal, Malaval's fascinating array of works is permeated by rock culture, with sound and music a constant presence. He endeavoured to paint as fast and as instantaneously as music, describing his drawings as songs. Close to the Rolling Stones, subject of his unpublished book written in 1973, his artistic vision is also tinted with hippy colours of pink, white and purple. Glitter explodes like fireworks in his paintings of the 1970s. A pioneer of glam rock and lover of science fiction, Malaval explored a darker side in his sculptures such as the *Aliment Blanc* works of the 1960s, where objects and figures are encrusted with a chalky white texture. A woman sits in a wheelchair, a stricken image of impotency and despair. Towards the end of the 1970s, consumed by alcohol and drugs, he wrote *Postcard to a Ghost*, expressing an existence plagued by boredom and cynicism. Robert Malaval took his own life in August 1980. A collection of his drawings, sculptures and paintings can be found at the **Centre Pompidou** (above).

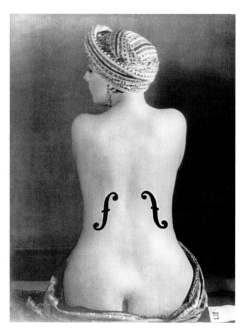

Le Violon d'Ingres (1924) gelatin silver print 30 x 23 cm

MAN RAY was born Emmanuel Radnitzky in Philadelphia, Pennsylvania, in 1890, and was brought up in New York. In 1911 the family changed their name to Ray to avoid anti-Semitism and 'Manny' changed his name to Man Ray. He started out as a book illustrator and was inspired by European avant-garde art to produce his first proto-surrealist object, the assemblage *Self Portrait* (1916), and in 1918 his first important photograph. With Marcel Duchamp, he formed the American branch of Dada, only to declare in 1920 that 'Dada cannot live in New York', leaving for Paris in 1921. Here he met Kiki de Montparnasse who became the subject of many of his photographs and films. For the next 20 years he revolutionized the art of photography, taking portraits of writers and artists including James Joyce and Jean Cocteau. In 1925 he took part in the first surrealist exhibition. He perfected the technique of photogram, which he named 'rayogram', where an object is placed on a photosensitive sheet of paper, leaving its print like a shadow. With the photographer and model Lee Miller, Man Ray discovered solarization, in which photographic negatives are partially exposed to light to create strangely luminous works. Man Ray died in 1976 in Paris. His tomb at the Cimetière de Montparnasse bears the epitaph 'Unconcerned, but not indifferent'. His work can be seen in the collection of the **Centre Pompidou** (above).

Zapping Zone (1990-94) video installation

CHRIS MARKER was born Christian François Bouche-Villeneuve in Neuilly-sur-Seine, west of Paris, in 1921. He earned his nickname, 'Marker', which was to become his pseudonym, as a Resistance fighter in World War One, when he wrote down (*marquer*) everything he saw. He studied philosophy in Paris, one of his teachers being Jean-Paul Sartre, and began making films in the 1950s, notably going on to create an apocalyptic short fiction film, *La Jetée* (1962), which he later disowned. He is also a photographer, a theoretician and a writer. Early on he developed a strong political stance, travelling the world to witness social change, wars, hardships and political distress. As a testimony of these experiences, he produced numerous films, combining fact and fiction in a poetic narrative (*Sans Soleil*, 1982; *Level Five*, 1997), or relating the calamitous conditions in different parts of the world – including France – with direct and emotionless voice-overs (*A Bientôt J'Espère*, 1968). In recent years he has started to incorporate the internet, VHS players and computer games into his work, and has created a series of interactive installations comprising many of his film works. He remains a fierce commentator on consumerist society, mass media and globalization. Chris Marker lives and works in Paris. His work can often be seen at the **Cinémathèque Française** and is in the collection of the **Centre Pompidou** (above).

La Terre (1939) sand and oil on plywood 43 x 53 cm

ANDRÉ MASSON was born in Balagne-sur-Thérain, Picardy, in 1896. Brought up in Brussels, he moved to Paris in 1912 to study at the École des Beaux-Arts. In 1914 he joined up but was seriously wounded, an experience that may explain the recurring violence of his drawings, in particular the *Massacre* series of the late 1930s. In 1920 Georges Bataille introduced him to André Breton and the surrealists, and he went on to create a complex and beautiful body of work combining references to Greek mythology – using the myth of the Minotaur and the labyrinth as metaphors for consciousness – with automatic drawing techniques and lyrical expressionistic paintings. His automatic ink drawings of this period, characterized by a free flowing line and erotic content, established his reputation. In the 1930s he experimented with collage, using sand and glue to explore the notion of metamorphosis. In 1934 he moved to Spain, producing a series of works evoking bullfights, before fleeing to the USA during the German occupation, where he became an important influence on American abstract expressionists. His later works were calm, colourful abstract landscapes, some of which decorate the ceiling of the Théâtre National de l'Odéon. André Masson died in Paris in 1987. His work can be seen in the collections of the Centre Pompidou (above) and the Musée d'Art Moderne de la Ville de Paris.

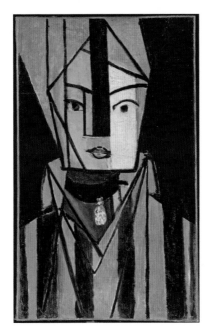

Tête Blanche et Rose (1914) oil on canvas
75 x 47 cm

HENRI MATISSE was born in Le Cateau-Cambrésis in 1869. Son of a grain merchant, he studied law and worked as a clerk before turning to painting, aged 21, while convalescing from a serious illness. In 1892 he left his job and attended classes at the École des Beaux-Arts in Paris before entering Gustave Moreau's studio as an apprentice. Influenced by the impressionist and post-impressionists, his style was characterized by bold colours. His first exhibition, in 1905, with André Derain and Maurice de Vlaminck, led to their grouping as 'fauves' by the critics. In 1909-10 Matisse painted *La Danse* and its counterpart *La Musique*, commissioned by the Russian collector Sergei Shchukin. Their fluid style and deep colours evoke a sense of rhythmic sensuality and purity. Influenced by a trip to Morocco in 1911-13, he began to incorporate decorative elements into his works, employing collage and gouache to create luminous works bordering on the abstract. One of the greatest colourists of his time, he is known for the rich variety of his sculptures, collages and paintings. In 1941, confined to a wheelchair by cancer, he produced paper cut-outs in vivid colours and daring compositions. Henri Matisse died in 1954 in Nice. Picasso is quoted as saying: 'All things considered, there is only Matisse.' His work can be seen in the collections of the Musée d'Orsay, the Centre Pompidou (above) and the Musée d'Art Moderne de la Ville de Paris.

Sans Titre (2004) acrylic on canvas 130 x 130 cm

MATHIEU MERCIER was born in Conflans-Ste-Honorine in 1970. He became interested from an early age in the urban environment and the everyday objects around him. His frequent trips to New York and Berlin, and his participation in many exhibitions of young artists, gave him the chance to experiment with different areas and renew his artistic language. His approach is characterized by his fine sense of observation and an understanding of the history of art, which results in detailed, precise constructions or interventions. His technique is often described as 'bricolage' or tinkering, working as he does with used or found materials such as paint, wood, cardboard and plastic. His remakes are witty and ironic allusions to the modern art and design of the 1920s. Via the re-appropriation of form, they question our link to modernity and its cultural ambitions of rationality, economy of means and standardization. In this way, his works evoke the domestic world, responding to a need for comfort, thrift and practicality. Mercier first came to prominence in the 1990s with miniature models of banal houses or pavilions, which he depicts in a derisive fashion due to their dramatic change of scale. In 2003 he was awarded the Marcel Duchamp prize. Mathieu Mercier lives and works in Paris. His work can be seen in the collection of the Centre Pompidou. He is also found at Galerie Chez Valentin.

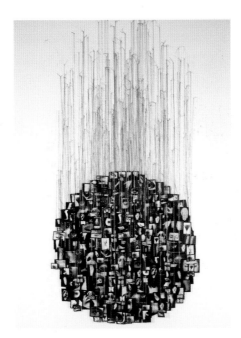

My Vows (1988-91) gelatin silver prints, string
320 x 160 x 7 cm

ANNETTE MESSAGER was born in Berck, Pas-de-Calais, in 1943. She attended the École des Arts Décoratifs, Paris, but was asked to leave for spending too much time in cinemas and museums. She soon began making 'collections' – cuttings and photographs pasted into albums, scribbled with notes and comments. In the early 1970s she created *Les Pensionnaires*, lines of stuffed sparrows swaddled in wool like tiny, frail mummies. The anxiety of childhood, the fragility of human existence, woman's identity and the intimacy of the human body are all themes that she explores under the pseudonyms *Annette artist*, *Annette collector*, *Annette practical woman*, *Annette faker*, *Annette pedlar*; using photography, drawing, knitting, embroidery and found objects. She documents her life, sometimes with violence, cataloguing ink blots and her children's drawings, alongside pictures of children with their eyes scratched out, embroidering misogynist proverbs or disarticulating stuffed toys into flailing puppets. In *Casino* (2005) red waves of material cover hybrid forms shadowed by a phantom clock, suggesting blood, sex, death, myth, fantasy and ritual in an amalgamation of all the themes underlying her work. Annette Messager lives and works in Malakoff. Her work can be seen in the collections of the **Centre Pompidou** (above) and the **Musée d'Art Moderne de la Ville de Paris**. She is also found at **Galerie Marian Goodman**.

Untitled (1959) Indian ink on paper 71.2 x 104.3 cm

HENRI MICHAUX was born in Namur in 1899. A poet and visual artist, his work is characterized by innovative experimentation with signs, questioning their literary and visual status in an attempt to render interior rhythm and dynamism. A solitary child, he became absorbed by books from an early age. After a year studying medicine, he took up sailing before settling in Paris, where he befriended the poet Jules Supervielle. For Michaux, the sign occupies an intermediate space between writing and drawing, bringing his poems and paintings together as an intricate whole. His first Indian-ink stain works, the '*taches*', appeared in 1927, and from 1936 he illustrated his own books. His dissatisfaction with his writing skills and his contacts with other civilizations in countries including Ecuador, India, Japan and Uruguay led him to create a dictionary of personal ideograms. Michaux's works can be divided into two extremes. In some, deformed signs mutate into heads or figures; others are made up of tense inscriptions scrawled across pages in an automatic gesture. In 1956 experiments with mescaline influenced both his written and artistic work, which veered towards a transcription of his hallucinations and imaginary travels. Henri Michaux died in 1984 in Paris. His work can be seen in the collections of the **Centre Pompidou** and the **Bibliothèque Nationale de France**.

No Ghost Just a Shell (2000) poster, silkscreen on paper
171 x 117 cm

M/M (PARIS) The duo M/M, represented by Michael Amzalag (born in 1968) and Mathias Augustyniak (born in 1967), was created in Paris in 1992. Amzalag studied at the École des Arts Décoratifs, Paris, and Augustyniak at the Royal College of Art, London. They met in 1989 and since then have been working in the wide-ranging domains of graphic design, fashion, music and art, creating numerous posters, album covers and books. They have also produced furniture and design objects such as lamps, which they consider, as with all their works, to be autonomous pieces or tools for the construction of possible situations. This philosophy is reflected in their exhibition practice, in which they recycle their archives in order to create landscapes or wallpaper as a background for the hanging of artworks, as was seen in their show at the **Palais de Tokyo** in 2005. Their collaboration with contemporary artists such as Philippe Parreno, Pierre Huyghe and Liam Gillick is epitomized by the project *No Ghost Just a Shell* for which they have made posters (above) and an installation entitled *Cabinet*. M/M (Paris) live and work in Paris. Their work can be found at **Air de Paris** and in the collections of the **Musée d'Art Moderne de la Ville de Paris**.

Violet, Bleu, Vert, Jaune, Orange, Rouge (1953-75) oil on wood 80 x 80 cm

FRANÇOIS MORELLET was born in Cholet, Maine-et-Loire, in 1926. He studied classics and oriental languages, then worked in the family toy business. At first a figurative painter, influenced by Aboriginal and Oceanic art, in 1950 the work of Max Bill opened his eyes to geometric abstraction. His paintings became sparse and purist, reminiscent of Piet Mondrian and De Stijl, and later kinetic and minimal, with simple forms in harmonious compositions on neutral backgrounds. His minimalist works were made according to a principle of infinitive repetition, occasionally taking motifs beyond the picture frame onto the wall. He devised a system to control the creative process, demystifying romantic notions of the artist leaving certain factors to chance. He established different systems (superposition, fragmentation, juxtaposition, interference) and created a grid of black lines. In 1961 he was co-founder of GRAV, a group to research experimental collective art based on scientific understanding of visual perception. In 1963 he used neon to create light sculptures and from 1970 he integrated architecture into his work in his search for a balance between the artwork and its environment. François Morellet lives and works in Cholet and Paris. *L'Arc de Cercles Complémentaires* can be seen in the Jardin des Tuileries and *Or et Désordre* at the Théâtre de la Ville. He is also found at Galerie Aline Vidal and Galerie Denise René.

La Nuée (2006) pencil and felt-tip pen on paper 56 x 44 cm

JEAN-LUC MOULÈNE was born in Reims in 1955. After graduating with a degree in literature and fine art from the Sorbonne in Paris, he worked as artistic advisor for a company manufacturing submarines and then in advertising. In 1990 he took the radical decision to become an artist, teaching art in Nancy, Amiens and Grenoble while launching his career with the series of photographs *Disjonctions*, in which he experimented with different photographic genres, including portraiture, landscape, still life and scenes from urban life, but always concerned with the banal. He followed this series with *Monuments de Paris*, carefully avoiding celebration, focusing instead on urban incidents or details in the foreground, while relegating monuments to the background. In 1999 he began the series *Objets de Grève*, photographs of objects made by workers on strike using company tools, in a subtle inversion of advertising techniques. In 2005 Moulène was invited to create a work inspired by the Louvre. He selected 24, mainly classical, sculptures and photographed them face-on in full daylight, emphasizing their strangeness. Brought together in the Salle des Maquettes at the Louvre, the photos resembled an imaginary museum. Jean-Luc Moulène lives and works in Paris. His work can be seen in the collections of the **Centre Pompidou** and the **Bibliothèque Nationale de France**. He is also found at Galerie Chantal Crousel.

Word(s) (2006) neon tubes and transformer 16 x 95 cm

MELIK OHANIAN was born in Lyons in 1969. He studied at the Écoles des Beaux-Arts in Montpellier and Lyons before moving to Paris, where he had his first one-man show at the opening of the Palais de Tokyo in 2002. He is part of the new generation of French artists and has participated in many shows internationally. Ohanian was confronted from an early age by the use of image as medium, highly influenced by his father who was a photographer and freelance cameraman. His work borrows from the cinema to explore – via the use of video, installation and photography – notions of time, memory, territory, community and identity. They take the viewer towards a more poetic and often imaginary reality and invite participation, either physically as in *Switch Off* (2002) where a map of the world can be lit up like a constellation at the touch of a button; or in the imagination as in *Seven Minutes Before* (2004), a beautifully filmed 21-minute work, projected over seven screens, which offers converging scenarios and multiple narratives to be interwoven by the viewer's own imagined interpretation. Interested in cosmology and the idea of infinity, Ohanian's work hides behind a more philosophical reflection on the relativity of man's place in the universe. Melik Ohanian lives and works in Paris. One of his pieces can be seen in the collection of the **Centre Pompidou**. He is also found at **Galerie Chantal Crousel**.

Le Kiosque des Noctambules (2000) glass, aluminium

JEAN-MICHEL OTHONIEL was born in St-Étienne, Loire, in 1964. Initially interested in working with unusual materials such as wax, phosphorus and lead, he first gained recognition with a series of sulphur sculptures exhibited at Documenta IX in Kassel in 1992. In 1993 he started using coloured glass, for which he is now internationally known, exploiting its jewel-like properties to create monumental, opulent sculptural works. In 1996 he hung huge glass necklaces from the bamboo trees of the Villa Medici in Rome, and the following year in the trees of the Venice garden of the Peggy Guggenheim Collection. The necklaces seem to change into shimmering trees, shifting between light and shadow and adding radiant movement to the landscape. In 2000 he transformed the Paris metro station Palais Royal–Musée du Louvre into the poetic *Le Kiosque des Noctambules (Kiosk of Nightwalkers)*. His work marries the baroque with minimalism, combining elegance, decorative festivity, sculpture and jewellery in what he describes as an attempt to render the city sublime, plunging the viewer into a sensual and hypnotic world. Jean-Michel Othoniel lives and works in Paris. His work can be seen in the collections of the Centre Pompidou, the Fondation Cartier pour l'Art Contemporain and the Musée d'Art Moderne de la Ville de Paris. He is also found at Galerie Emmanuel Perrotin and Galerie Pierre-Alain Challier.

Escalade Non-Anesthésiée (1971) mixed media 323 x 320 x 23 cm

GINA PANE was born in Biarritz in 1939. One of the key proponents of body art in France, her work survives in a series of shocking images taken from her performances. *Escalade Non-Anesthésiée* (above) shows her climbing with bare feet on a ladder studded with nails. In *Action Sentimentale* (1973) she pricks her forearms with rose thorns, drawing blood, then slashing her palm with a razor blade. Her work also embraced a philosophical and subtle vision of the human body and its relationship with the world. After graduating from the École des Beaux-Arts, Paris, in 1965, she produced a series of monumental sculptures, hollowed out to allow the visitor to explore them from the inside. In 1968 she started using her body, executing live 'actions': in *Situation Idéale*, she stands with her hands in her pockets, feet planted on the ground in an immobile 'action', confirming the consciousness of her existence. In the early 1970s Pane started performing in public, superficially wounding her body in an exploration of mind and body, playing with the viewer's emotional response. She turned to installation in the 1980s with *Partitions*, mixing photos of her performances with objects. A late series of panels was inspired by the theme of martyrdom, revealing an obsession with the sacred that underlies much of her work. Gina Pane died in Paris in 1990. Her work can be seen in the collection of the **Centre Pompidou** (above).

Zidane: un Portrait du 21e Siècle with Douglas Gordon (2006) film still

PHILIPPE PARRENO was born in Oran, Algeria, in 1964. Throughout his career he has worked collaboratively with artists in all media, his first such project being *Sibéria* (1988), a mix of TV images, photographs by Pierre Joseph and paintings by Bernard Joisten. He worked again with Joseph and Joisten, as well as with Dominique Gonzalez-Foerster, on *Ozone* (1990), featuring a series of images stitched together from disparate sources. In *No More Reality* (1991-93) Parreno gave 'video conference' lectures incorporating footage from TV shows and movies. In his film *La Nuit des Héros* (1994) an art historian, played by television star Yves Lecoq, goes mad. The same character also appears in *L'Ordre du Discours* (1994) and Parreno continued to work with the same character in projects such as *Un Homme Public* (1994-95). Parreno has undertaken several collaborations with Pierre Huyghe, including *No Ghost Just a Shell* (2000). Other projects include *Sodium Dreams* (2003) with Gonzalez-Foerster, Huyghe and others, and *Zidane: un Portrait du 21e Siècle* (above), with Douglas Gordon, in which he trained 17 cameras on the footballer Zinedine Zidane during a football match between Real Madrid and Villareal. Philippe Parreno lives and works in Paris. His work can be seen in the collections of the **Centre Pompidou** and the **Musée d'Art Moderne de la Ville de Paris**. He is also found at **Air de Paris**.

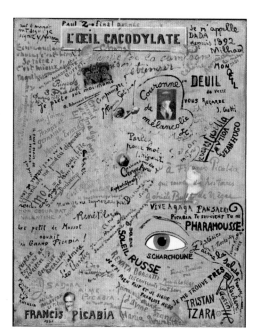

L'Oeil Cacodylate (1921) oil with photomontage and collage
on canvas 148.6 x 117.4 cm

FRANCIS PICABIA was born in Paris in 1879. Son of a Spanish father and a French mother, he studied at the École des Arts Décoratifs in Paris. His early works were influenced by the impressionist painters Alfred Sisley and Camille Pissarro, and later cubism, fauvism and abstraction: the watercolour *Caoutchouc* (1909) is considered to be a seminal abstract work. In New York, in 1913, he founded the review *291* with Marcel Duchamp and Man Ray. Inspired by Duchamp's concept of the 'ready-made', he began a series of graphic works that adopted the aesthetic of industrial design, their mechanical sobriety lifted by the ironic humour of their titles and the inclusion of texts. New York marked the beginnings of Dada, which Picabia both instigated and participated in, taking it to Barcelona in 1916 where he launched review *391*. He met Tristan Tzara and the Zurich Dada group in 1918 and became, with André Breton, the propagator of Paris Dada, creating provocative events and humorous works before breaking with Dada in 1921, denouncing it for no longer being new. Picabia moved to Tremblay-sur-Mauldre and returned to figurative art, but moved back to Paris after World War One, when he befriended Gertrude Stein and again painted in an abstract style. Francis Picabia died in 1953 in Paris. His work can be seen in the collections of the **Centre Pompidou** (above) and the **Musée d'Art Moderne de la Ville de Paris**.

Jacqueline aux Mains Croisées (1954) oil on canvas
116 x 88.5 cm

PABLO PICASSO was born in Malaga, Spain, in 1881. One of the most loved artists of all time, his prolific output, poetic character and political beliefs have helped shape the history of art. After training in Barcelona and Madrid, he settled in Paris in 1900. Moving through his intimate, melancholic and romantic 'Blue' and 'Pink' periods, he went on to develop cubism with Georges Braque, influenced by African art and with formal aspirations to decompose the subject. He subsequently combined these influences in a characteristic formal language, which he applied to sculpture, drawing, ceramic and painting. In the 1920s he joined the Paris surrealists, producing a series of works influenced by their desire to liberate the subconscious. In 1937 Picasso captured the horror of the German bombardment of the Basque city of Guernica in one of his most famous works. He became a pacifist and joined the French Communist Party in 1944, refusing to return to Franco-ruled Spain. He spent the last 25 years of his life on the French Riviera, surrounded by friends, family and lovers, and continued to produce works of compelling energy. Pablo Picasso died in Mougins, Côte d'Azur, in 1973. His work can be seen in the collections of the Musée Picasso (above), the Musée National de l'Orangerie, the Centre Pompidou and the Musée d'Art Moderne de la Ville de Paris. His tapestries can be found at the Manufacture des Gobelins.

La Madone au Cœur Blessé (1991) painted
photograph 112.3 x 73.7 cm

PIERRE ET GILLES is the artistic signature of Pierre Commoy, born in La Roche-sur-Yon in 1950, and Gilles Blanchard, born in Le Havre in 1953. Together they make sumptuous, kitsch images – Pierre taking photographs and Gilles painting them to fantastical, often surreal, effect. The saturated sensuality of their work contrasts with the middle-class values of their upbringings. As teenagers they were both drawn to the bright colours of Korean, Chinese and Bollywood cinema, and to pop art. Gilles graduated from art school in 1973, while Pierre took a degree in photography in Geneva. In 1976 they met in Paris, beginning their close collaboration. Their singular iconography incorporates figures from the pop, gay and fashion worlds, mixing religious and mythological references with the pornographic, adding a burlesque, fairy-tale aspect to popular imagery. Saint Sebastian languishes against a beribboned post, his perfect torso pierced by two arrows. Mercury glances over his naked shoulder, muscles rippling, at the snake at his feet. A sailor sulks, chest deep in water, while smoke from factory chimneys wafts across a starry sky. Each image is conceived as an aesthetic whole and tells a story with enchantment and cruelty. Pierre et Gilles live and work in Paris. Their work can be seen in the collections of the **Centre Pompidou** and the **Musée d'Art Moderne de la Ville de Paris**. They are also found at **Galerie Jérôme de Noirmont**.

La Pression des Rêves (1974) inflatable cushion and manometer 40 x 91.5 x 40 cm

PRÉSENCE PANCHOUNETTE was an artists' collective created in 1969 by Frédéric Roux, Jean-Yves Gros, Jacques Soulillou and Michel. Its members met at Bordeaux University in the late 1960s, where Roux was known for his graffiti and Gros dressed in a white suit and carried a pot of paint, decorating everything 'in Pollock'. This eccentricity and interest in minor art was to characterize the group's actions for 20 years. Rebellious, humorous and provocative, the group added a literary and ironic twist to the 'ready-made'. They courted controversy, promoting bad taste, popular imagery and an aesthetic of the absurd. Their first performance was a faked motorbike accident incorporating 20 litres of cow's blood complete with maggots. The group always maintained a mysterious invisibility. Intent on revealing the hypocrisy of the art world, they produced exhibitions in disdain of the milieu: Versailles replicated in miniature allowing everyone a share of national heritage; a plaster garden gnome snubbing its nose at fine art sculpture. Each creation verged on the kitsch yet was defined by an attitude of derision. In 1990, just as they became successful, they split. Once their work became normal, it no longer had any point. Mocking their own success, their last work was a gold-plated Solex bicycle. Their work can be seen in the collections of the **Centre Pompidou** (above) and the **Fondation Cartier pour l'Art Contemporain**.

Le Pot Doré (1985) polystyrene, gold leaf 350 cm tall

JEAN-PIERRE RAYNAUD was born in Courbevoie in 1933. A recurring motif in his work is the flower pot, perhaps epitomized by the huge *Pot Doré* (above) in the piazza by the **Centre Pompidou**. The choice is hardly surprising for an artist who graduated with a degree in horticulture. Filled with concrete, the pot loses its function and becomes what Raynaud calls a 'psycho-object' – a container for a coded language, which hides other meanings. It becomes a metaphor for shelter, a home, somewhere to hide, a place of appropriation. Each motif, from no-entry signs to numbers, beds, greenhouses and crosses, operates a 'psychological inversion', opening the way for subjective interpretations. In 1969 Raynaud constructed a house from white ceramic tiles in Celle St-Cloud. A monument to collective behavioural codes, it was built in units as if to constrain the body in its repetition of everyday gestures. Raynaud destroyed it in 1993. He recently invested the national flag with his ironic humour, with pots in red, white and blue. Jean-Pierre Raynaud lives and works in Paris. His work can be seen in the collections of the **Centre Pompidou**, the **Musée d'Art Moderne de la Ville de Paris**, the **Fondation Cartier pour l'Art Contemporain**, and at **La Défense** (*La Carte du Ciel*) and in Café Richelieu, **Musée du Louvre**. He is also found at **Galerie Daniel Templon**, **Galerie Jérôme de Noirmont** and **Galerie Pierre-Alain Challier**.

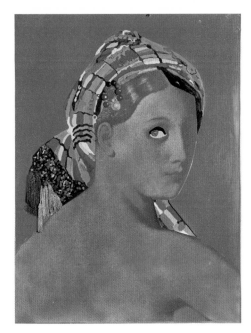

Made in Japan – La Grande Odalisque (1964) acrylic and photograph on canvas 130 x 97 cm

MARTIAL RAYSSE was born in Golfe Juan, Alpes-Maritimes, in 1936. Born into a family of potters, he graduated with a degree in literature before creating his first 'assemblages' in 1959, enclosing objects in transparent boxes. He developed a love for neon light and smooth plastic forms, buying products from hardware stores and staging them as artworks, embodying a 'hygienic' vision for an aseptic world. This appropriation of banal objects placed him in close relation to Arman, Daniel Spoerri and Jean Tinguely with whom he founded the new realists in 1960. However, he soon became influenced by the bright colours and grinning heads of pop art. His interest in consumer images inspired works about the representation of female stereotypes. *Made in Japan – La Grande Odalisque* (above), a fragment of Ingres' painting reproduced in industrial colours, exemplifies his interest in a kitsch aesthetic. In 1968 he moved to the Dordogne, setting up a community producing artisan works and classical paintings. Martial Raysse still lives and works in Isigeac. In 2001 he designed stained-glass windows for Notre-Dame de l'Arche d'Alliance in Paris. His work can be seen in the collections of the **Centre Pompidou** (above), the **Musée d'Art Moderne de la Ville de Paris**, the **Bibliothèque Nationale de France** and in place d'Iéna (*Sol et Colombe*). He is also found at **Galerie Nathalie Seroussi**.

La Charmeuse de Serpents (1907) oil on canvas 169 x 189.3 cm

HENRI ROUSSEAU was born in Laval in 1844, into a working-class family of tinsmiths. He grew up in northern France and worked for a lawyer before joining the army in 1863. He was later known as Le Douanier because of his job as a customs officer. A mediocre student, he left school early and taught himself how to paint. In 1884 he acquired a 'copyist' card from the Louvre, allowing him to become familiar with the museum's masterpieces. The origin of his inspired landscapes is, however, mysterious. With their lush jungle settings, his works are painted in a naïve childlike style. Lions and tigers fight antelopes, a woman reclines naked in a tropical Garden of Eden. Guillaume Apollinaire spread the rumour that Rousseau spent several years in Mexico – an unfounded story, as Rousseau never left the Paris region. Copying exotic plants from the Jardin des Plantes or from illustrated magazines, he created a very personal iconography, halfway between the imaginary and the real, suspended in time, which lends his works their strangeness. Perhaps because of his original style, criticized for its oddity, he became involved with other avant-garde fauvists such as André Derain and Henri Matisse only late in life. Henri Rousseau died from gangrene in 1910, just as his work began to be appreciated for its innovative vision. His work can be seen in the collections of the **Musée d'Orsay** (above) and the **Musée National de l'Orangerie.**

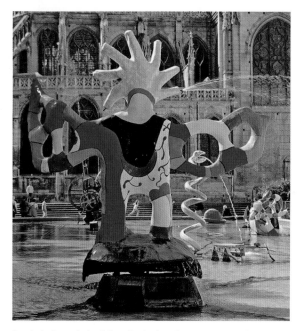

Stravinsky Fountain detail (1983) mixed media 1,650 x 350 x 3,600 cm

NIKI DE SAINT-PHALLE was born Catherine Marie-Agnès Fal de Saint Phalle in Neuilly-sur-Seine in 1930. Daughter of a rich banker and an American heiress, she spent her childhood between America and France, an upbringing blighted at the age of 12 by an incestuous father. After a failed early marriage and a period in a psychiatric home, she settled in Nice in 1953 where she began painting as a form of therapy. A trip to Barcelona introduced her to the organic strutures of Gaudí. From 1956 she started producing assemblages of wood and cardboard stuck with sharp objects, and created monsters from toys, combs and paint tubes. In the 1960s her work *Tirs* led to an association with the new realists. At her first exhibition in 1961, during the Algerian War of Independence, she invited visitors to shoot at plaster objects, bursting paint bags beneath them in explosions of colour like blood. A friend's pregnancy inspired her first *Nanas*, small cloth figures, and later the sumptuous, vivacious Venuses for which she is best known. In 1971 she married Jean Tinguely and they created the ***Stravinsky Fountain*** (above) in the piazza next to the **Centre Pompidou** and the *Cyclops* at Milly-la-Forêt. After Tinguely's death in 1991 she moved to Switzerland and produced sculptures for the *Tarot Garden* in Tuscany. Niki de Saint Phalle died in 2002 in San Diego. Her work can be seen in the collection of the **Centre Pompidou**.

Pousse-Caillou (2003) acrylic on canvas 100 x 130 cm

JEAN-MICHEL SANEJOUAND was born in Lyons in 1931. Considered one of the first conceptual artists, he studied law in Lyons and political science in Paris. Despite his lack of artistic education, he has been painting and sculpting since the 1950s, producing major works that resist all categorization in their continuous search for renewal. Although radically different in form, Sanejouand's works are nevertheless related by a very distinctive style, based on a simple painterly or sculptural gesture bordering on the naïve, as well as the balance between two associated forms and their link to surrounding space. His first series, entitled *Charges-Objets* (1963), is often associated with the 'ready-mades' of Marcel Duchamp. His drawings and paintings are divided into series such as *Calligraphies d'Humeur* (1968-78), humorous erotic caricatures in heavy ink, *Espace-Peintures* (1978-86), brightly coloured imaginary landscapes in flattened perspective, or the later more abstract paintings of the 1990s characterized by thick brushstrokes against white monochromatic backgrounds. These works are counterbalanced by series of monolithic monumental stone sculptures such as *The Magician* (1989), a huge work made of two roughly hewn stones. Jean-Michel Sanejouand lives and works in Vaulandry, Maine-et-Loire. His work can be seen in the collection of the **Centre Pompidou** (above). He is also found at **Galerie Chez Valentin**.

Hwang Yi Min, Yu Man Hyeong, Park Jun Kyu (devant le bâtiment des syndicats), Séoul (2001)
framed Ilfochrome on aluminium 128 x 159 cm

BRUNO SERRALONGUE was born in Châtellerault, Poitou-Charentes, in 1968. His artistic practice can be compared to that of a photojournalist, as the principal subjects for his work are major events from the political and media world such as the World Forum in 2002 or the World Summit in Geneva in 2003. Yet his methods and approach are very different. His camera is heavy and does not allow for close-ups or snapshots, he does not hold a press badge, which would allow him to infiltrate the borders of a demonstration. Instead, he captures parallel situations providing an alternative interpretation of an event differing from that of mass-media coverage. This parasitic activity undermines media manipulation and the possibility of a purely linear interpretation. In this way, the artist questions production processes and how information is disseminated through images, operating as he does outside pre-defined and controlled press zones. His pictures, once enlarged and framed, are endowed with a subtle distance from the subject, a certain timelessness. By showing us the other side of the story, he questions our place within global society and our constant bombardment with information. Bruno Serralongue lives and works in Paris. His work can be seen in the collections of the **Centre Pompidou** and the **Musée d'Art Moderne de la Ville de Paris**. He is also found at **Air de Paris**.

Peinture, 175 x 222 cm, 17 février 2007 (2007) acrylic on canvas 175 x 222 cm

PIERRE SOULAGES was born in Rodez in 1919. He is known for his black paintings, yet his primary material is light and the tension between dark and light. His immense canvases, striated by imposing black brushstrokes, reveal and rearrange light as it reflects off the shiny surface or is absorbed by the dark depths, drawing the viewer into another space. Prehistoric and Roman art were his first loves. On a school trip aged 12 he was struck by the Roman abbey at Conques, a decisive moment in his artistic career, and he was later to design 104 stained-glass windows for it. He enrolled at the École Nationale des Beaux-Arts in Paris, only to leave, disillusioned by what he considered its mediocrity. In Paris he was, however, influenced by major exhibitions of Paul Cézanne and Pablo Picasso. Living in the Free Zone of Montpellier during the war, he returned to Paris in 1946 and showed at the Salon des Indépendants in 1947, where his sombre canvases contrasted sharply with the colourful works of the post-war abstract painters. In 1979 he exhibited his first mono-pigment paintings, which he described as '*outré-noir*' (beyond black) and which seemed to radiate a physical, tactile presence and intense primal energy. Pierre Soulages lives and works in Paris. His work can be seen in the collections of the **Centre Pompidou** and the **Musée d'Art Moderne de la Ville de Paris**. He is also found at **Galerie Karsten Greve**.

Le Repas Hongrois, Tableau-Piège (1963) metal, glass, porcelain, fabric, paint, chipboard 103 x 205 x 33 cm

DANIEL SPOERRI was born Daniel Issac Feinstein in Galati, Romania, in 1930. Following the execution of his father by the Nazis, his family fled to Switzerland. His friendship with Jean Tinguely dates from this period, during which he dedicated himself to dance and theatre, produced avant-garde poems and plays and founded the literary reviews *Material* and later *MAT* (*Multiplication d'Art Transformable*) with Tinguely in Paris in 1959. This collaboration, and his discovery of Yves Klein in 1960, encouraged him to make his first artworks, the *Tableaux-Pièges* (*Trap Paintings* – above). Influenced by the new realists, he stuck everyday objects to flat surfaces, changing their status by hanging the finished work on the wall, allowing little space for any creative gesture. Covered with fur, broken plates and bric-à-brac, these works play with the notion of permanence. In parallel to this series, Spoerri developed the idea of the '*détrompe-l'oeil*' attaching quirky objects to paintings in order to demystify the artwork and place it in the realms of banality. Spoerri moved on to produce what he termed 'Eat Art' in 1963, cooking meals and fixing its debris to the restaurant table. He opened his own restaurant in Dusseldorf in the 1970s, inviting artists and customers to prepare their own dishes in an endeavour for a collective, convivial art. Daniel Spoerri lives and works in Tuscany. His work can be seen in the collection of the **Centre Pompidou** (above).

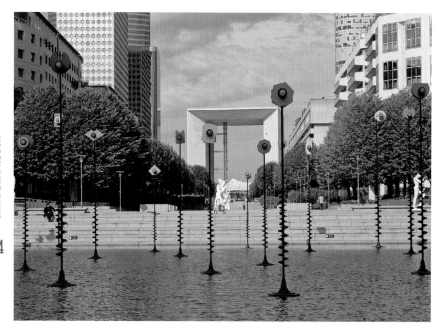

Signaux Lumineux (1990) mixed media

VASSILAKIS TAKIS was born in Athens in 1925. He was brought up during the Metaxas dictatorship in Greece and the German occupation of his home country during World War Two. After his first exhibitions in a gallery that he and friends set up in Athens, he moved to Paris in 1955. There, Takis discovered the works of Pablo Picasso and Alberto Giacometti, as well as the Egyptian sculptures in the Louvre, all of which would have a lasting influence on his work. Fascinated by science and energy, he used the findings of scientific research in his ever-evolving oeuvre, introducing kinetic energy, magnetic fields (which led him to work with MIT), electricity, light and, later on, music by the Greek composer Iannis Xenakis and the American John Cage. His creations move, hover, emit blinking light or elaborate sounds, often generating a whole ensemble of visual (and phonic) stimulations, creating complex, animated landscapes that invite exploration. He also composes music and has collaborated with different artists to develop stage designs and performances around his sculptures. Vassilakis Takis lives and works in Paris. His work can be seen in the collections of the **Centre Pompidou**, at **La Défense** (*Signaux Lumineux* – above) and at **UNESCO**. An installation at the Charenton headquarters of the Crédit Foncier de France can be glimpsed through its glass façade. His work is also found at **Galerie Xippas**.

Metamorphose II (1955) painted metal, motor 76 x 100 x 30 cm

JEAN TINGUELY was born in Fribourg, Switzerland, in 1925. Described as emitting an electric energy by his wife Niki de Saint Phalle, his kinetic works embodied the cliché of the inspired, expansive creative genius, imbued with this same frenzied, somewhat demented, vigour. Made from scraps of iron and rusting screws, they often incorporate the whirring and clicking of an amateur motor, held together by an artistic miracle. Tinguely started making his 'meta-mechanics' at an early age, creating his first hydraulic wheels with sound effects. In the late 1940s he worked as a window dresser while taking classes at the École des Arts Appliqués in Basel where Daniel Spoerri described him as producing works with an extraordinary magical power, tinkering with rotating wheels and animated comical figurines. He left for Paris in 1952, creating works of art employing sound, touch and smell, and even producing a rickety theatre set with Spoerri that collapsed at the first rehearsal. He gained recognition with his *Crocodrome de Zig et Puce* for the opening of the **Centre Pompidou**. His humorous works play with ideas of imperfection, mocking the precision of design and consumer objects. Jean Tinguely died in 1991 in Bern, Switzerland. His famous *Stravinsky Fountain*, made with Niki de Saint Phalle, is in the piazza by the **Centre Pompidou**, while *Cyclops* at Milly la Forêt outside Paris, is also worth visiting.

Red Painting – imprints of #50 brush, repeated at regular intervals of 30 cm (1997) latex acrylic on canvas 300 x 140 cm

NIELE TORONI was born in Muralto, Switzerland, in 1937. Rigorously faithful to a working principle he set himself in 1967, his paintings are minimalist, with no hidden meanings, mystical or spiritual references or mysterious symbolism. As part of the BMPT with Daniel Buren, Olivier Mosset and Michel Parmentier, a group formed in the late 1960s claiming to revaluate pictorial activity, Toroni asserted the 'zero degree of painting'. His works are offered with no other explanation than the method of their making: '*imprints of #50 brush, repeated at regular intervals of 30 cm.*' Carefully painted red, blue, yellow or green dots cover a white surface in rows, filling a canvas or room, flattening volumes and bordering on decoration. The simplicity of his purpose is disconcerting. He questions the medium of painting itself, attempting to establish its autonomy, breaking links with representation and the emotive or psychological input of the brushstroke. The work's relationship with space and the viewer is of prime importance, concerned with perception and the appropriation of space. It is about effort in the practical sense of climbing a scaffold and repeating the same gesture, but it is also about the limits of paint, the spaces in between. Niele Toroni lives and works in Paris. His work can be seen in the collections of the **Centre Pompidou** and the **Musée d'Art Moderne de la Ville de Paris**. He is also found at **Yvon Lambert** and **Galerie Marian Goodman**.

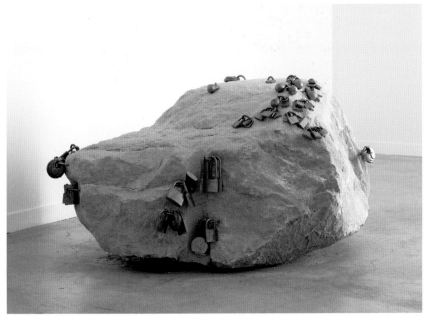

Rock (2007) rock, bronze 63 x 106 x 122 cm

TATIANA TROUVÉ was born in Cosenza, Italy, in 1968, and grew up in Dakar, Senegal. After her studies at the Villa Arson in Nice and then in Holland, she devoted herself from 1997 to the making of the one and unique work entitled the *BAI* or *Bureau of Implicit Activities*. First conceived of as an archival structure destined to harbour unfinished projects it soon developed into a proliferation of fragile, miniature modules, each dedicated to a specific activity related to the genesis and memory of her work itself. These modules classify, codify and reorganize the artist's thoughts, projects or acts. Together they form a kind of imaginary enterprise or laboratory of the mind where artistic projects are forever in process and never finally accomplished. More recently the modules have been joined by small-scale constructions called *Polders* in reference to the famous Dutch structures that are built to reclaim land from the sea. Functioning as memory errors or accidents, the *Polders'* parasitic activity infiltrates and contaminates the modules like a living organism that invades their space. Tatiana Trouvé lives and works in Paris. Her work can be seen in the collections of the **Centre Pompidou** and the **Musée d'Art Moderne de la Ville de Paris**. She is also found at **Galerie Emmanuel Perrotin**.

Hommage à Georges Pompidou (1976) aluminium
500 x 400 x 6 cm

VICTOR VASARELY was born Victor Vasarhelyi Gyözö in Pecs, Hungary, in 1908. He studied medicine in Budapest, before taking drawing and design classes at the Bauhaus-influenced Mühely. He settled in Paris in 1930, where he worked for different advertising companies and was in charge of graphic identity and poster design. His training in a constructivist institution and his work as a graphic designer led him to experiment with the optical effects generated by two-dimensional forms, having previously explored and rejected various artistic styles including surrealism, cubism and expressionism. From the late 1940s he established his own formal vocabulary, giving birth to what would be known as optical art. During the next 50 years, he used optical illusion through geometric patterns, simple forms and colour associations, as well as classic perspective methods of darkening or lightening colour fields. His paintings, drawings and sculptures fool the eye into seeing movement or three-dimensionality instead of a flat surface. A humanist, Vasarely insisted on the universality of art and the need for it to be socially engaging and accessible. Victor Vaserely died in 1997 in Paris. His work can be seen in the collection of the **Centre Pompidou**, where his emblematic portrait of President Georges Pompidou (above) greets visitors in the forum as they arrive. He is also found at **Galerie Denise René**.

Xavier (2006) lacquered polyurethane 152 x 52 x 48 cm

XAVIER VEILHAN was born in Lyons in 1963. He graduated from the École des Arts Décoratifs in Paris at the beginning of the 1980s. He spent the next few of years in Berlin working in Georg Baselitz's studio and taking classes at the Hochschule der Künste before returning to Paris in 1989 and enrolling at the Institut des Hautes Études en Arts Plastiques. He is an established figure of the French contemporary art scene and his works range from large-scale public sculptures, such as the red rhinoceros or pictures of a giant mobile that inhabited the Centre Pompidou forum for a while, to digitally worked landscapes and the flickering images of the series of *Light Machines*. Veilhan's work explores different ways of understanding and representing the real. Employing references to the history of art, consumer society and everyday objects via a sophisticated use of technology and mechanics, he remixes familiar images in an ironic and poetic manner without falling into criticism or caricature. Brought together in an encyclopaedic fashion, these images revolve around the idea of the generic, placing the spectator in the position of potential narrator. Xavier Veilhan lives and works in Paris. His work can be seen in the collection of the **Centre Pompidou**. He is also found at **Galerie Emmanuel Perrotin.**

Sans Titre no. 20 (2006) acrylic on tarpaulin 180 x 180 cm

CLAUDE VIALLAT was born in Nîmes in 1936. As a student at the École des Beaux-Arts, Montpellier, and later in Paris, he inaugurated in 1966 a formal language questioning the conventions of traditional painting. Working systematically with one shape to cover entire canvases in an 'all-over' technique, his paintings are colourful and primitive, employing a bean- or sponge-like motif on parasols, tents and large outdoor pieces. Working on the floor, he uses stencils and acrylic paint to create undulating patterns in a ceaseless exploration of space, matter and colour. His laborious and hazardous way of working has provoked comparisons with the American abstract artists Jackson Pollock, Sam Francis and Kenneth Noland. In France he founded the supports/surfaces group with four other artists in 1969. During the 1970s this group overthrew established painterly conventions, placing canvases without frames, like banners and flags, on the beaches of the South of France in protest against the constraints of the art market. He continues to experiment, developing in the 1980s a love for rich materials such as velvet and silk which he cuts out and sticks onto used canvases. Claude Viallat lives and works in Nîmes. His work can be seen in the collections of the Centre Pompidou, the Fondation Cartier pour l'Art Contemporain and the Bibliothèque Nationale de France. He is also found at Galerie Daniel Templon.

Rue de Bretagne (1975) ripped posters mounted on canvas 117.5 x 89 cm

JACQUES VILLEGLÉ was born in Quimper in 1926. Known as the 'poster ripper', he rejected the creative role of the artist in a radical approach to art as anonymous and collective phenomena, taking posters from the street and tearing them up before transferring them onto canvas. The result is a colourful montage of superimposed motifs, built up like a collage of detritus to form a new language of hieroglyphs and truncated signs. Often associated with Raymond Hains, Villeglé was one of the first artists to reappropriate a consumerist product in a way that can be seen to be a precursor of pop art. Influenced by time spent working with an urban architect, his new approach flew in the face of the trend for lyrical abstract art. A meeting with François Dufrêne in the 1950s led him to found the new realist group with artists such as Yves Klein and Jean Tinguely, for whom art's primary concern was to reveal sociological behaviour via the appropriation of everyday objects. The street was a continual source of inspiration, providing a 'permanent picture', which enabled the artist to reconstitute the language and manipulations of media and political propaganda with subtle irony. Jacques Villeglé lives and works in Paris. His work can be seen in the collections of the **Centre Pompidou** and the **Musée d'Art Moderne de la Ville de Paris**. He is also found at **Galerie Georges-Philippe et Nathalie Vallois**.

Statue pour Jardin (1943-44) bronze 54 x 138.5 x 61 cm

OSSIP ZADKINE was born in Smolensk, Belarus, in 1890, to a Russian-Jewish family of partially British extraction. He studied at the art school in Sunderland and Regent Street Polytechnic, London, before settling in Paris in 1909 and briefly studying at the École des Beaux-Arts. He claimed that he learnt more from drawing the classical statues of the British Museum and the Louvre than from any art class. Zadkine associated with Pablo Picasso, Constantin Brancusi and Amedeo Modigliani, and experimented with both cubism and fauvism. He began exhibiting his sculptures in the 1910s but joined the army during World War One and was gassed in Belgium, which affected him both physically and psychologically. In 1920 he married the artist Valentine Prax, who helped him channel these traumas into powerful sculptures combining the experimentations of his early years with the emotions he had accumulated throughout his life. Best-known nowadays as a sculptor, he was also a draughtsman and painter, and taught extensively during a prolonged period in the USA. Ossip Zadkine died 1967 in Paris. His former house is now the **Musée Zadkine** where many of his works can be seen. His work can also be seen in the collections of the **Centre Pompidou** and the **Musée d'Art Moderne de la Ville de Paris**, as well as in public spaces (*Le Messager*; *Le Poète*; *Le Promethée*) including the Cimetière Montparnasse where he is buried.

Directory

Detailing over **300 public** and **private galleries, art venues, public art** and **art fairs** in **Paris**, plus **15 special features**, covering **must-see galleries** and **organizations**. Opening days and times vary considerably, especially among private galleries. Ring ahead or check websites before visiting.

PUBLIC GALLERIES AND ART VENUES

Bagatelle Château/Parc
*Route de Sèvres à Neuilly
75016
t: 01 40 67 97 00*

Best known for its rose garden, the Bagatelle also mounts occasional but often witty exhibitions of contemporary works in its extensive grounds.
MAP 1/1

Bibliothèque Nationale de France (BNF)
t: 01 53 79 59 59
www.bnf.fr

Site François Mitterand
Quai François Mauriac 75706

Given the strong historical ties between literature and the visual arts in France, the library is a natural forum for exploration of the relationship of art and literature. Exhibitions focus on figures such as Antonin Artaud and Henri Cartier-Bresson who straddled both worlds. Eight monumental artworks on the site include works by Louise Bourgeois, Gérard Garouste, Roy Lichtenstein, Joan Mitchell, Martial Raysse, Claude Viallat.
MAP 9/6

Site Richelieu
58 rue de Richelieu 75002

Mounts exhibitions of books and prints by contemporary artists. Galerie de Photographie exhibits work from the BNF's extensive photographic archive.
MAP 6/26

Centre Culturel Calouste Gulbenkian
*51 avenue d'Iéna 75116
t: 01 53 23 93 93*

www.gulbenkian-paris.org
Presents the work of Portuguese and other artists across the areas of painting, photography, sculpture and architecture in a palatial setting.
MAP 3/4

Centre Culturel Canadien
*5 rue de Constantine 75007
t: 01 44 43 21 90*

www.canada-culture.org
Mounts four exhibitions of Canadian artists' work per year.
MAP 4/30

Centre Culturel de Serbie et Monténégro
*123 rue St-Martin 75004
t: 01 42 72 50 50*

www.slavika.com
Faces the Centre Pompidou and stages regular exhibitions of Serb and Montenegrin art as part of a larger programme including film, literature and other events.
MAP 8/17

Centre Culturel Irlandais
*5 rue des Irlandais 75005
t: 01 58 52 10 30*

www.centreculturelirlandais.com
Housed in the ancient Collège des Irlandais. Mounts regular exhibitions of Irish artists, hosts an artist-in-residence and offers accommodation to Irish citizens for research purposes.
MAP 5/12

Centre Culturel Suédois
*11 rue Payenne 75003
t: 01 44 78 80 20*

www.ccs.si.se
Exhibits the work of Swedish artists in the lovely setting of a 17th-century mansion.
MAP 8/35

Centre Culturel Suisse
*32 & 38 rue des Francs Bourgeois 75003
t: 01 42 71 44 50*

www.ccsparis.com
An active art centre with regular exhibitions of major Swiss artists.
MAP 8/28

Centre d'Art d'Ivry (Le Crédac and Galerie Fernand Léger)
*93 avenue Georges Gosnat
Ivry-sur-Seine 94200
t: 01 49 60 25 06
RER Ivry-sur-Seine*

www.credac-and-co.com
Offers an exhibition programme of adventurous new work and sponsors a biennial prize for monumental work - winners stage an outdoor show.

Centre Georges Pompidou/ Musée National d'Art Moderne (MNAM)
*Place Georges Pompidou
75004
t: 01 44 78 12 33*

www.centrepompidou.fr
SEE PAGE 118

Le Centre Tchèque
*18 rue Bonaparte 75006
t: 01 53 73 00 22*

www.centretcheque.org
Dedicated to the promotion of Czech visual and performing arts.
MAP 7/36

Centre Wallonie Bruxelles
*127-29 rue St-Martin 75004
t: 01 53 01 96 96*

www.cwb.fr
Situated near the Pompidou the centre features the work of contemporary Belgian artists.
MAP 8/22

Chapelle Saint-Louis de la Salpêtrière
47 boulevard de l'Hôpital 75013
t: 01 45 70 27 27

Spectacular 17th-century building with exhibitions organized in association with the Festival d'Automne. Past exhibitions include Nan Goldin, Anish Kapoor, Anselm Kiefer.
MAP 9/10

Cinémathèque Française
51 rue de Bercy 75012
t: 01 71 19 32 00

www.cinematheque.fr

A programme of mainstream cinema includes French surrealist and other art films. Exhibitions examine the impact of cinema on other art forms. Housed in an interesting early Frank Gehry building in Bercy with extensive research facilities.
MAP 9/21

Cité de l'Architecture et du Patrimoine
Palais de Chaillot
1 place du Trocadéro 75116
t: 01 58 51 52 00

www.citechaillot.fr

A new space dedicated to urban studies. Houses a permanent display about the growth of cities and stages temporary exhibitions on approaches to architecture, planning and city life worldwide.
MAP 2/1

Colette
213 rue St-Honoré 75001
t: 01 55 35 33 90

www.colette.fr

A concept store with a space on the first floor dedicated to exhibitions that change every first Monday of the month.
MAP 6/19

Couvent des Cordeliers
21 rue de l'École de Médecine 75006
t: 01 53 67 40 00

A dramatic 18th-century chapel and occasional venue for exhibitions and events.
MAP 7/7

Le Cube
20 cours St-Vincent 92130 Issy-les-Moulineaux
t: 01 58 88 30 00

www.lesiteducube.com

A centre promoting new technology and digital arts, with spaces for installations, projections and digital works.
MAP 1/18

La Défense

In and around the Place de la Défense, much of the competition with Johann Otto von Spreckelsen's *La Grande Arche* is on a grand scale, but alongside the monumental sculptures are smaller works, some exploring playful relationships with water.
MAP 3/27

École Nationale Supérieure des Beaux-Arts (ENSBA)
14 rue Bonaparte 75006
t: 01 55 04 56 50

www.ensba.fr

The most historic and prestigious art school in Paris, ENSBA shows students' and graduates' work as well as a full programme of other exhibitions.
MAP 7/35

L'Entrepôt
7-9 rue Francis de Pressensé 75014
t: 01 45 40 07 50

www.lentrepot.fr

A cultural centre with a full programme of exhibitions, cinema, theatre and conferences.
MAP 5/1

Espace Dalí
11 rue Poulbot 75018
t: 01 42 64 40 10

www.daliparis.com

A permanent exhibition of over 300 works with a focus on Dalí's sculptures and engravings. Also hosts temporary exhibitions.
MAP 1/6

Espace EDF Electra
6 rue Récamier 75007
t: 01 53 63 23 45

www.foundation.edf.com

Housed in a former electricity substation; mounts contemporary exhibitions often relating in some way to the interface between art and science, technology and the environment.
MAP 7/1

Espace Paul Ricard
9 rue Royale 75008
t: 01 53 30 88 00

www.espacepaulricard.com

A space run by the Fondation d'Entreprise Ricard (of anise drink fame) with a programme focusing on new artists.
MAP 6/32

Espace Pierre Cardin
1 avenue Gabriel 75008
t: 01 44 56 02 02

www.pierrecardin.com

A cultural complex in a former theatre housing theatre and gallery spaces showing contemporary works in all media. Hosts the Show Off art fair.
MAP 3/9

La Ferme du Buisson

Allée de la Ferme - Noisiel
77448 Marne-la-Vallée
t: 01 64 62 77 77
RER Noisiel

www.lafermedubuisson.com

In the wing of a wonderful 19th-century building, the venue organizes performances, events and exhibitions favouring the work of artists at the interface of different disciplines.

La Fondation Arp

21 rue des Châtaigniers
92140 Clamart
t: 01 45 34 22 63
RER Meudon-Val-Fleury

www.fondationarp.org

A gemlike example of the modernist spirit, the house and atelier of Jean Arp and his wife Sophie Taeuber were conceived by Taeuber and built with the architect Jacques-Émile Lecaron. It is sited in a small architects' compound, which includes several dramatic examples of avant-garde architecture of the 1920s. The atelier/museum includes over 150 of Arp's works.

Fondation Cartier pour l'Art Contemporain

261 boulevard Raspail 75014
t: 01 42 18 56 50

www.fondation.cartier.com

SEE PAGE 121

Fondation Dubuffet

137 rue de Sèvres 75006
t: 01 47 34 12 63

www.dubuffetfondation.com

The Dubuffet archive is housed in a traditional 19th-century studio building providing a great contrast of work and setting.
MAP 5/9

Fondation Henri Cartier-Bresson

2 impasse Lebouis 75014
t: 01 56 80 27 00

www.henricartierbresson.org

Housed in an early modernist building, the foundation runs a research centre and exhibition space for the work of Cartier-Bresson, his contemporaries and photographers working in his tradition. Sponsors an annual prize for contemporary work with exhibitions of the winning works.
MAP 5/2

Fondation Le Corbusier

8-10 square du Docteur
Blanche 75016
t: 01 42 88 41 53

www.fondationlecorbusier.asso.fr

Housed in the best example of the handful of 'Corbu' buildings in Paris. Principally a research centre, it also stages exhibitions of Le Corbusier's paintings and work by photographers and artists associated with him.
MAP 1/2

FRAC Île-de-France - Le Plateau

Place Hannah Arendt 75019
(between rue des Alouettes
and rue Carducci)
t: 01 53 19 84 10

www.fracidf-leplateau.com

SEE PAGE 123

La Galerie

1 rue Jean Jaurès 93130
Noisy-le-Sec
t: 01 49 42 67 17

www.noisylesec.net

A centre with a history of sponsoring unusual work by contemporary artists.
MAP 1/4

Grand Palais

Galeries Nationales du
Grand Palais
3 avenue du Général
Eisenhower 75008
t: 01 44 13 17 17

www.grandpalais.fr

The building includes two galleries with exhibitions of widely known moderns. The extraordinary main space, the 'Nef' (nave), has recently been restored and is now site of the FIAC art fair and 'Monumenta' projects in the summer: Anselm Kiefer 2007, Richard Serra 2008, Christian Boltanski 2009.
MAPS 3/7, 4/1

Halle Saint-Pierre

2 rue Ronsard 75018
t: 01 42 58 72 89

www.hallesaintpierre.org

A cultural centre housed in the old cloth hall. Exhibitions focus on outsider art, art brut and artists of the developing world.
MAP 1/7

Hôtel de Ville

5 rue de Lobau 75004
t: 01 42 76 51 53

Exhibitions relating to Paris or France in two large gallery spaces. Very strong on photography.
MAP 8/2

Institut du Monde Arabe

1 rue des Fossés St-Bernard
Place Mohammed V 75236
t: 01 40 51 38 38

www.imarabe.org

Runs an exhibition programme that focuses on Arab culture and history, including contemporary photographers and artists.
MAP 9/15

Air de Paris

32 rue Louise Weiss 75013
t: 01 44 23 02 77
www.airdeparis.com
MAP 9/9

The gallery Air de Paris is located in an otherwise grey office building, which it shares with the Ministry of Finance on rue Louise Weiss. Despite its relatively central location, 'Louise', as the locals affectionately call the street, is far from crowded on weekdays. On opening days, however, when all the other galleries on the spot also start their new exhibitions, the young and the hip of the Parisian art world bring this empty street to life.

'Air de Paris' was the title Marcel Duchamp gave to his 1919 'ready-made' consisting of a glass vial of physiological serum whose original content was replaced by Parisian air. From 1990, Air de Paris was also the name of the gallery founded and still run by Florence Bonnefous and Edouard Merino. The positioning of their desk in the exhibition space is indicative of their desire to be accessible. The two met at the École du Magasin, a prestigious international curatorial training programme based in Grenoble, and opened Air de Paris in Nice in 1990. In 1994 the gallerist duo moved to Paris, and settled in the Marais, but in 1997 they joined a collective move to the rue Louise Weiss along with six other young galleries. This opened up a whole new zone of the city to art and introduced Parisians to a more daring type of gallery.

Current stars, including Dominique Gonzalez-Foerster and Philippe Parreno were first noticed by the gallerists back in Grenoble. Baudelaire's statement 'the beautiful is always bizarre' comes to mind when looking at the work of the gallery artists: Jean-Luc Verna, nude and tattooed, re-enacting scenes of classical paintings and sculptures to a rock soundtrack, or Olaf Breuning disturbing crowds of human-size blanket ghosts or giant bunnies. The gallery's uncompromisingly avant-garde stance and its lively openings, which often feature concerts or events by invited artists, have proved highly popular. Other gallery artists include Guy de Cointet, François Curlet, Brice Dellsperger, Trisha Donnelly, Liam Gillick, Carsten Höller, M/M (Paris), Sarah Morris, Allen Ruppersberg and Bruno Serralongue.

Air de Paris and the neighbouring gallery Praz-Delavallade recently opened a joint exhibition space called the Random Gallery, occupying the common shop window from 28 to 32 rue Louise Weiss.

Centre Georges Pompidou/Musée National d'Art Moderne (MNAM)

Place Georges Pompidou 75004
t: 01 44 78 12 33
www.centrepompidou.fr
MAP 8/24

The Centre Pompidou was inaugurated on 31 January 1977, three years after the death of the man who had conceived it and whose name it was eventually given: President Georges Pompidou of France. In a speech of 1969, Pompidou had called for the creation of a new public institution in the heart of Paris, with the aim of presenting and uniting all aspects and forms of contemporary art under one roof – visual arts, theatre, cinema, music and literature – allowing these diverse disciplines to interact with one another. Thirty years after its opening, Beaubourg, as it is sometimes known, has more than fulfilled its original brief: the iconic, colourful building designed by Renzo Piano and Richard Rogers houses one of the most popular cultural institutions in the world and its vast spaces are visited by between five and six million people a year.

118

The building instantly became a world-famous landmark. One of the many successful initiatives implemented in the original design is the large sloped plaza in front of the building. This occupies as much land as the building itself and allows breathing space to enjoy the architecture as well as providing a public arena for art events with a connection to the museum.

Not only is the Pompidou home to the Musée National d'Art Moderne (MNAM), comprising nearly 60,000 works of art from the 20th and 21st centuries, the second largest collection of its kind in the world, it also houses France's second largest reference library, the BPI (Bibliothèque Publique d'Information) and the music research centre IRCAM (L'Institut de Recherche et Coordination Acoustique/ Musique). The Pompidou runs a programme of films, discussions, lectures and media workshops, and stages temporary exhibitions of historically important and emerging artists and movements from all fields, with the Espace 315 gallery reserved for new work by younger artists. The Atelier Brancusi, constructed by Renzo Piano in the place Georges Pompidou, displays Brancusi's work in a re-creation of his studio and is used to exhibit other contemporary works.

The Centre Pompidou remains one of the most ambitious and comprehensive cultural institutions in the world, providing the unique opportunity to experience and research all aspects of modern and contemporary culture in a single location.

Institut Goethe: Galerie Condé

32 rue de Condé 75006
t: 01 40 46 69 90

www.goethe.de/paris

Exhibitions of contemporary art make up part of a programme showcasing German culture.
MAPS 5/16, 7/5

Instituto de Mexico

119 rue Vieille du Temple 75003
t: 01 44 61 84 44/5

www.mexiqueculture.org

Mounts photographic exhibitions relating to Mexican history and Mexican and other Latino artists.
MAP 8/56

Jardin des Tuileries

Jardin des Tuileries 75001

Running from the Louvre to the Champs-Élysées, the garden has numerous sculptures, as well as housing the Jeu de Paume and Musée National de l'Orangerie.
MAPS 4/13, 6/11

Jardin du Luxembourg

Jardin du Luxembourg 75006

www.senat.fr

Exhibitions are periodically held in the gardens and the Orangerie, often interacting with the 19th-century statuary.
MAP 5/15

Jeu de Paume

www.jeudepaume.org
Site Concorde
1 place de la Concorde 75008
t: 01 47 03 12 50

Site Sully
62 rue St-Antoine 75004
t: 01 42 74 47 75
SEE PAGE 132

Les Laboratoires d'Aubervilliers

41 rue Lécuyer 93300 Aubervilliers
t: 01 53 56 15 90
ⓜ *Aubervilliers-Pantin Quatre Chemins*

www.leslaboratoires.org

A centre with an exhibition agenda extending across the arts, with an exciting range of guest curators and artists.

MAC/VAL (Musée d'Art Contemporain du Val-de-Marne)

Place de la Libération 94404 Vitry-sur-Seine
t: 01 43 91 64 20

www.macval.fr

SEE PAGE 135

Mains d'Oeuvres

1 rue Charles Garnier 93400 Saint-Ouen
t: 01 40 11 25 25
ⓜ *Garibaldi*

www.mainsdoeuvres.org

An art centre with a large exhibition space offering residencies and studios.

Maison de la Culture du Japon

101 bis quai Branly 75015
t: 01 44 37 95 01

www.mcjp.asso.fr

This hi-tech building houses a great gallery space featuring exhibitions and a tea house.
MAP 2/8

Maison de l'Amérique Latine

217 boulevard St-Germain 75007
t: 01 49 54 75 00

www.mal217.org

A Latin cultural centre with top-quality exhibitions, often highlighting contemporary work that is rarely on view elsewhere.
MAP 4/24

Maison de l'Indochine

1 place St-Sulpice 75006
01 40 51 95 15

www.maisondelindochine.com

Provides a showcase for Indochinese artists and is also a supporting sponsor of work relating to the local area.
MAPS 5/18, 7/4

La Maison Européenne de la Photographie (MEP)

5-7 rue de Fourcy 75004
t: 01 44 78 75 00

www.mep-fr.org

Housed in an old mansion with a modern extension, with four floors of exhibition space for photographers and video artists, a library and café.
MAP 8/4

Maison Populaire de Montreuil

9 bis rue Dombasle 93100 Montreuil
t: 01 42 87 08 68
ⓜ *Mairie de Montreuil*

www.maisonpop.fr

Houses the Centre d'Art Moderne, which juxtaposes the work of established artists and newcomers, and the Espace Multimedia, which promotes work using new technologies.

La Maison Rouge

10 boulevard de la Bastille 75012
t: 01 40 01 08 81

www.lamaisonrouge.org
SEE PAGE 137

Manufacture des Gobelins
42 avenue des Gobelins 75013
t: 01 44 61 21 69

www.manufacturedesgobelins.fr

The royal factories operating here have produced state and private commissions worldwide since the time of Louis XIV. The collection, just reopened to the public after a hiatus of 35 years, has carpets and tapestries from all periods including modern (e.g. Joan Miró, Pablo Picasso) and contemporary examples. Work in progress can be viewed.
MAP 9/1

Musée Bourdelle
18 rue Antoine Bourdelle 75015
t: 01 49 54 73 73

www.bourdelle.paris.fr

Impressive Montparnasse studio and garden housing a display devoted to Antoine Bourdelle, a colleague of Auguste Rodin and influential teacher (Alberto Giacometti, Germaine Richier, among others). Hosts exhibitions of contemporary sculpture.
MAP 5/8

Musée Carnavalet
Hôtel Carnavalet
23 rue de Sévigné 75003
t: 01 44 59 58 58

www.carnavalet.paris.fr

Exhibits work from its strong photographic collection relating to the history of Paris and the work of Paris-based photographers from the mid-19th century to the present day.
MAP 8/29

Musée d'Art et d'Histoire du Judaïsme
Hôtel de St-Aignan
71 rue du Temple 75003
t: 01 53 01 86 60

www.mahj.org

Narrow but comprehensive permanent collection includes modern works by Russian and German Jewish artists, artists from the Paris school and some contemporary works. Temporary exhibitions include contemporary work that relates to the museum.
MAP 8/78

Musée d'Art Moderne de la Ville de Paris (MAMVP)
11 avenue du Président Wilson 75116
t: 01 53 67 40 00

www.mam.paris.fr
SEE PAGE 138

Musée de la Chasse et de la Nature
62 rue des Archives 75003
t: 01 53 01 92 40

www.chassenature.org

Reopened in 2007, the museum is devoted to aspects of the hunt and wildlife, with exhibitions including contemporary work relating to nature or animals.
MAP 8/74

Musée de la Vie Romantique
Hôtel Scheffer Renan
16 rue Chaptal 75009
t: 01 55 31 95 67

www.vie-romantique.paris.fr

Houses artefacts relating to the Romantics in George Sand's former home. Exhibitions include modern and contemporary work in the romantic tradition.
MAP 1/5

Musée des Arts Décoratifs
107-11 rue de Rivoli 75001

www.lesartsdecoratifs.fr

Renovated in 2006, the museum provides a history of decorative and applied arts in France from the Middle Ages to the present. Includes works by Jean Dubuffet donated by him to the museum.
MAP 6/16

Musée des Arts Derniers
28 rue St-Gilles 75003
t: 01 44 49 95 70

www.art-z.net

Exhibits the work of African and French artists who have worked and travelled in Zimbabwe.
MAP 8/33

Musée de Sculpture en Plein Air
Jardin Tino Rossi
Quai St-Bernard 75005

www.paris.org/musees/sculpture/Plein-Air/info.html

The sculpture park stretches from the Pont de Sully to the Pont d'Austerlitz. Constructed in the 1980s, it includes a selection of late 20th-century work.
MAP 9/13

Musée d'Orsay
66 rue de Lille 75343
t: 01 40 49 48 14

www.musee-orsay.fr

A strong permanent collection of works by post-impressionists and forerunners of early modernism. *Correspondances* exhibitions juxtapose new works with pieces from the collection that have informed or relate to them.
MAPS 4/27, 7/44

Musée du Louvre
99 rue de Rivoli 75058
t: 01 40 20 50 50

www.louvre.fr

The Louvre recently instigated an annual exhibition *Contrepoint* juxtaposing historical and

Fondation Cartier pour l'Art Contemporain

261 boulevard Raspail 75014
t: 01 42 18 56 50
www.fondation.cartier.com
MAP 5/4

Established in 1984 by the prestigious eponymous Paris jewellers, the Fondation Cartier presents an important overview of new and breaking contemporary artists, combining an eclectic and international programme of contemporary exhibitions with an acquisition policy which, rather than following the latest trends in the art market, more often dictates trends itself.

The foundation was originally located in the southern Paris suburb of Jouy-en-Josas and included spaces dedicated to artist residencies. In 1994 it moved into a striking new building by Jean Nouvel: a giant glass box with accommodation arranged over eight floors, set in a leafy garden and shielded from the street by an old cedar tree. Although the residency programme could not be incorporated in the new building, the generous proportions of the exhibition spaces and the flexibility of the new structure in part compensated for this. In its new location, the foundation quickly became one of the most impressive exhibition spaces in Paris.

The temporary exhibitions are monographic or thematic and extend beyond fine art to embrace fashion, furniture design, photography, architecture and even conceptual presentations of different ideologies. The foundation sets out to present a different angle on a known subject, for example, by exhibiting paintings and drawings by the independent film director David Lynch, dedicating its spaces to the Italian car manufacturer Ferrari, or by staging a show about the sources of rock and roll music and its impact on popular culture.

The Fondation Cartier is active in commissioning new work and for over 20 years it has served as an independent patron of the arts, supporting established French artists and younger emerging artists from around the world. The permanent collection includes work by Richard Artschwager, Nan Goldin, Raymond Hains, Huang Yong Ping, Ron Mueck, Jean-Michel Othoniel and Jean-Pierre Raynaud.

On the mezzanine there is an excellent bookshop and live art events incorporating music, dance, video and film are presented on Thursday evenings under the title *Les Soirées Nomades* (*Nomadic Nights*). In the summer months these are held outside in the garden, designed by the conceptual artist Lothar Baumgarten and filled with native and medicinal plants.

contemporary art. Contemporary artists make or exhibit works in response to the building or to works in the collection. Look out for the three ceiling paintings by Georges Braque in the Henri II room, and for the decorations by Daniel Buren and Jean-Pierre Raynaud in the Café Richelieu.
MAP 7/46

Musée du Quai Branly
37 quai Branly
Portail Debilly 75007
t: 01 56 61 70 00

www.quaibranly.fr

A new Jean Nouvel building houses a major ethnographic collection supplemented by temporary exhibitions devoted to traditional cultures and contemporary artists.
MAP 2/7

Musée Maillol:
La Fondation Dina Vierny
61 rue de Grenelle 75007
t: 01 42 22 59 58

www.museemaillol.com

The main museum displays Aristide Maillol alongside early moderns, with the strange addition of works by Marcel Duchamp. Also shows temporary exhibits of modern and contemporary works.
MAP 4/22

Musée Marmottan Monet
2 rue Louis Boilly 75016
t: 01 44 96 50 33

www.marmottan.com

Devoted exclusively to Claude Monet's work and his collection, which includes a stunning group of Japanese prints.
MAP 1/3

Musée National de l'Orangerie
Place de la Concorde
Jardin des Tuileries 75001
t: 01 42 97 48 16

www.musee-orangerie.fr

Home to the *Nymphéa* cycle of 8 enormous works painted by Claude Monet late in his life and, since 2006, hung as they were originally intended. Also holds post-impressionists and early moderns including Pierre-Auguste Renoir, Henri Rousseau and Pablo Picasso.
MAPS 4/7, 6/1

Musée Picasso
Hôtel Salé
5 rue de Thorigny 75003
t: 01 42 71 25 21

www.musee-picasso.fr

SEE PAGE 140

Musée Rodin
79 rue de Varenne 75007
t: 01 44 18 61 10

www.musee-rodin.fr

A comprehensive survey of Auguste Rodin's work in a wonderful setting; also presents exhibitions of key contemporary sculptors such as Anthony Caro.
MAP 4/29

Musée Zadkine
100 bis rue d'Assas 75006
t: 01 55 42 77 20

www.zadkine.paris.fr

Works by Ossip Zadkine are shown in a garden setting, with with work by his contemporaries.
MAP 5/11

Palais de Tokyo: Site de Création Contemporaine
13 avenue du Président Wilson
75116
t: 01 47 23 54 01

www.palaisdetokyo.com
SEE PAGE 143

Palais Royal
Place du Palais Royal 75001

Daniel Buren's piece is one of the most visitor-friendly works in the city. Also on site are two fountains by Pol Bury. Sculpture exhibitions are held in the garden courtyard in spring and summer.
MAP 6/21

Parc André Citroën
Parc André Citroën 75015

On the site of the old Citroën works, the whole park is worthy of attention, with sculptural watercourses, themed gardens and contemporary greenhouses. Patrick Berger and Gilles Clément's fountain is noteworthy.
MAP 1/16

Parc de la Villette
211 avenue Jean Jaurès 75019
t: 01 40 03 75 75

www.villette.com

Numerous events and exhibitions take place at venues in the park, including regular exhibitions of contemporary work at the Grande Halle. The Villette Digital Festival, devoted to electronic arts and new media, is a joint venture with the Cité des Sciences and the Cité de la Musique.
MAPS 1/13, 11/8

Passage de Retz
9 rue Charlot 75003
t: 01 48 04 37 99

www.passagederetz.com

A former toy factory in an old mansion converted into a hi-tech gallery. Hosts an interesting programme of exhibitions, including Russian propaganda

FRAC Île-de-France - Le Plateau

Place Hannah Arendt 75019
(between rue des Alouettes and rue Carducci)
t: 01 53 19 84 10
www.fracidf-leplateau.com
MAP 11/6

Because of its unassuming entrance, first impressions on arriving at Le Plateau might suggest a big name for a little place – but that would be misleading because the concept, the collection and the range of exhibitions is immense.

Created in 1983, the FRAC Île-de-France (Regional Collection of Contemporary Art for the Île-de-France region) is an institution resulting from the French policy of decentralization. Each of the 22 regions of France now has an independent structure for collecting and exhibiting mostly, but not exclusively, French contemporary art in all fields. Since 1983 the Île-de-France region, incorporating the city of Paris, has established a collection of over 700 works, often representing the first institutional acquisition of work by many young artists.

Since 2002 the Paris regional collection has been based at the Plateau building in the north-west of the city, part of a wider plan to revitalize this mostly working-class area. The FRAC Île-de-France uses the new space to present annual exhibitions of work from its rich permanent collection while also maintaining an innovative programme of temporary exhibitions, frequently of work by young up-and-coming artists and with a particular emphasis on those whose practice questions the very notion of art. Artists are sometimes given free rein to curate and produce their own exhibitions. Exhibitions are often accompanied by discussions with curators and artists, with the aim of involving the public both in the organization and in the broader issues and questions raised by contemporary art.

This policy of integration with the local community dictates much of the decision-making at Le Plateau, including a recent contemporary arts trail through the local neighbourhood, in which art was exhibited in shops, public buildings and even private homes. L'Antenne, located nearby, is a second space devoted to education, with activities and events aimed at all ages, from amateur to specialist. 'For the Public' provides a guide to the artistic programme of Le Plateau. There is a small but well-stocked bookshop and a reference library at the Antenne site.

A visit to Le Plateau is highly recommended for anyone who wants to get to the heart of contemporary and emerging art.

Galerie Chantal Crousel

10 rue Charlot 75003
t: 01 42 77 38 87
www.crousel.com
MAP 8/62

Galerie Chantal Crousel opened in 1980 in rue Quincampoix. After 25 years in the same location, the gallery moved to the current site, marking the event with the group exhibition *Land Marks*. One of the gallery's key criteria in its selection of work for this exhibition was diversity and it included ten artists with very different origins, from Romania to the Antarctic, Thailand to Puerto Rico. One of the only pieces not linked to a specific geographic spot was *North Flash* by Thomas Hirschhorn, winner of the Marcel Duchamp (2001) and Joseph Beuys (2004) awards. This small graphic work, incorporating several human eyes of different sizes, seemed metaphorically to affirm the means by which artists bring geographic and cultural territories into artistic existence.

The current space, opened in autumn 2005 in the Marais, is almost hermetic: once inside, one has the feeling that that two-storey structure could be located anywhere, contributing to the intensity of the aesthetic experience. The opening exhibition, *Lesson Zero*, showed artists who had their first solo exhibitions in France at the gallery: the international artists Tony Cragg, Alighiero e Boetti, Jenny Holzer and Cindy Sherman, alongside the Paris-based artists Sophie Calle, Jean-Luc Moulène, Marie-Ange Guilleminot, Melik Ohanian and Fabrice Gygi.

Thematic group shows provide an ideal opportunity to see a gallery's range. *Beware of the Holy Whore* (2006) highlighted artists' concerns with the contemporary context of artistic production. Exploring questions such as the value of art and the role of the art market in aesthetic taste, the exhibition displayed Andy Warhol's *Piss Paintings* alongside *Money Paintings* by Reena Spaulings (a fictive artist, who is in fact part of an artists' collective playing the double role of artists and dealers of their own work). The inclusion of the *Invitation Card* by Marcel Broodthaers, which unceremoniously lampoons the role of the dealer, affirms a brave curatorial approach. Since its inception, the gallery has retained its reputation for supporting emerging artists and exhibiting international greats.

Gallery artists include Jennifer Allora & Guillermo Calzadilla, Darren Almond, Mona Hatoum, Thomas Hirschhorn, Hassan Khan, Michael Krebber, Jean-Luc Moulène, Gabriel Orozco, Anri Sala, Sean Snyder and Rirkrit Tiravanija.

posters and the 'packaging' of presidential candidates.
MAP 8/61

La Périphérie
17 rue Rouget de Lisle 92240 Malakoff
t: 01 46 57 70 10

www.laperipherie.com

An organization set up to promote young designers, photographers and artists, with a sizeable exhibition space.
MAP 1/14

Petit Palais
Avenue Winston Churchill 75008
t: 01 53 43 40 00

www.petitpalais.paris.fr

Renovated in 2006, the museum houses the Musée des Beaux-Arts de la Ville de Paris, a broad collection of mainly decorative arts with 19th-century paintings including works by Pierre Bonnard and Paul Cézanne.
MAPS 3/6, 4/2

Pinacothèque de Paris
28 place de la Madeleine 75008
t: 01 42 68 02 01

www.pinacotheque.com

Arranged over three floors, with the principal exhibition space in the basement, the inaugural exhibitions of Roy Lichtenstein and Chaim Soutine suggest a historical but off-beat approach.
MAP 6/31

Point Éphémère
200 quai de Valmy 75010
t: 01 40 34 02 48

www.pointephemere.org

Housed in an old dock building on the canal St-Martin. Hosts around six exhibitions per year of work by young artists across many creative areas.
MAP 1/12

Le Siège LVMH
22 avenue Montaigne 75008
t: 01 44 13 22 22

www.lvmh.fr

Louis Vuitton/Moët Hennessy's headquarters, moving to a Frank Gehry building in the Bois de Boulogne in late 2009, is described as 'a space open to contemporary creativity'. Jean-Michel Wilmotte's cool plan features a work by Richard Serra alongside other contemporaries.
MAPS 2/6, 3/5

Tram: Réseau d'Art Contemporain
32 rue Yves Toudic 75010
t: 01 53 34 64 15

www.tram-idf.fr

An association set up to promote the arts around Paris, Tram organizes exhibitions, artist events, performances and tours.
MAP 1/11

UNESCO
7 place de Fontenoy 75007
t: 01 45 68 16 42

Houses numerous works by 20th-century masters including Le Corbusier, Joan Miró, Pablo Picasso and Antoni Tàpies in the building, and Alexander Calder's *La Spirale* (1958) in the grounds along with works by Tadeo Ando, Jean Arp, Alberto Giacometti, Dani Karavan, Henry Moore, Erik Reitzel, Vassilakis Takis. Don't miss Isamu Noguchi's *Garden of Peace*. Guided tours only (Tuesdays at 3pm in English).
MAP 2/10

PRIVATE GALLERIES

Air de Paris
32 rue Louise Weiss 75013
t: 01 44 23 02 77

www.airdeparis.com

SEE PAGE 117

Art : Concept
16 rue Duchefdelaville 75013
t: 01 53 60 90 30

www.galerieartconcept.com

True to its name, exhibits cutting-edge work with a strong conceptual element.
MAP 9/3

Artcurial
Hôtel Marcel Dassault
7 rond-point des Champs-Élysées-Marcel Dassault 75008
t: 01 42 99 20 20

www.artcurial.com

In an 18th-century mansion, this auction house runs a gallery showing well-curated exhibitions.
MAPS 2/5, 3/8

art process
52 rue Sedaine 75011
t: 01 47 00 90 85

www.art-process.com

A gallery, agency and centre for diverse activities bringing people and art together. Organizes customized art tours and publishes *IcoNomix* magazine.
MAP 10/5

Atelier Cardenas Bellanger
43 rue Quincampoix 75004
t: 01 48 87 47 65

www.ateliercardenasbellanger.com

Features young West-Coast Americans and others relatively unknown in France.
MAP 8/20

Galerie Emmanuel Perrotin

76 rue de Turenne 75003
t: 01 42 16 79 79
www.galerieperrotin.com
MAP 8/48

Galerie Emmanuel Perrotin occupies a beautiful building in a 17th-century courtyard that once housed the director of Bastille prison. The gallery moved to the Marais in 2005 and recently opened a second exhibition space in the same building. With over 2,000 square metres of space and a sculpture garden, Perrotin sealed his reputation as one of the premier gallerists in Paris. When you first visit the gallery's bookshop, you might think that you had dropped into a Japanese comics store. Indeed, five of the gallery's artists are young Japanese. But, if some of its artists are of the playful kind, others, such as Eric Duyckaerts and Sophie Calle – who represented their respective countries, Belgium and France, at the 52nd Venice Biennale in 2007 – are more conceptual and introspective.

After dropping out of school, Perrotin began working as a gallery assistant when he was only 14. Four years later he started a gallery in his own flat, which became the venue for Damien Hirst's first solo exhibition in France in 1991. Two years later he took on a less domestic space in the Marais, where he ran his gallery between 1992 and 1996. In 1997 Perrotin was one of the first galleries to move to the rue Louise Weiss in the 13th arrondissement. It was here that the Italian, Maurizio Cattelan, showed his work *La Nona Ora* (*The Ninth Hour*) for the first time. Photographs of this naturalistic sculpture, depicting Pope John Paul II struck down by a meteorite, were published in newspapers around the world. Cattelan was also responsible for transforming Perrotin into *Errotin, the True Rabbit*, forcing him to wear an ambiguous phallic rabbit costume around the gallery during the five weeks of exhibition.

Perrotin says he has managed to change the perception of young French artists from 'suspect' to 'exciting' (and financially rewarding). His pioneering attitude seems likely to have had an important impact on the renaissance of contemporary French art in the past seven years.

Gallery artists include Sophie Calle, Maurizio Cattelan, Peter Coffin, Wim Delvoye, Trenton Duerksen, Eric Duyckaerts, Lionel Estève, Naomi Fisher, Bernard Frize, Félix González-Torres, Mariko Mori, Mr., Takashi Murakami, Jean-Michel Othoniel, Tatiana Trouvé, Xavier Veilhan and Peter Zimmermann.

Baudoin Lebon
38 rue Ste-Croix de la Bretonnerie 75004
t: 01 42 72 09 10

www.baudoin-lebon.com

Mainly photography, with eclectic interests including multiples and artists dealing with the bizarre or grotesque, such as Olivier Rebufa, Joël-Peter Witkin. See also Galerie 13 Sévigné.
MAP 8/26

La Blanchisserie Galerie
24 rue d'Aguesseau 92100 Boulogne
t: 01 48 25 57 78
Ⓜ *Boulogne-Jean Jaurès*

www.lablanchisserie.com

In an industrial building that once housed a laundry, the 300m² space hosts a programme of exhibitions, large-scale projections, concerts and performances.

Claudine Papillon
13 rue Chapon 75003
t: 01 40 29 07 20

www.claudinepapillon.com

Papillon has figured on the city's art scene since the 1970s with the first Paris exhibitions of artists such as Joseph Beuys and Sigmar Polke. Exhibits works by established and emerging, mainly European, artists.
MAP 8/82

ColletPark
203 bis rue St-Martin 75003
t: 01 40 46 00 20

www.colletpark.com

Provides 'a structure for exchange and experimentation within contemporary art' for established and emerging artists.
MAP 8/84

Cosmic Galerie
7-9 rue de l'Équerre 75019
t: 01 42 71 72 73

www.cosmicgalerie.com

A large 1930s industrial space that exhibits international emerging and established artists including Haluk Akakçe, Vanessa Beecroft, Pierre Bismuth.
MAP 11/5

Darthea Speyer
6 rue Jacques Callot 75006
t: 01 43 54 78 41

Longstanding gallery showing primarily figurative work with a strong American presence.
MAP 7/22

Espace Meyer Zafra
4 rue Malher 75004
t: 01 42 77 05 34

www.espace-zafra.com

Promotes geometric abstraction and kinetic art, featuring a strong group of South-American artists.
MAP 8/9

Galerie Agathe Gaillard
3 rue du Pont Louis-Philippe 75004
t: 01 42 77 38 24

www.agathegaillard.com

One of the first Paris galleries to specialize in photography. Shows a selection of classic, largely well-known names.
MAP 8/3

Galerie Aittouarès
2 rue des Beaux Arts 75006
t: 01 40 51 87 46

www.aittouares.com

Shows work by a large group of 20th-century modernists – Robert Delaunay, Albert Gleizes, Hans Hartung, Jean Metzinger, Jules Pascin – along with some

lesser-known contemporary figurative artists.
MAP 7/28

Galerie Alain Blondel
128 rue Vieille du Temple 75003
t: 01 42 78 66 67

www.galerie-blondel.com

Features the work of figurative artists, from photorealistic to theatrically gothic.
MAP 8/68

Galerie Alain Gutharc
7 rue St-Claude 75003
t: 01 47 00 32 10

www.alaingutharc.com

Devoted to emerging artists and known for launching new talent. Shows cross-disciplinary work with the emphasis on media, photography and one-offs.
MAPS 8/42, 10/7

127

Galerie Alain Le Gaillard
19 rue Mazarine 75006
t: 01 43 26 25 35

www.alainlegaillard.com

Small, sharp, international gallery. Exhibits mainly emerging painters, photographers, sculptors and digital artists.
MAP 7/11

Galerie Alain Margaron
5 rue du Perche 75003
t: 01 42 74 20 52

www.galerieamargaron.com

Exhibits work centred on drawing and painting, loosely in the surrealist tradition, including Dado, Fred Deux.
MAP 8/54

Galerie Albert Loeb
12 rue de Beaux Arts 75006
t: 01 46 33 06 87

www.galerieloeb.com

Shows established Continental and Latino artists including Wilfredo Lam.
MAP 7/13

Galerie Aline Vidal
70 rue Bonaparte 75006
t: 01 43 26 08 68

www.alinevidal.com

A good space exhibiting artists concerned with the state of the planet, social and urban realities and the human condition, including François Morellet, Jean-Luc Vilmouth, Jens Wolf.
MAP 7/3

Galerie Almine Rech
19 rue de Saintonge 75003
t: 01 45 83 71 90

www.galeriealminerech.com

Exhibits major names – Joseph Kosuth, Ange Leccia, James Turrell – and younger Europeans including Anselm Reyle, Ugo Rondinone, Gavin Turk.
MAP 8/64

Galerie Anatome
38 rue Sedaine 75011
t: 01 48 06 98 81

www.galerie-anatome.com

In a converted industrial space, this is the only Paris gallery devoted entirely to contemporary graphic arts and typography, including poster art.
MAP 10/4

Galerie Anne Barrault
22 rue St-Claude 75003
t: 01 44 78 91 67

www.galerieannebarrault.com

Exhibits a lively mix of younger and more established artists; strong on photography.
MAP 8/46

Galerie Anne de Villepoix
43 rue de Montmorency 75003
t: 01 42 78 32 24

www.annedevillepoix.com

Impressive list of artists includes John Coplans, Huang Yong Ping, Franck Scurti, Rosemarie Trockel. Work ranges across all media, including video and installation, but especially photography.
MAP 8/85

Galerie Antoine Helwaser
32 rue Jean Mermoz 75008
t: 06 85 55 97 32

Exhibits modern masters and younger contemporary artists.
MAP 3/14

Galerie Anton Weller
9 rue Christine 75006
t: 01 43 54 56 32

www.anton-weller.com

Specializes in video and installation work and promotes the work of young French artists.
MAP 7/9

Galerie Applicat-Prazan
16 rue de Seine 75006
t: 01 43 25 39 24

www.applicat-prazan.com

Focuses on French painting from the second School of Paris (1945-65).
MAP 7/25

Galerie Atelier Clot
19 rue Vieille du Temple 75004
t: 01 40 29 91 59

www.atelierclot.com

One of the oldest lithographic ateliers for artists' books and prints (Pierre Bonnard, Edgar Degas), it continues to print with major artists. Permanent display of original editions.
MAP 8/12

Galerie B.A.N.K.
42 rue Volta 75003
t: 01 42 72 06 90

www.bankgalerie.com

Focuses on emerging artists (including performance) and quality thematic exhibitions.
MAP 1/10

Galerie Baumet-Sultana
20 rue St-Claude 75003
t: 01 44 54 08 90

www.galeriebaumetsultana.com

Shows work by young artists, weighted towards painting, drawing and photography.
MAP 8/45

Galerie Berès
35 rue de Beaune 75007
t: 01 49 27 94 11
25 quai Voltaire 75007
t: 01 42 61 27 91

www.galerieberes.com

Holds museum-level works by early to mid 20th-century moderns and 19th-century French avant-garde artists.
MAPS 4/20, 7/40

Galerie Bernard Bouche
123 rue Vieille du Temple 75003
t: 01 42 72 60 03

www.galeriebernardbouche.com

Holds four exhibitions a year and represents artists across all media including Henri Étienne-Martin, Henri Laurens.

MAP 8/57

Galerie Bernard Jordan
77 rue Charlot 75003
t: 01 42 77 19 61

www.galeriebernardjordan.com

A bright new gallery representing a group of largely European artists, including sculptors. Also

Galerie Marian Goodman

79 rue du Temple 75003
t: 01 48 04 70 52
www.mariangoodman.com
MAP 8/79

Marian Goodman opened her first gallery in New York in 1977. More than two decades later she moved to Paris and opened a second space, which shares the grand spaces of the Hôtel Montmort with several other institutions. With its heavy closed door it is easy to miss, but ringing the bell provides access to one of the loveliest courtyards and most prestigious spaces in Paris. The gallery itself occupies part of the right wing of the building and includes a ground floor with several huge windows overlooking the courtyard, and two basements – one offering a vaulted intimate space for film projections.

Many of the gallery's artists are concerned with captured images – whether still or moving, simple or complex. Exhibitions by Thomas Struth (urban landscapes purged of human presence), Lothar Baumgarten (American landscapes modified by human activity), David Goldblatt (South African images of the architectural stigmas of apartheid), Chantal Ackermann (Paris-based filmmaker), Jeff Wall (the star of Canadian monumental photography) or Hiroshi Sugimoto (whose life-size photographs of white corners of his house in Japan produced a stunning mirror effect when placed on the pristine white walls of the gallery) have presented richly evocative documentary-style work. The captured image as element of complex *mises en scène* has been the theme of exhibitions by Francesca Woodman (American creator of photographs in which an ageless female character evolves in vague, foggy spaces), Yang Fudong (young Chinese artist revealing the uneasiness of his generation through oneiric filmic objects) and John Baldessari (graphic compositions using movie stills).

A second focus for the gallery is the Italian arte povera movement, whose search for the real through the use of basic or found materials has been beautifully celebrated in a number of group and monographic exhibitions of work by Luciano Fabro, Mario and Marisa Merz, and Giuseppe Penone.

Other gallery artists include Christian Boltanski, Marcel Broodthaers, Tony Cragg, Richard Deacon, Tacita Dean, Rineke Dijkstra, Dan Graham, Pierre Huyghe, Steve McQueen, Annette Messager, Gabriel Orozco, Gerhard Richter, Hiroshi Sugimoto and Lawrence Weiner.

organizes site-specific projects outside the gallery.
MAP 8/72

Galerie Brimaud
4 rue de Thorigny 75003
t: 01 42 72 42 02

www.galeriebrimaud.com

Specializes in surrealism and French artists from the latter half of the 20th century. Has mounted numerous André Masson exhibitions.
MAP 8/37

Galerie Camera Obscura
268 boulevard Raspail 75014
t: 01 45 45 67 08

www.galeriecameraobscura.fr

An elegant gallery showing established photographers.
MAP 5/3

Galerie Catherine Putman
40 rue Quincampoix 75004
t: 01 45 55 23 06

www.catherineputman.com

Specializes in prints and works on paper, often by top-ranking European and American artists, sometimes at modest prices.
MAP 8/18

Galerie Cazeau-Béraudière
16 avenue Matignon 75008
t: 01 45 63 09 00

www.cazeau-beraudiere.com

Covers late 19th- to mid 20th-century impressionists, surrealists and modernists.
MAP 3/13

Galerie cent8 Serge Le Borgne
108 rue Vieille du Temple 75003
t: 01 42 74 53 57

www.cent8.com

Shows established Europeans making highly emotive work, including Marina Abramovic, Elisabeth Ballet, Gloria Friedmann, Valérie Mréjen.
MAP 8/52

Galerie Chantal Crousel
10 rue Charlot 75003
t: 01 42 77 38 87

www.crousel.com
SEE PAGE 124

Galerie Chez Valentin
9 rue St-Gilles 75003
t: 01 48 87 42 55

www.galeriechezvalentin.com

Young gallery promoting artists working at the boundaries between architecture, design and installation, including Olivier Dollinger, Mathieu Mercier.
MAP 8/32

Galerie Claude Bernard
7-9 rue des Beaux Arts 75006
t: 01 43 26 97 07

www.claude-bernard.com

A Paris institution, promoting representational art. Holds six exhibitions a year of living artists, and one of a master: e.g. Francis Bacon, Giorgio Morandi.
MAP 7/27

Galerie Claude Samuel
Le Viaduc des Arts
69 avenue Daumesnil 75012
t: 01 53 17 01 11

www.claude-samuel.com

An elegant space under the arches at Le Viaduc des Arts, showing a heterogeneous group of younger artists, mostly painters or photographers.
MAP 9/19

Galerie Daniel Malingue
26 avenue Matignon 75008
t: 01 42 66 60 33

e: galerie@malingue.net

Deals in 19th to mid-20th-century work by well-known French artists. Stages an annual comprehensive exhibition focusing on a single artist.
MAP 3/15

Galerie Daniel Templon
30 rue Beaubourg 75003
t: 01 42 72 14 10

www.danieltemplon.com

This longstanding Paris gallery shows an impressive range of artists, including Jean-Michel Alberola, Larry Bell, Ben, Alain Jacquet, Claude Viallat.
MAP 8/87

Galerie Darga et Lansberg
36 rue de Seine 75006
t: 01 40 51 84 34

e: lansberg@club-internet.fr

Exhibits work from the beginning of the 20th century, including 1950s abstraction, pop art and new realism as well as some more recent artists.
MAP 7/19

Galerie de France
54 rue de la Verrerie 75004
t: 01 42 74 38 00

e: info@galeriedefrance.com

A long-established gallery with an A-list of contemporaries including Rebecca Horn, Ilya & Emilia Kabakov, William Wegman.
MAP 8/14

Galerie de Multiples
17 rue St-Gilles 75003
t: 01 48 87 21 77

www.galeriedemultiples.com

Shows and handles multiples of

Galerie Thaddaeus Ropac

7 rue Debelleyme 75003
t: 01 42 72 99 00
www.ropac.net
MAP 8/51

Since its foundation in Salzburg in 1983, Galerie Thaddaeus Ropac has specialized in European and North American contemporary art. The Paris gallery opened in 1990 and extends over three floors with 800 square metres of exhibition space. The basement – where younger artists are often exhibited – and the new drawings gallery above the main, ground floor gallery, are more intimate, but still impressive spaces. The latter was inaugurated in April 2007 with *Pop Stars*, a monographic exhibition of drawings by Andy Warhol created from projected Polaroid photos.

The gallery has proved eager to collaborate with non-commercial art institutions and even with other private galleries: in autumn 2006, its co-operation with the Yvon Lambert gallery allowed Parisians to enjoy the exhibition *Für Paul Celan*, held simultaneously in both venues, of the monumental paintings and sculptures of the German artist Anselm Kiefer inspired by the works of the Jewish poet Paul Celan.

Thaddaeus Ropac initially wanted to be an artist himself. When he realized that he was 'not talented enough to become a great artist' he decided to open a gallery, showing mainly American artists, including his friends and contemporaries Jean-Michel Basquiat and Peter Halley. However, his interest in European art grew quickly over the years. He has resisted the trend for European galleries to open spaces in North America, claiming that despite his internationalism he 'believes in Europe'. His artists span a wide range of ages, since Ropac makes a commitment to them for the long term. And his ambition of seeing them recognized as significant contributors to the art world seems to be fulfilled by events like the Georg Baselitz retrospective in 2007 at the Royal Academy of Arts in London or Lee Bul's installation at the Fondation Cartier. This is undeniably one of the leading galleries in Paris – if not Europe.

Gallery artists include Stephan Balkenhol, Jean-Marc Bustamante, Francesco Clemente, Tony Cragg, Richard Deacon, Elger Esser, Sylvie Fleury, Gilbert & George, Antony Gormley, Wang Guangyi, Peter Halley, Lori Hersberger, Ilya & Emilia Kabakov, Mimmo Paladino, Jack Pierson, Rona Pondick, Gerwald Rockenschaub, James Rosenquist, Lisa Ruyter, Tom Sachs, David Salle, Thomas Struth, Banks Violette, Andy Warhol, Lawrence Weiner and Robert Wilson.

Jeu de Paume

Site Concorde
1 place de la Concorde 75008
t: 01 47 03 12 50
www.jeudepaume.org
MAPS 4/3, 6/7

Site Sully
Hôtel de Sully
62 rue St-Antoine 75004
t: 01 42 74 47 75
MAP 8/5

Constructed in the mid-19th century, the Jeu de Paume originally housed a royal tennis court. Located in the north-west corner of the Jardin des Tuileries, the building has been used since the 1920s as an exhibition space for modern and contemporary art. In the mid-1980s its original collection of impressionist paintings was moved to the converted Musée d'Orsay and the Jeu de Paume was totally renovated. The original exterior was retained but the galleries inside were reconfigured. A further artistic development transformed the Musée du Jeu de Paume into a centre focusing on the presentation and conservation of photographic, electronic and mechanical images, including video and moving images. A second site devoted to still photography is located in a wing of the Hôtel de Sully – an aristocratic townhouse built in the 16th century and located in the Marais, which has been used by a number of arts organizations over the years, only becoming an exhibition venue in the 1990s.

In May 2004 the two sites were united and designated as the new home of three formerly independent cultural institutions: the Galerie Nationale du Jeu de Paume, the Centre National de la Photographie and Patrimoine Photographique. Since this date, the activities of the museum have been split between the two sites.

The Hôtel de Sully houses the national photographic collection and presents its treasures in temporary exhibitions spanning the entire history of photography, from its foundations in the early 19th century to the present day. The Concorde site, on the other hand, presents both monographic and thematic exhibitions of contemporary photography, as well as of architecture, film, video and installations – from established artists in addition to those emerging from the younger scene. Internet-based art productions are also shown here. There is a wide-ranging programme of events, films and conferences, as well as a well-stocked bookshop at the Concorde site.

In 2006 the museum initiated the annual national photography prize, Les Prix Photo du Jeu de Paume, in which two awards are presented, one selected by jury and the other by the public.

all kinds, two- and three-dimensional, in all media, by an international collection of artists including Daniel Buren, Claude Closky, Mike Kelley, Bertrand Lavier, Sol LeWitt, Kiki Smith.
MAP 8/31

Galerie Denise René
www.deniserene.com
A doyenne of the Paris art scene and longtime champion of geometric abstraction, kinetic, formalist and constructivist art, exhibits high-level examples in two branches.
Denise René: Rive Gauche
196 boulevard St-Germain 75007
t: 01 42 22 77 57
MAPS 4/21, 7/37

Denise René: Espace Marais
22 rue Charlot 75003
t: 01 48 87 73 94
MAP 8/63

Galerie Di Meo
9 rue des Beaux Arts 75006
t: 01 43 54 10 98
www.dimeo.fr
Exhibits major French moderns (Jean Dubuffet, Jean Fautrier, Henri Michaux) and established artists including Cy Twombly.
MAP 7/27

Galerie Dominique Fiat
16 rue des Coutures St-Gervais 75003
t: 01 40 29 98 80
www.galeriefiat.com
Focuses on a group of European artists working at the forefront of contemporary practice.
MAP 8/53

Galerie du Centre
5 rue Pierre au Lard, corner of 22 rue du Renard 75004
t : 01 42 77 37 92
www.galerie-du-centre.net
Handles French new realists and 1960s artists including British and American pop artists Derek Boshier, Peter Saul.
MAP 8/25

Galerie du Jour Agnès b.
44 rue Quincampoix 75004
t: 01 44 54 55 90
www.galeriedujour.com
Agnès b., a collector of contemporary art and photography, highlights a cross-section of interdisciplinary work, in a space that is all about style.
MAP 8/19

Galerie Emmanuel Perrotin
76 rue de Turenne 75003
t: 01 42 16 79 79
www.galerieperrotin.com
SEE PAGE 126

Galerie Eric Dupont
13 rue Chapon 73003
t: 01 44 54 04 14
www.eric-dupont.com
Dupont is committed to the work of a selected group of young artists whose work spans a wide range of interests and practices.
MAP 8/81

Galerie Eric Mircher
26 rue St-Claude 75003
t: 01 48 87 02 13
www.mircher.com
Shows emerging and well established painters and sculptors.
MAP 8/47

Galerie Esther Woerdehoff
36 rue Falguière 75015
t: 01 43 21 44 83
www.ewgalerie.com
Shows classic and contemporary photography in a historic building where Camille Claudel and Constantin Brancusi had studios.
MAP 5/7

Galerie Eva Hober
16 rue St-Claude 75003
t: 01 48 04 78 68
www.evahober.com
Represents younger artists – mostly French – with a particular interest in highly emotionally charged and imagist work.
MAP 8/44

Galerie Fabien Boulakia
10 avenue Matignon 75008
t: 01 56 59 66 55
www.artnet.com/gallery/173/galerie-fabien-boulakia.html
Specializes in impressionists, modern masters and well-known contemporaries.
MAP 3/12

Galerie Fanny Guillon-Laffaille
4 avenue de Messine 75008
t: 01 45 63 52 00
www.guillonlaffaille.com
Primarily devoted to Raoul Dufy, but also exhibits work by other artists including André Derain.
MAP 3/18

Galerie Françoise Paviot
57 rue Ste-Anne 75002
t: 01 42 60 10 01 / 01 42 60 68 08
www.paviotfoto.com
One of the first galleries in Paris to devote itself to photography, it continues to show classic work

from early masters, such as Eugène Atget, to the present.
MAP 6/25

Galerie Frank Elbaz
7 rue St-Claude 75003
t: 01 48 87 50 04

www.galeriefrankelbaz.com

Shows young Europeans and Americans across the spectrum of current aesthetic and social concerns, including Olivier Babin, Davide Balula, Marcelline Delbecq, Rainier Lericolais.
MAPS 8/42, 10/7

Galerie Frédéric Giroux
8 rue Charlot 73003
t: 01 42 71 01 02

www.fredericgiroux.com

This space has an up-to-the-minute atmosphere with shows spanning all areas of current practice including installation and performance art.
MAP 8/60

Galerie Gabrielle Maubrie
24 rue Ste-Croix de la Bretonnerie 75004
t: 01 42 78 03 97

www.gabriellemaubrie.com

Shows major artists whose conceptual work is often difficult to categorize, including Gordon Matta-Clark, Robert Smithson.
MAP 8/27

Galerie gb agency
20 rue Louise Weiss 75013
t: 01 53 79 07 13

www.gbagency.fr

Exhibits a mixed international group of traditional and media-based artists. Organizes events and commissions at sites around the globe.
MAP 9/5

Galerie Georges-Philippe et Nathalie Vallois
36 rue de Seine 75006
t: 01 46 34 61 07

www.galerie-vallois.com

Retains connections to new realist artists (Arman, Jacques Villeglé) while exhibiting younger French and international artists (Boris Achour, Alain Bublex, Vincent Lamouroux). A 'project room' shows site-specific work.
MAP 7/19

Galerie Ghislaine Hussenot
5 bis rue des Haudriettes 75003
t: 01 48 87 60 81

e: ghislaine.hussenot@liberty surf.fr

Exhibits a range of international artists across all media, including Glenn Brown, Andreas Gursky, Roni Horn, Mike Kelley, Cindy Sherman, Chen Zhen.
MAP 8/77

Galerie G-Module
15 rue Debelleyme 75003
t: 01 42 71 14 75

www.g-module.com

A small space showing young, New York-based artists exploring relationships with experimental areas of research – scientific and political – in their work.
MAP 8/67

Galerie Hopkins-Custot
2 avenue Matignon 75008
t: 01 42 25 32 32

www.hopkins-custot.com

Handles modernism from impressionists and 20th-century masters to contemporaries including David Hockney, Marc Quinn, Andy Warhol.
MAP 3/10

Galerie Jacques Elbaz
1 rue d'Alger 75001
t: 01 40 20 98 07

www.galeriejacqueselbaz.spaces.live.com

Exhibits a group of painters, sculptors and photographers.
MAPS 4/17, 6/17

Galerie Janos
9 rue Christine 75006
t: 01 44 07 10 60

www.galeriejanos.com

Focuses on art, rock posters from the 1960s and '70s, and serigraphs to the present.
MAP 7/9

Galerie Jean Brolly
16 rue de Montmorency 75003
t: 01 42 78 88 02

www.jeanbrolly.com

A beautiful space exhibiting up-and-coming younger artists.
MAP 8/80

Galerie Jean Fournier
22 rue du Bac 75007
t: 01 42 97 44 00

www.galerie-jeanfournier.com

Exhibits the work of well-known moderns including Simon Hantaï, Claude Viallat.
MAPS 4/25, 7/41

Galerie Jean-Jacques Dutko
6 rue des Beaux Arts 75006
t: 01 43 26 96 13

www.dutko.com

A mix of art-deco objects, primitive, modern and contemporary art.
MAP 7/30

Galerie Jérôme de Noirmont
36-38 avenue Matignon 75008
t: 01 42 89 89 00

www.denoirmont.com

MAC/VAL (Musée d'Art Contemporain du Val-de-Marne)

Place de la Libération 94400 Vitry-sur-Seine
t: 01 43 91 64 20
www.macval.fr
RER Vitry-sur-Seine, then bus 180 direction Villejuif/Louis Aragon
Ⓜ *Porte de Choisy, then bus 183 direction Orly Terminal Sud*
Ⓜ *Villejuif-Louis Aragon to terminus, then bus 180 direction Charenton-Écoles*
or bus 172 direction Créteil-Échat

The MAC/VAL, Museum of Contemporary Art of the Val-de-Marne, stems from the decision of an administrative region (département) encompassing the south-eastern suburbs of Paris, the Val-de-Marne, to create a space dedicated to contemporary art outside the city limits of Paris. For a country that is so centralized around its capital city, this constitutes a bold, even daring step. An architectural competition for the new building was won by the architects Ripault-Duhart for their radical but elegant white structure. Located in a lush park, the museum opened in 2005, with the monumental polychrome sculpture by Jean Dubuffet, *La Chaufferie avec Cheminée,* already in place.

The institution provides a home for the collection of contemporary art of the Val-de-Marne, comprising over 1,000 artworks, either made or exhibited in France, from the 1950s to the present day. The holdings of art from post-war movements in France are especially strong. Works are displayed in thematic groups, and displays are regularly changed. The region has an active acquisition policy and consequently the collection at MAC/VAL is constantly growing. Works include pieces by Christian Boltanski, Claude Closky and Ange Leccia.

MAC/VAL also stages temporary exhibitions of contemporary art, both monographic (such as its two inaugural exhibitions dedicated to Claude Lévêque and Jacques Monory) and thematic, often including many new works. Temporary exhibitions run in yearly cycles of three, each series planned around a different theme. MAC/VAL also runs a research centre, media library and cinema as well as organizing an extensive programme of films, lectures, artist demonstrations and tours. Residences for two visiting foreign artists are attached to the site.

The comprehensive holdings of the collection, providing a panorama of French contemporary art, and the innovative exhibition policy, along with relatively straightforward transport links to the centre of Paris, make MAC/VAL a worthwhile and enjoyable excursion.

Shows a range of international artists with a strong imagist, ironic or pop slant, including Fabrice Hyber, Jeff Koons, Pierre et Gilles, Andy Warhol.
MAP 3/16

Galerie Jocelyn Wolff
78 rue Julien Lacroix 75020
t: 01 42 03 05 65

www.galeriewolff.com

Exhibits younger artists working in all media in a pristine and beautifully airy space, including Stéphane Calais, Valérie Favre, Guillaume Leblon.
MAP 11/3

Galerie Kamel Mennour
47 rue St-André des Arts 75006
t: 01 56 24 03 63
60 rue Mazarine 75006
t: 01 43 25 64 80

www.galeriemennour.com

High-quality, if provocative, even transgressive, work by artists including Adel Abdessemed, Daniel Buren, Shirin Neshat and photographers Nobuyoshi Araki, Larry Clark, Martin Parr.
MAP 7/8

Galerie Karsten Greve
5 rue Debelleyme 75003
t: 01 42 77 19 37

www.galerie-karsten-greve.com

Housed in a palatial space. Exhibits established painters, sculptors and photographers including Louise Bourgeois, John Chamberlain, Tony Cragg, Pierre Soulages, Cy Twombly.
MAP 8/50

Galerie Kreo
22 rue Duchefdelaville 75013
t: 01 53 60 18 42

www.galeriekreo.com

Displays furniture and objects by internationally known designers from the 1950s to the present, including Jasper Morrison, Marc Newson, Martin Szekely. Some limited-edition ranges available.
MAP 9/2

Galerie Lahumière
17 rue du Parc Royal 75003
t: 01 42 77 27 74

www.lahumiere.com

Strongly committed to geometric and 'constructed' abstraction, promoting both past and current artists working in that tradition.
MAP 8/36

Galerie Lara Vincy
47 rue de Seine 75006
t: 01 43 26 72 51

www.lara-vincy.com

Committed to experimentation since the 1950s, promoting work in the area of modern sound and 'actions' as well as visual works. Since the 1990s the gallery has mainly mounted monographic exhibitions, including Ben, Esther Ferrer, Raymond Hains.
MAP 7/18

Galerie Larock-Granoff
13 quai de Conti 75006
t: 01 43 54 41 92

www.larockgranoff.com

A riverside gallery in the grand manner exhibiting classic French moderns and Europeans of the mid-20th century.
MAP 7/32

Galerie Laurent Godin
5 rue du Grenier St-Lazare 75003
t: 01 42 71 10 66

www.laurentgodin.com

Exhibits a diverse collection of artists working in a wide range

of media including sculpture and installation.
MAP 8/86

Galerie Laurent Strouk
8-16 bis rue Jacques Callot 75006
t: 01 40 46 89 06

www.popgalerie.com

Shows mainly figurative, new realist and pop art work as well as contemporary photography. Exhibited artists include Arman, Ben, César, Gérard Fromanger, Raymond Hains, Jean-Pierre Raynaud, Martial Raysse, Niki de Saint Phalle, Jacques Villeglé.
MAP 7/21

Galerie Lavignes Bastille
27 rue de Charonne 75011
t: 01 47 00 88 18

www.lavignesbastille.com

A multi-level gallery showing both young and established artists (Carlos Cruz-Diez, Wolf Vostell) working in traditional media as well as film and digital imagery. Also organizes exhibitions at other sites.
MAP 10/2

Galerie Lelong
13 rue de Téhéran 75008
t: 01 45 63 13 19

www.galerie-lelong.com

Internationally established gallery shows painting, sculpture, photography and prints by well-established artists including Pierre Alechinsky, Karel Appel, Andy Goldsworthy, Arnulf Rainer, Sean Scully, Kiki Smith.
MAP 3/20

Galerie Léo Scheer
14-16 rue de Verneuil 75007
t: 01 44 55 01 90

www.leoscheer.com

La Maison Rouge

10 boulevard de la Bastille 75012
t: 01 40 01 08 81
www.lamaisonrouge.org
MAP 9/20

The former gallerist and collector Antoine de Galbert established the Maison Rouge in order to create a public space that reflected his passion for contemporary art. Opened in 2003, the gallery is located in a former industrial building, the 18th-century Red House, just south of the Bastille area. In a sympathetic development that preserves the essence of the place, a large contemporary atrium space has been constructed around the original building, and existing features, such as the large skylights, have been retained.

Ever since its opening, the Maison Rouge has set out to present all forms of contemporary art in three to six innovative temporary exhibitions per year. In over 1,300 square metres of space, the gallery invites individual artists to exhibit their work, and independent curators are invited to conceive original monographic, group or thematic shows, in which work by international artists, often from private collections around the world, are displayed. It is an interesting concept that collectors themselves are also given curatorial opportunities to showcase their private collections at the gallery.

As well as the large atrium, the building has two smaller spaces, the Patio and the Vestibule. While the former is dedicated to site-specific installations and ephemeral interventions by artists, the Vestibule, with its constantly-changing programme, presents smaller exhibitions of very young and emerging artists.

The exhibitions at the Maison Rouge vary enormously, both in their approach and their content, reflecting the wide ranging and often daring preoccupations, inspirations and ideas of the contemporary artists, curators and collectors who devise them. Exhibited artists have included Dieter Appelt, Berlinde de Bruyckere, Gerda Steiner & Jörg Lenzlinger, and Luc Delahaye. A programme of talks, symposiums, meetings with artists or curators, concerts and films give a deeper understanding of the exhibited works.

Although the location is central, the street alongside the Bastille canal is grey and the approach to the Maison Rouge somewhat bleak, but don't be put off, it is well worth visiting. An additional draw is the branch of Bookstorming next door, which maintains a huge stock of art books and magazines.

Musée d'Art Moderne de la Ville de Paris (MAMVP)

11 avenue du Président Wilson 75116
t: 01 53 67 40 00
www.mam.paris.fr
MAPS 2/4, 3/2

The Musée d'Art Moderne de la Ville de Paris (MAMVP) is home to the large and continuously expanding collection of 20th-century art belonging to the city of Paris. The museum has works from all the major art movements of the 20th century, with an emphasis on France, and was built up with the help of generous patrons, collectors and artists associated with the city. The collection is located in the east wing of the Palais de Tokyo, a classic art deco building, which rises from the banks of the Seine in a series of staircases and superimposed structures. Originally built for the 1937 International Fair, the long-term plan was to house the municipal museum in one of its wings and the national museum of modern art in the other. However, the outbreak of World War Two meant that the collection only moved into the east wing of the building in 1961.

Since this date the museum has remained one of the most active institutions for modern and contemporary art in Europe. In 1967 a new area of the collection, ARC (Animation, Research, Confrontation), was established, dedicated specifically to contemporary, multi-disciplinary and international works. ARC remains distinct from the art-historical mission of the museum since it focuses exclusively on living artists, especially younger ones. This part of the collection is located on the fourth floor although rather discreet signage makes it easy to miss.

An ongoing programme of renovation has allowed the museum to present its ever-growing collection in chronological groupings divided into modern and contemporary art. The former section includes works by Robert Delaunay, André Derain, Raoul Dufy, Henri Matisse and Francis Picabia as well as many members of the School of Paris. The latter section presents representative work from most art movements from after 1960, with an emphasis on French artists but also new media and video, including Bernard Frize, Raymond Hains, Bertrand Lavier, Jean-Luc Moulène, Philippe Parreno, Bruno Serralongue and Tatiana Trouvé.

The museum houses some permanent works in dedicated rooms, including large-scale works by Henri Matisse in the Matisse Hall (the Henry Thomas Collection) and Raoul Dufy's mural *La Fée Electricité* in the Salle Dufy (illustrated on page 13).

The publisher Léo Scheer uses his gallery space as a centre for events – lectures, performances and projections – related to his publications, but also to exhibit photography, video and film.
MAP 7/39

Galerie Les Filles du Calvaire
17 rue des Filles du Calvaire 75003
t: 01 42 74 47 05

www.fillesducalvaire.com

Ranges from abstract painting of the 1980s to '90s, photography, installation, sculpture and video.
MAP 8/70

Galerie Loevenbruck
40 rue de Seine/2 rue de l'Echaudé 75006
t: 01 53 10 85 68

www.loevenbruck.com

Shows energetic, sometimes humorous, work by younger artists working in painting, sculpture and photography.
MAP 7/17

Galerie L'Or du Temps
25 rue de l'Echaudé 75006
t: 01 43 25 66 66

www.lordutemps.com

Specializes in avant-garde early 20th-century art and deals in artists' books: e.g. Simon Hantaï, Henri Michaux, Claude Viallat.
MAP 7/13

Galerie Louis Carré & Cie
10 avenue de Messine 75008
t: 01 45 62 57 07

www.louiscarre.fr

A Paris institution since 1938, exhibiting work by modern masters and younger international artists.
MAP 3/19

Galerie Luc Bellier
20 rue de l'Élysée 75008
t: 01 44 94 84 84

www.bellier-art.com

In the same location since 1920. Handles a wide range of work from the modern period and has mounted major exhibitions of work by Edvard Munch, Pablo Picasso, Édouard Vuillard.
MAP 3/11

Galerie Lucie Weill & Seligmann
6 rue Bonaparte 75006
t: 01 43 54 71 95

www.galerie-lws.com

Open since 1930. Deals in modern and contemporary work and has published books illustrated by Jean Arp, Jean Cocteau, Max Ernst, Pablo Picasso. There is a photographic department, Photo4, next door.
MAP 7/33

Galerie Maeght
42 rue du Bac 75007
t: 01 45 48 45 15

www.maeght.com

The last vestige in Paris of the Maeght family's considerable art presence sells prints and books by major European artist/printmakers from the 20th century to the present, with regular exhibitions by artists including Gérard Gasiorowski and Ellsworth Kelly.
MAPS 4/23, 7/38

Galerie Magda Danysz
78 rue Amelot 75011
t: 01 45 83 38 51

www.magda-gallery.com

Features young artists, often working outside or across traditional disciplines.
MAP 10/8

Galerie Maisonneuve
22 rue de Poitou 75003
t: 01 43 66 23 99

www.galerie-maisonneuve.com

Promotes work that challenges boundaries of traditional art. Artists include Mathieu Briand, Ralph Samuel Grossmann.
MAP 8/66

Galerie Maria Lund: La Galerie Danoise
48 rue de Turenne 75003
t: 01 42 76 00 33

www.marialund.com

A Paris showcase for the work of Scandinavian artists, with eight exhibitions per year.
MAP 8/34

Galerie Marian Goodman
79 rue du Temple 75003
t: 01 48 04 70 52

www.mariangoodman.com
SEE PAGE 129

Galerie Martine Aboucaya
5 rue Ste-Anastase 75003
t: 01 42 76 92 75

www.martineaboucaya.com

This small, but unique, gallery runs a programme of exhibitions and events about art, cinema, music, literature and architecture. Artists include Pash Buzari, Hanne Darboven, Agnès Varda.
MAP 8/41

Galerie Martine et Thibault de la Châtre
4 rue Saintonge 75003
t: 01 42 71 89 50

www.lachatregalerie.com

A large space showing work by both established international artists (Glen Baxter, Sol LeWitt) alongside new talents.
MAP 8/55

Musée Picasso

Hôtel Salé
5 rue de Thorigny 75003
t: 01 42 71 25 21
www.musee-picasso.fr
MAP 8/38

Arguably the loveliest of the Paris galleries, the Musée Picasso is located in the Hôtel Salé, one of the grandest 17th-century townhouses of the *ancien régime* in the Marais, where many contemporary art galleries have also settled in recent years. The museum moved into this prestigious location in 1985, following more than eight years of careful building renovations in which the spaces were adapted to display a comprehensive survey of artworks and documents from one of the most famous artists of the 20th century. The renovation was a huge success – with the exterior being retained along with key elements from the interior, including the superb baroque staircase. The interventions are so subtle, and the work so beautifully displayed and lit that, once in the exhibition spaces themselves, one ceases to be aware of the building. The choreography of the spaces leads effortlessly from one to another, resulting in a rich overview of Picasso's life and work. A small (but not enclosed) projection space is a welcome break along the way and includes footage of the artist at work.

After Picasso's death in 1973 his heirs opted to allow the French state to take a selection of his works in lieu of paying inheritance tax. As a result, over 200 paintings, 150 sculptures and thousands of drawings, prints and documents were united in a single, public collection. They were preserved from the dispersion that would eventually be the fate of many of his other works, and could be made accessible to the public in the best possible conditions.

Over the years many more works and documents were added to the collection through donations and acquisitions, filling in gaps in the collection and opening up new insights into his personal life and non-artistic activities. The large collection includes his haunting blue period *Self Portrait* (1901), studies for *Les Demoiselles d'Avignon*, 1906-07 (now in the Museum of Modern Art, New York), his classical *Women Running along a Beach* (1922), the surreal *Large Nude in a Red Armchair* (1929) and portraits of his lovers, particularly Dora Maar and Marie-Thérèse Walter. The Musée Picasso also presents temporary exhibitions that both highlight aspects of Picasso's work and explore his influence on other artists.

Galerie Marwan Hoss
12 rue d'Alger 75001
t: 01 42 96 37 96

www.marwanhoss.com

In a beautiful courtyard space, shows the work of established giants of modern art.
MAPS 4/18, 6/18

Galerie Michèle Chomette
24 rue Beaubourg 75003
t: 01 42 78 05 62

Deals in photographic images from the 19th century and modern era (particularly strong on the Bauhaus) to the present. Also promotes contemporary photography.
MAP 8/88

Galerie Michel Rein
42 rue de Turenne 75003
t: 01 42 72 68 13

www.michelrein.com

Shows new work in all media including installations and photography. Handles artists as disparate as Saâdane Afif, Maja Bajevic, Orlan, Allan Sekula.
MAP 8/30

Galerie Nathalie Obadia
3 rue du Cloître St-Merri 75004
t: 01 42 74 67 68

www.galerie-obadia.com

A lively gallery showing a stimulating mix of mid-career and younger artists, including Fiona Rae, Jessica Stockholder.
MAP 8/15

Galerie Nathalie Seroussi
34 rue de Seine 75006
t: 01 46 34 05 84

Exhibits work spanning the early modern period through to the latter end of the 20th century.
MAP 7/20

Galerie Nelson-Freeman
59 rue Quincampoix 75004
t: 01 42 71 74 56

www.galerie-nelson.com

Exhibits work in all art disciplines, especially photography. Artists include Rodney Graham, Thomas Ruff, Anne-Marie Schneider, Thomas Schütte. Large holdings of work by Robert Filliou.
MAP 8/21

Galerie Nikki Diana Marquardt
9 place des Vosges 75004
t: 01 42 78 21 00

www.galerienikkidianamarquardt. com

A gallerist with a history of collaboration with Leo Castelli, and of association with Robert Rauschenberg and Frank Stella, shows a wide range of current work with an occasional surprise, such as Dan Flavin in 2006.
MAP 8/6

Galerie 1900-2000
8 rue Bonaparte 75006
t: 01 43 25 84 20

www.galerie1900-2000.com

Marcel Fleiss, one of the principal gallerists of the later Dada and surrealist movements and a friend of Man Ray, opened his gallery in 1972.
MAP 7/34

Galerie Nuke
11 rue Ste-Anastase 75003
t: 01 42 78 36 99

www.guillaume.paquin.free.fr

Linked to the magazine of the same name, provides an anarchic, hip forum for ideas about the environment, politics and sex in photography, fashion, graphic design and literature.
MAP 8/40

Galerie Patrice Trigano
4 bis rue des Beaux Arts 75006
t: 01 46 34 15 01

Paintings, sculptures and works on paper including Europeans (Alberto Giacometti, Hans Hartung), American photorealists (Robert Cottingham, Duane Hanson) and Russian artists.
MAP 7/29

Galerie Philippe Samuel
62 rue de Saintonge 75003
t: 01 42 77 71 14

www.galerie-philippe-samuel.com

A new gallery showing work from 20th-century French moderns to present day contemporaries.
MAP 8/71

Galerie Pièce Unique
4 rue Jacques Callot 75006
t: 01 43 26 54 58
Pièce Unique Variations
26 rue Mazarine 75006
t: 01 43 26 85 93

www.galeriepieceunique.com

Shows only one work to be seen from the street (lit until 2am) and often specially commissioned for the space. More works are on view at Pièce Unique Variations.
MAP 7/23

Galerie Pierre-Alain Challier
8 rue Debelleyme 75003
t: 01 49 96 63 00

e: galerie@pacea.fr

Great gallery space over three floors designed by Christopher Pillet. Specializes in modern and contemporary art, editions and multiples by artists including Arman, Sonia Delaunay, Man Ray, Jean-Michel Othoniel, Jean-Pierre Raynaud, Zao Wou-Ki.
MAP 8/49

Galerie Polaris
15 rue des Arquebusiers 75003
t: 01 42 72 21 27

www.galeriepolaris.com

A high-profile gallery showing a mix of French and international artists focusing on photography.
MAPS 8/43, 10/6

Galerie Rabouan Moussion
121 rue Vieille du Temple 75003
t: 01 48 87 75 91

www.rabouan-moussion.com

A lively gallery exhibiting a wide ranging, rather eccentric collection of artists, both young and more established, including Oleg Kulik, Pierrick Sorin.
MAP 8/58

Galerie Raymond Dreyfus
3 rue des Beaux Arts 75006
t: 01 43 26 09 20

www.raymond-dreyfus.com

Deals in the work of 20th-century and contemporary artists including Pierre Alechinsky, Jean Dubuffet, Hiroshi Sugimoto.
MAP 7/24

Galerie Re:Voir – The Film Gallery
18 rue de Saintonge 75003
t: 08 73 86 47 00

www.re-voir.com/gallery

Re:Voir promotes and produces while the Film Gallery presents and sells experimental films and video. Represents avant-garde filmmakers such as Jonas Mekas.
MAP 8/65

Galerie Rive Gauche: Marcel Strouk
23 rue de Seine 75006
t: 01 56 24 42 19

www.galerie-strouk.com

Specializes in American pop art and related European figuration, showing all well-known names.
MAP 7/12

Galerie RX
6 avenue Delcassé 75008
t: 01 45 63 18 78

www.galerierx.com

Represents Continental and Asian photographers and painters in a generous space.
MAP 3/17

Galerie Samy Kinge
54 rue de Verneuil 75007
t: 01 42 61 19 07

e: skinge@wanadoo.fr

Shows the work of surrealists, notably Victor Brauner, as well as more recent work by artists such as Martial Raysse, Paul Thek.
MAPS 4/26, 7/42

Galerie Schleicher + Lange
12 rue de Picardie 75003
t: 01 42 77 02 77

www.schleicherlange.com

A sharp gallery exhibiting interesting work with a focus on conceptual art and drawing. Artists include Chris Cornish, Zoë Mendelson, Laurent Montaron.
MAP 8/73

Galerie Serge Aboukrat
7 place de Fürstemberg 75006
t: 01 44 07 02 98

A micro-gallery for photography with a social and psychological edge. Also publishes multiples.
MAP 7/14

Galerie Suzanne Tarasiève
171 rue du Chevaleret 75013
t: 01 45 86 02 02

www.suzanne-tarasieve.com

A great split-level space

specializing in painting, photography and other media.
MAP 9/4

Galerie Thaddaeus Ropac
7 rue Debelleyme 75003
t: 01 42 72 99 00

www.ropac.net

SEE PAGE 131

Galerie Thessa Herold
7 rue de Thorigny 75003
t: 01 42 78 78 68

www.thessa-herold.com

Presents work by 20th-century surrealist and abstract artists.
MAP 8/39

Galerie Thierry Marlat
2 rue de Jarente 75004
t: 01 44 61 79 79

A high-class gallery showing photography in an elegant space.
MAP 8/7

Galerie 13 Sévigné
13 rue de Sévigné 75004
t: 01 42 74 32 61

www.13sevigne.com

Presents the work of emerging artists with an interest in the fantastic.
MAP 8/8

Galerie Vanessa Quang
7 rue des Filles du Calvaire 75003
t: 01 44 54 92 15

www.galerie-quang.com

Promotes the work of young artists, both traditional and new media, and installation artists.
MAP 8/69

Galerie Véronique Smagghe
10 rue de Saintonge 75003
t: 06 08 50 19 46

www.nouveauxrealistes.com

Palais de Tokyo: Site de Création Contemporaine

13 avenue du Président Wilson 75116
t: 01 47 23 54 01
www.palaisdetokyo.com
MAPS 2/3, 3/3

Located in the west wing of the Palais de Tokyo complex, originally built in 1937 to house the International Fair, the Palais de Tokyo: Site of Contemporary Creation, was founded in 1999. It moved into its current location, with entrances off avenue du Président Wilson, in 2002, after major renovation of the vast spaces that were previously home to a number of different cultural institutions.

The Palais de Tokyo does not own a collection or have a fixed programme of prescribed exhibitions but rather sees itself as a place where creative developments can take place, through experimentation and open discussion. While maintaining a programme of small-scale monographic exhibitions and large thematic shows, split evenly between French and international artists, it sets out to be as accessible as possible, incorporating humorous and entertaining elements alongside the more academic aspects of its productions. The Palais de Tokyo makes a point of involving artists in its exhibitions beyond lending or producing works of art – for example, by inviting established contemporary artists such as the Swiss Ugo Rondinone in 2007 to organize large-scale thematic shows. Other artists include Ronald Bladen, Martin Boyce, Joe Brainard, Vija Celmins, Verne Dawson, Trisha Donnelly, Urs Fischer, Nancy Grossman, Karen Kilimnik, Emma Kunz, Sarah Lucas, Josh Smith and Paul Thek. The complex also runs a residency programme – Le Pavillon – directed by Ange Leccia, which is a creative laboratory for up to ten young international artists and newly qualified curators per year, which is located in a separate structure on the roof of the building.

As a result of these initiatives the Palais de Tokyo has managed to maintain a popular, multi-faceted and comprehensive approach to all elements of contemporary visual arts, allowing artists to introduce their own approach and point of view, and encouraging visitors to gain a better understanding of contemporary art, free from the rigid constraints of institutional boundaries and in a congenial and lively environment. Through a combination of its daring and sometimes challenging exhibitions, its long opening hours – from noon to midnight – and user-friendly public spaces, including a bookshop and café, it has quickly become a hotspot for followers of contemporary art.

Small works by new realist collagists François Dufrêne, Raymond Hains, Jacques Villeglé.
MAP 8/59

Galerie Vidal-Saint Phalle
10 rue de Trésor 75004
t: 01 42 76 06 05

www.vidal-stphalle.com

A spacious gallery showing established European painters with a strong British contingent.
MAP 8/10

Galerie Vieille du Temple
23 rue Vieille du Temple 75004
t: 01 40 29 97 52

www.galerievieilledutemple.com

Shows the work of a broad group of artists, promoting their work over the long term.
MAP 8/11

Galerie Xippas
108 rue Vieille du Temple 75003
t: 01 40 27 05 55

www.xippas.com

A dramatic gallery, wrapped around the glass roof of the Yvon Lambert gallery. Photographic artists include Valérie Belin, Valérie Jouve, Philippe Ramette. Painters include Chuck Close, Ian Davenport, Lisa Milroy.
MAP 8/52

Galerie Yvonamor Palix
13 rue Keller 75011
t: 01 48 06 36 70

e: yapalix@aol.com

Promotes an international mix of artists working in painting, photography, media, video and installation, as well as focusing on contemporary Mexican arts.
MAP 10/3

Galerie Zlotowski
20 rue de Seine 75006
t: 01 43 26 93 94

www.galeriezlotowski.fr

Devoted to the European avant-garde of 1910-30.
MAP 7/26

Galerie Zürcher
56 rue Chapon 75003
t: 01 42 72 82 20

www.galeriezurcher.com

Exhibits emerging artists in painting, photography, video, sculpture and installation. Artists include Philippe Hurteau, Gary Lang, Mathilde Rosier.
MAP 8/83

La Générale
10-14 rue du Général Lasalle 75019
t: 06 24 98 30 51

www.lagenerale.org

In an industrial building from 1903, provides four floors of art activities with studio, rehearsal, production and exhibition spaces showing a wide range of work.
MAP 11/4

In Situ/Fabienne Leclerc
6 rue du Pont de Lodi 75006
t: 01 53 79 06 12

www.insituparis.fr

Shows the work of artists ranging from Gary Hill to the Blue Noses in two exhibition spaces.
MAP 7/10

JGM. Galerie
79 rue du Temple 75003
t: 01 43 26 12 05

www.jgmgalerie.com

Exhibits work by well-known painters, photographers and video artists but especially strong on sculpture. Organizes events in

which large works are shown in public spaces.
MAP 8/79

Jousse Entreprise
24 & 34 rue Louise Weiss 75013
t: 01 45 83 62 48

www.jousse-entreprise.com

Exhibits a young, cutting-edge group of artists including photographers and sculptors, but also classic designers.
MAP 9/7

Mouvements Modernes
68 rue Jean Jacques Rousseau 75001
t: 01 45 08 08 82

www.mouvementsmodernes.com

A gallery devoted to modern design objects that wittily cross over into sculpture: for example, Joe Cesare Colombo's tube chair and Claudio Colucci's shelf units.
MAP 6/24

Objet Trouvé
24 rue de Charenton 75012
t: 01 53 33 01 70

www.objet-trouve.com

The only gallery in Paris dedicated to art brut and outsider art.
MAPS 9/17, 10/1

Patricia Dorfmann
61 rue de la Verrerie 75004
t: 01 42 77 55 41

www.patriciadorfmann.com

Promotes the work of young artists largely unknown in France with exhibitions and events.
MAP 8/13

Philippe Casini
13 rue Chapon (courtyard) 75003
t: 01 48 04 00 34

Has built the reputations of a group of artists and established artists from abroad in France.
MAP 8/82

Praz-Delavallade
28 rue Louise Weiss 75013
10 rue Duchefdelaville 75013
t: 01 45 86 20 00

www.praz-delavallade.com

Two spaces showing challenging work including Marc Couturier, Jim Shaw, Marnie Weber.
MAP 9/8

Sutton Lane
6 rue de Braque 75003
t: 01 40 29 08 92

www.suttonlane.com

Exhibits work by international artists, some from Britain.
MAP 8/75

La Vitrine
24 rue Moret 75011
t: 01 43 38 49 65

www.ensapc.fr/lavitrine

A Paris venue for young artists from the École National Supérieure d'Arts de Paris-Cergy.
MAP 11/1

Vu' La Galerie
2 rue Jules Cousin 75004
t: 01 53 01 85 81

www.galerie-vu.com

Shows photographers from the picture agency Vu, including Sébastien Boffredo, Denis Dailleux, Zhang Haï Er.
MAP 9/16

Yvon Lambert
108 rue Vieille du Temple 75003
t: 01 42 71 09 33

www.yvon-lambert.com

SEE PAGE 147

PUBLIC ART

Yaacov Agam
Fountain *(1975-77)*
Place de la Defénse
La Défense 4
MAP 3/23

Carl Andre
Roaring Forties *(1988)*
Jardin des Tuileries 75001
MAPS 4/15, 6/12

Arman
Consigne à Vie *(1985)*
Cour de Rome, outside Gare St-Lazare 75008
MAP 6/30

Arman
L'Heure de Tous *(1985)*
Cour du Havre, outside Gare St-Lazare 75008
Illustrated on page 21
MAP 6/29

Ben
Il Faut se Méfier des Mots *(1993)*
Place Fréhel (corner of 52 rue de Belleville and 103 rue Julien-Lacroix) 75020
MAP 11/2

Patrick Berger and Gilles Clément
Fountain *(1992)*
Parc André Citroën 75015
MAP 1/15

Jean-Charles Blais
Paintings for Assemblée Nationale Metro Station *(1990)*
Boulevard St-Germain 75007
MAP 4/28

Patrick Blanc
Garden 'murals' on façades of Musée du Quai Branly; Fondation

Cartier pour l'Art Contemporain; BHV Homme, 30 rue de la Verrerie; Marithe et François Girbaud store, 6 rue du Cherche Midi; La Défense.

Ricardo Bofill and Dani Karavan
L'Axe Majeur *(1985–86)*
Place des Colonnes 95000 Cergy-Pontoise
RER Cergy-St-Christophe

François Boisrond
Coup de Chapeau *(2001)*
Wall painting at gable end of 171 rue La Fayette and 4 rue de l'Aqueduc 75010
MAP 1/8

Louise Bourgeois
The Welcoming Hands *(1996)*
Jardin des Tuileries 75001
MAPS 4/5, 6/5

Constantin Brancusi
The Kiss *(1910)*
Cimetière de Montparnasse 75014
MAP 5/5

Pierre Buraglio
Decoration for Chapelle Saint-Symphorien *(1992)*
Eglise St-Germain-des-Prés 3 place St-Germain-des-Prés 75006
MAP 7/15

Daniel Buren
Les Deux Plateaux *(1985-86)*
Cour d'Honneur
Place du Palais Royal 75001
Illustrated on page 35
MAP 6/22

Pol Bury
Fountains à Boules *(1985)*
Galerie d'Orléans
Place du Palais Royal 75001
MAP 6/23

Alexander Calder
L'Araignée Rouge (1976)
Place de la Defénse
La Défense 4
Illustrated on page 37
MAP 3/24

Alexander Calder
Les Cinq Ailes (1967)
Bois de Vincennes - Parc Floral
Ⓜ Château de Vincennes
RER Vincennes

César
Le Centaure (1985)
Carrefour de la Croix-Rouge
75006
Illustrated on page 40
MAP 7/2

146 **César**
Icare (1980)
Place des Degrés
La Défense 7
MAP 3/26

César
Le Pouce (1965)
Place Carpeaux
La Défense 6
MAP 3/30

Marc Chagall
Ceiling (1964)
Opéra Garnier
Place de l'Opéra 75009
MAP 6/28

**Gérard Chamayou (with
Adrien Fainsilber)**
La Géode (1985)
Parc de la Villette 75019
MAP 11/11

Robert Combas
Untitled Mural (2001)
3 rue des Haudriettes 75003
MAP 8/76

Jan Dibbets
Paris Meridian (1994)

www.amb-pays-bas.fr/frlambass
ade/pcz/arag/htlm
Commemorating the 19th-
century astronomer, François
Arago, this work comprises 135
medallions bearing the name
ARAGO set into the ground
along the Paris meridian line.

Jean Dubuffet
L'Acceuillant (1986)
Hôpital Robert Debré
48 boulevard Sérurier 75019
MAP 11/7

Jean Dubuffet
Le Bal Costumé (1973)
Jardin des Tuileries 75001
Illustrated on page 47
MAPS 4/4, 6/6

Jean Dubuffet
Le Réséda (1968)
Caisse des Dépôts building
13 quai Voltaire 75007
MAPS 4/19, 7/43

Jean Dubuffet
La Tour aux Figures (1988)
Parc de l'Île St-Germain
Issy-les-Moulineaux
MAP 1/17

Max Ernst
Le Grand Assistant (1967-72)
Place Georges Pompidou
75004
MAP 8/89

Henri Étienne-Martin
Demeure no. 1 (1954-58)
Musée de Sculpture en Plein
Air, Jardin Tino Rossi
Quai St-Bernard 75005
MAP 9/14

Henri Étienne-Martin
Demeure no. 10 (1968)
Parc de Bercy 75012
MAP 9/22

Henri Étienne-Martin
Personnages III (1967)
Jardin des Tuileries 75001
Illustrated on page 50
MAPS 4/11, 6/10

**Dominique Gonzalez-
Foerster**
Light and Film Projection
(2001)
Bonne Nouvelle Metro Station
Boulevard Bonne Nouvelle
75002
MAP 6/27

**Clara Halter (with Jean-
Michel Wilmotte)**
Le Mur pour la Paix (2000)
Champ-de-Mars 75007
MAP 2/9

Fabrice Hyber
Artère (2006)
Parc de la Villette 75019
Illustrated on page 64
MAP 11/9

Fabrice Hyber
Le Cri, l'Écrit (2007)
Jardin du Luxembourg 75006
MAP 5/14

Henri Laurens
La Douleur (c. 1900)
Cimetière de Montparnasse
75014
MAP 5/6

Henri Laurens
La Grande Musicienne (1937)
Jardin des Tuileries 75001
Illustrated on page 70
MAPS 4/12, 6/9

André Masson
Ceiling (1965)
Théâtre National de L'Odéon
2 rue Corneille 75006
MAPS 5/17, 7/6

Yvon Lambert

108 rue Vieille du Temple 75003
t: 01 42 71 09 33
www.yvon-lambert.com
MAP 8/52

Yvon Lambert was 14 when he bought his first work of art, a neo-impressionist painting, near his hometown in Provence. For the 40th anniversary of his gallery in 2006, Anselm Kiefer came bearing sunflowers – not the regular kind but the monumental, steel and ashes variety. What happened in between? From the very start Lambert seemed to know his way. When he opened his first gallery in 1966 in a traditional neighbourhood of artistic Paris, St-Germain, he showed artists like Carl Andre, Robert Barry and Sol LeWitt while others were still into pop art. A decade later he was the first to move his gallery to the Marais, close to the Centre Pompidou, which had just opened its doors. Lambert's gallery has continued to grow in size, and it has come to be one of the most important places for contemporary art in France.

In 1986 it moved into its present location, still in the Marais, a beautiful glass-fronted building that now includes an art library: a great spot to catch up on the contemporary art scene. The fact that the list of artists who are the subjects of its books corresponds almost exactly to the gallery's list of artists, highlights the significance of Lambert's role in contemporary art.

In 2000 the Lambert Foundation opened its doors in Avignon, staging temporary exhibitions based on Lambert's personal collection of works by more than 500 contemporary artists, which he plans to donate to the French state. When he opened a branch of the gallery in New York in 2003, Lambert confirmed his status as one of the world's top art dealers. But while he continues to show artists of his own generation, whom he discovered early and who are now well established, he also keeps in touch with more recent developments and has recently embraced younger artists like the Romanian Mircea Cantor (born in 1977) and the American Adam Pendleton (born in 1980).

Other gallery artists include Alice Anderson, Carl Andre, Anna Gaskell, Nan Goldin, Douglas Gordon, Loris Gréaud, Candida Höfer, Jonathan Horowitz, Bethan Huws, Idris Khan, Anselm Kiefer, Koo Jeong-A, Barbara Kruger, Thierry Kuntzel, Bertrand Lavier, Sol LeWitt, Glenn Ligon, Christian Marclay, Jonathan Monk, Tsuyoshi Ozawa, Kay Rosen, David Shrigley, Niele Toroni and Sislej Xhafa.

Joan Miró
Deux Personnages Fantastiques (1976)
Parvis de la Défense
La Défense 7
Illustrated on page 150
MAP 3/25

Henry Moore
Reclining Figure (1951)
Jardin des Tuileries 75001
MAPS 4/9, 6/3

François Morellet
L'Arc de Cercles Complémentaires (1999-2000)
Jardin des Tuileries 75001
MAPS 4/6, 6/4

François Morellet
Or et Désordre (1991)
Théâtre de la Ville
2 place du Châtelet 75004
MAP 8/1

Claes Oldenburg and Coosje van Bruggen
Buried Bicycle (1990)
Parc de la Villette 75019
MAP 11/10

Jean-Michel Othoniel
Le Kiosque des Noctambules (2000)
Place du Palais Royal 75001
Illustrated on page 89
MAP 6/20

I.M. Pei
Pyramide du Louvre (1989)
Cour Napoléon
Palais du Louvre 75001
MAPS 6/15, 7/45

Jean-Pierre Raynaud
La Carte du Ciel (1989)
La Défense 92040
MAP 3/29

Jean-Pierre Raynaud
Le Pot Doré (1985)
Place Georges Pompidou
75004
Illustrated on page 96
MAP 8/23

Martial Raysse
Sol et Colombe ou *la Naissance de la Pensée* (1989-92)
Mural at Conseil Économique et Sociale, place d'Iéna 75016
MAPS 2/2, 3/1

Germaine Richier
L'Echiquier, Grand (1959)
Jardin des Tuileries 75001
MAPS 4/14, 6/14

Auguste Rodin
Le Baiser (1886-98)
Eve (1881)
La Grande Ombre (1880)
La Méditation (1886-98)
Jardin des Tuileries 75001
MAPS 4/8, 6/2

Auguste Rodin
Balzac (1893-97)
142 rue de la Grande Chaumière 75006
MAP 5/10

Françoise Schein
Decoration for Concorde Metro Station (1989)
Place de la Concorde 75001
MAP 6/33

Nicholas Schöffer
Chronos 10 (1978)
Musée de Sculpture en Plein Air, Jardin Tino Rossi
Quai St-Bernard 75005
MAP 9/12

David Smith
Primo Piano II (1962)
Jardin des Tuileries 75001
MAPS 4/16, 6/13

T3 Tramway
75013 to 75014 to 75015

www.tramway.paris.fr

Recently commissioned works from Christian Boltanski, Angela Bulloch, Sophie Calle (illustrated on page 38), Didier Fiuza Faustino, Dan Graham, Peter Kogler, Bertrand Lavier, Claude Lévêque strategically positioned along the T3 tramway route, which traverses southern Paris.

Vassilakis Takis
Signaux Lumineux (1990)
Esplanade du Général de Gaulle
La Défense 2-10
Illustrated on page 104
MAP 3/21

Jean Tinguely and Niki de Saint Phalle
Stravinsky Fountain (1983)
Place Igor Stravinsky 75004
Illustrated on page 99
MAP 8/16

James Turrell
Lighting for Façade of Caisse des Dépôts Headquarters (2003)
43-63 quai de la Gare 75013
MAP 9/11

Bernar Venet
Deux Lignes Indeterminées (1988)
Cour Michelet
La Défense 10
MAP 3/22

Le Viaduc des Arts
Periodic sculpture exhibitions, usually coinciding with major art fairs in the city, are held along the 4-km route of this elevated garden, the Promenade Plantée, on a disused railway track. Runs along avenue Daumesnil

from near avenue Ledru-Rollin, behind the Bastille Opéra, to rue Edouard Lartet.
MAP 9/18

Johann Otto von Spreckelsen
La Grande Arche (1982–90)
Parvis de la Defénse
La Défense 92040
MAP 3/28

Lawrence Weiner
Placé sur un Point Fixe (1992)
Jardin des Tuileries 75001
MAPS 4/10, 6/8

Yvaral
Saint Vincent de Paul (1987)
Wall painting at gable end of 107 rue du Faubourg St-Denis and square Alban Satragne 75010
MAP 1/9

Ossip Zadkine
Le Messager (1937)
Place de Finlande 75007
MAP 4/31

Ossip Zadkine
Le Poète (1954)
Jardin du Luxembourg 75006
MAP 5/13

Ossip Zadkine
Le Prométhée (1956)
Place St-Germain-des-Prés 75006
MAP 7/16

ART FAIRS

ArtParis
Grand Palais, Avenue Winston Churchill 75008
t: 01 56 26 52 16

www.artparis.fr

Over 100 modern and contemporary galleries of which about one-third are from outside France. Held in March/April.

Les Élysées de l'Art
Avenue des Champs-Élysées 75008
t: 01 49 28 51 30

www.orexpo.eu

A new event staged to coincide with FIAC, with more than 50 galleries. Highlights major artists of the modern period as well as innovative contemporary work. Held in October.

FIAC (Foire International de l'Art Contemporain)
Grand Palais, avenue Winston Churchill 75008
Cour Carrée du Louvre, rue de Rivoli 75001
t: 01 47 56 64 21

www.fiacparis.com

Paris's biggest art fair has two locations, with over 180 modern and contemporary galleries, a film and performance programme and sculpture in the Tuileries and Louvre. Held in late October.

Mois de la Photo à Paris
t: 01 44 78 75 00

www.mep-fr.org/moisdelaphoto

A biennial event sponsored by the Maison Européenne de la Photographie with over 70 photo exhibitions across Paris. Held every two years in November.

Paris Photo
Le Carrousel du Louvre 75001
t: 01 47 56 64 77

www.parisphoto.fr

Over100 exhibitors from 21 countries. Events include the 2,000-euro BMW-Paris Photo prize. Held in November.

Pavillon des Arts et du Design
Jardin des Tuileries
Esplanade des Feuillants 75001

www.pavillonartfair.com

80 galleries take part, dealing in work from the Renaissance to the present, Held in March/April.

Salon du Dessin Contemporain
60 bis avenue d'Iéna 75016
t: 01 44 07 21 87

www.salondudessincontempo rain.com

First salon held in 2007, with 40 galleries showing drawing-based works from the 1950s to the present. Held in March/April.

Show Off
Espace Pierre Cardin
1 avenue Gabriel 75008
t: 01 44 61 76 76

www.showoffparis.com

A young, cutting-edge fair with about 35 dealers from Europe, America and Canada. Held annually in late October.

Slick
La Bellevilloise
19-21 rue Boyer 75020
Carré de Baudouin
121 rue Ménilmontant 75020
t: 06 78 75 20 52

www.slick-paris.com

Opened in 2006, with 22 galleries. Held in late October.

*musée du quai Branly

Maps

KEY TO MAPS

- ● public galleries and art venues
- ● private galleries
- ● public art
- Ⓜ metro station
- (RER) railway station

151

1. PARIS OVERVIEW (inside front cover)

1 Bagatelle Château/Parc
2 Fondation Le Corbusier
3 Musée Marmottan Monet
4 La Galerie
5 Musée de la Vie Romantique
6 Espace Dalí
7 Halle Saint-Pierre
8 François Boisrond *Coup de Chapeau*
9 Yvaral *Saint Vincent de Paul*
10 Galerie B.A.N.K.
11 Tram: Réseau d'Art Contemporain
12 Point Éphémère
13 Parc de la Villette
14 La Périphérie
15 Patrick Berger and Gilles Clément *Fountain*
16 Parc André Citroën
17 Jean Dubuffet *La Tour aux Figures*
18 Le Cube

Opposite (left to right from the top): Anselm Kiefer *Falling Stars* (2007), Grand Palais; Jardin du Luxembourg; Palais de Tokyo; La Défense; Air de Paris; Galerie Georges-Philippe et Nathalie Vallois; Joan Miró *Deux Personnages Fantastiques* (1976); Michel Blazy installation (2005), FRAC Île-de-France - Le Plateau; FIAC 2006; Galerie Chantal Crousel; Musée du Quai Branly; view from Centre Pompidou; Palais de Tokyo.

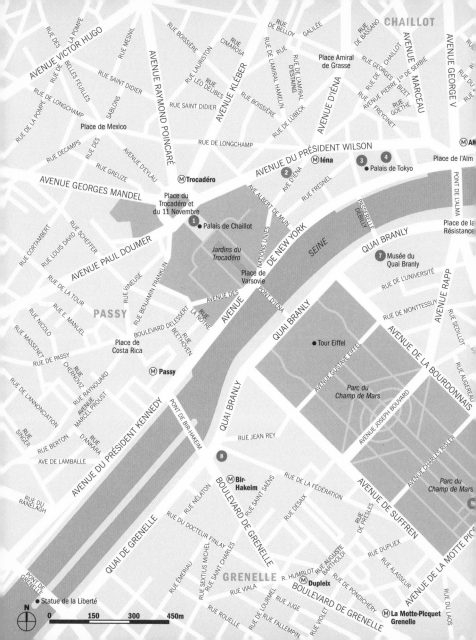

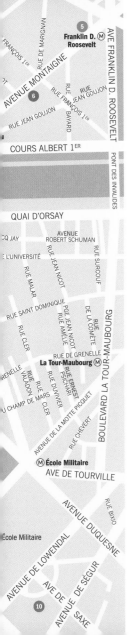

2. GRENELLE/TROCADÉRO

1 Cité de l'Architecture et du Patrimoine

2 Martial Raysse
Sol et Colombe ou *La Naissance de la Pensée*

3 Palais de Tokyo: Site de Création Contemporaine

4 Musée d'Art Moderne de la Ville de Paris (MAMVP)

5 Artcurial

6 Le Siège LVMH

7 Musée du Quai Branly

8 Maison de la Culture du Japon

9 Clara Halter (with Jean-Michel Wilmotte)
Le Mur pour la Paix

10 UNESCO

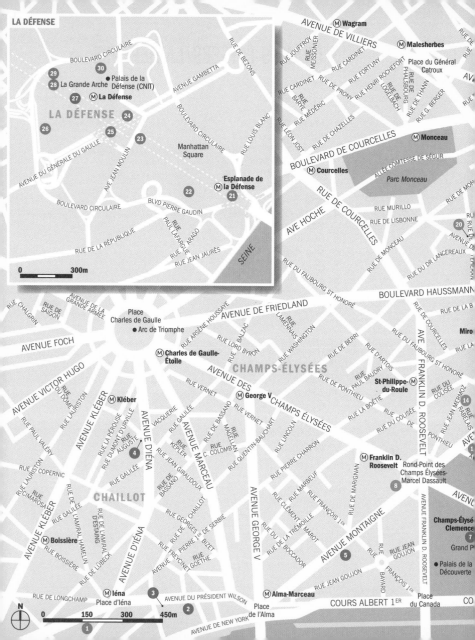

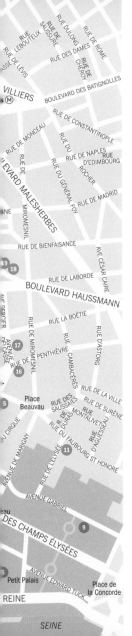

3. CHAMPS-ÉLYSÉES/LA DÉFENSE

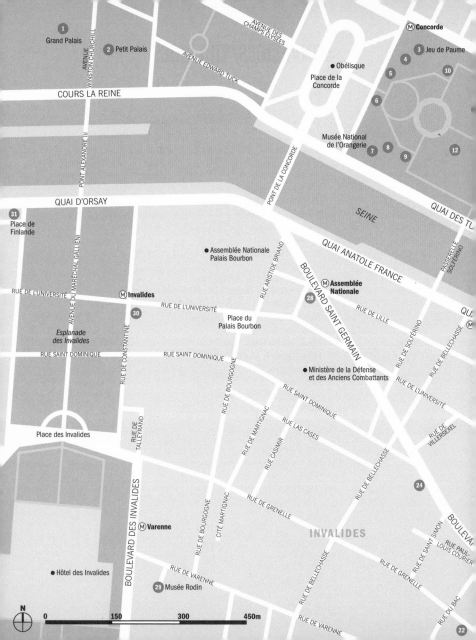

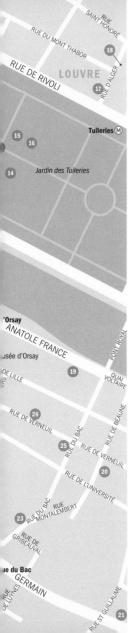

4. INVALIDES/TUILERIES

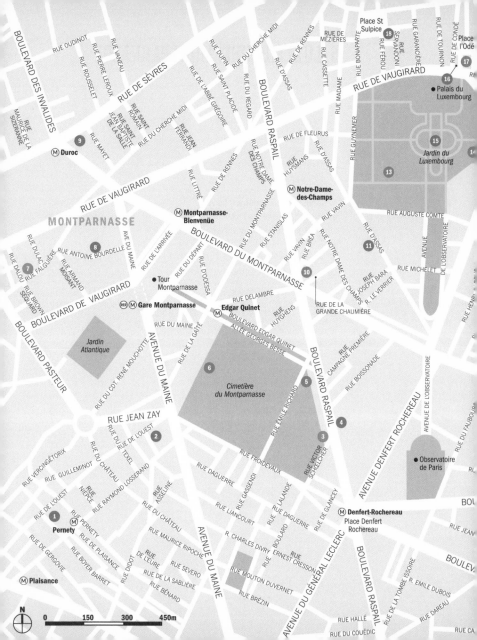

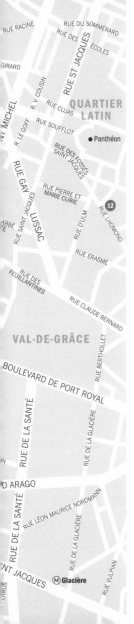

5. LUXEMBOURG/MONTPARNASSE

1 L'Entrepôt
2 Fondation Henri Cartier-Bresson
3 Galerie Camera Obscura
4 Fondation Cartier pour l'Art Contemporain
5 Constantin Brancusi *The Kiss*
6 Henri Laurens *La Douleur*
7 Galerie Esther Woerdehoff
8 Musée Bourdelle
9 Fondation Dubuffet
10 Auguste Rodin *Balzac*
11 Musée Zadkine
12 Centre Culturel Irlandais
13 Ossip Zadkine *Le Poète*
14 Fabrice Hyber *Le Cri, l'Écrit*
15 Jardin du Luxembourg
16 Institut Goethe: Galerie Condé
17 André Masson *Ceiling*
18 Maison de l'Indochine

159

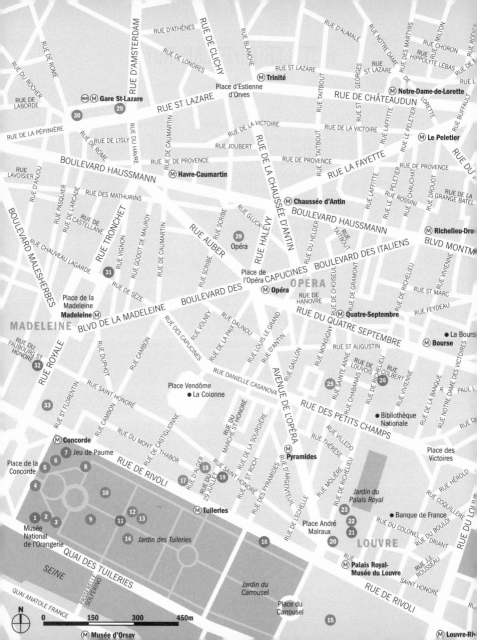

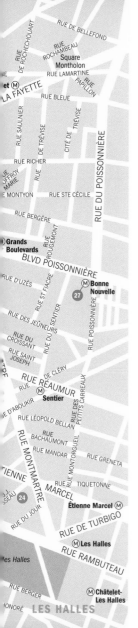

6. TUILERIES/PALAIS ROYAL

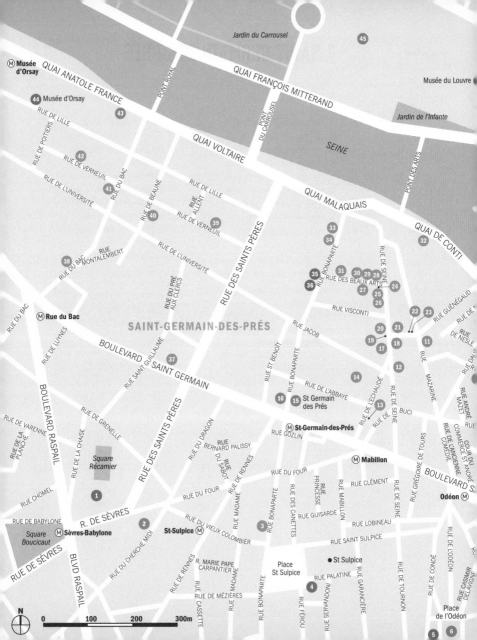

7. SAINT-GERMAIN-DES-PRÉS

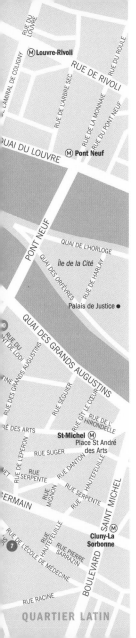

163

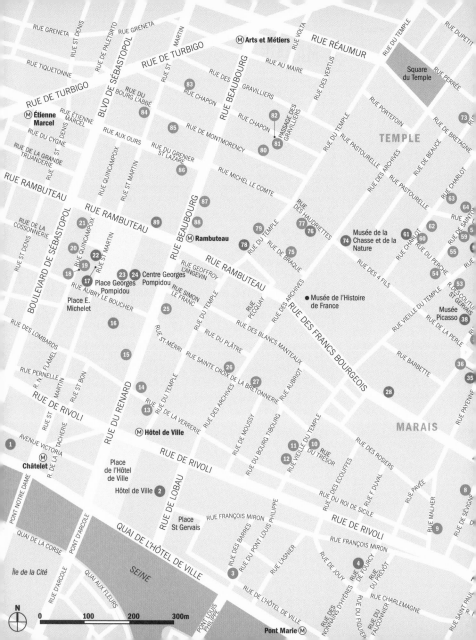

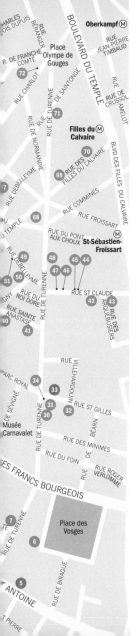

8. MARAIS

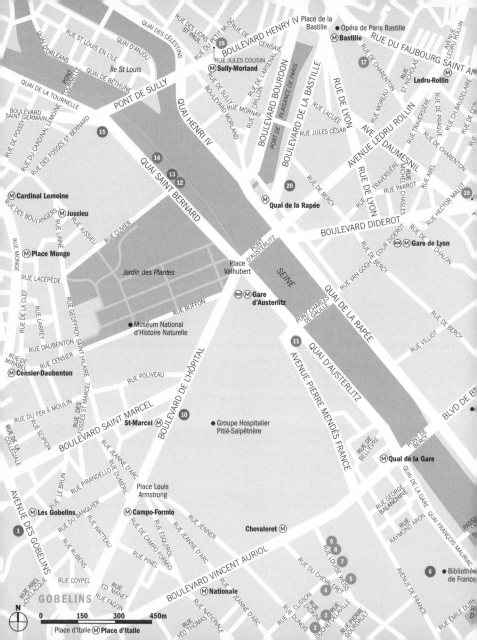

9. BERCY/GOBELINS

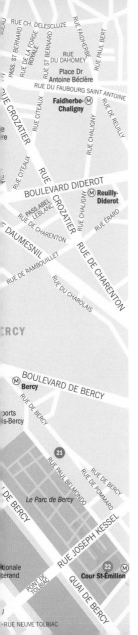

167

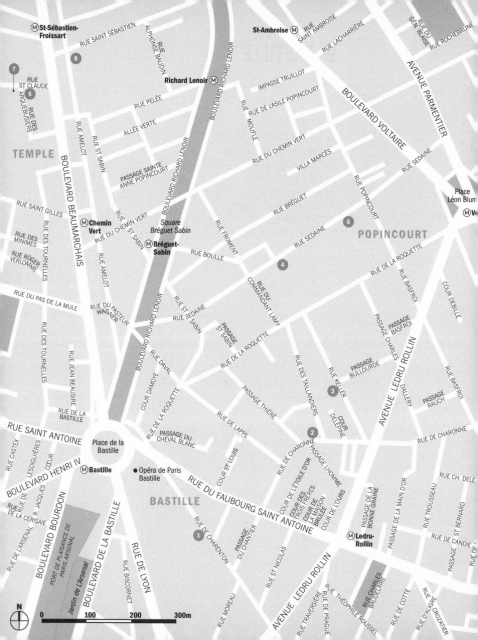

10. BASTILLE

1 Objet Trouvé
2 Galerie Lavignes Bastille
3 Galerie Yvonamor Palix
4 Galerie Anatome
5 art process
6 Galerie Polaris
7 Galerie Alain Gutharc
 Galerie Frank Elbaz
8 Galerie Magda Danysz

Square de
la Rocquette

HEMIN VERT
RUE SERVAN
RUE DURANTI
RUE DU MORVAN
RUE SAINT MAUR
RUE DURANTI
JE C. DESMOULINS
RUE PACHE
RUE SERVAN
RUE DE LA ROQUETTE
RUE LÉON
RUE AUGUSTE LAURENT
RUE MERCŒUR
BOULEVARD VOLTAIRE
RUE DE BELFORT
RUE RICHARD LENOIR
RUE GOBERT
CAVAIGNAC
RUE DE CHARONNE
RUE CHARRIÈRE
RUE FAIDHERBE
RUE JEAN MACÉ
RUE CHANZY
RUE ST BERNARD
RUE FAIDHERBE
RUE PAUL BERT
RUE DU DAHOMEY
Place Dr
Antoine Béclère
E DU FAUBOURG SAINT ANTOINE

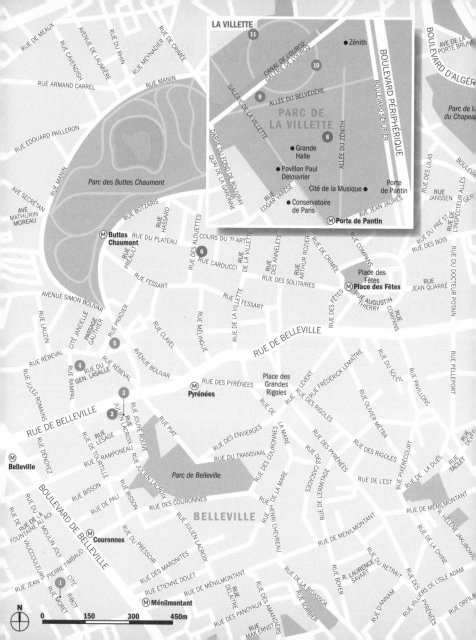

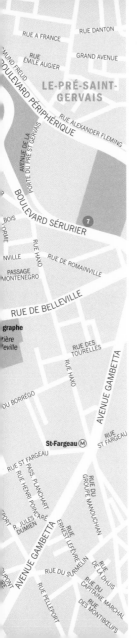

11. BELLEVILLE/LA VILLETTE

Picture credits

2-3 © Pipilotti Rist/Georges Meguerditchian, courtesy Hauser & Wirth, Zürich, London; 7 Urba Images/E Racioppi; 13 Karl Blackwell/© DACS, London 2007; 17 © Adel Abdessemed; 18 © Boris Achour, courtesy Galerie Georges-Philippe & Nathalie Vallois/Guillaume Grasset; 19 © Saâdane Afif, courtesy Galerie Michel Rein, Paris; 20 © Photo CNAC/MNAM Dist RMN/© Jacqueline Hyde/© ADAGP Paris/DACS, London 2007; 21 Christian Sarramon/© ADAGP Paris/DACS, London 2007; 22 © Photo CNAC/MNAM Dist RMN/© Philippe Migeat/© DACS 2007; 23 © Photo CNAC/MNAM Dist RMN/© Philippe Migeat/© ADAGP Paris/DACS, London 2007; 24 Galerie Nathalie Obadia; 25 Galerie Enrico Navarra/© ADAGP Paris/DACS, London 2007; 26 © Photo CNAC/MNAM Dist RMN/© Philippe Migeat/© ADAGP Paris/DACS, London 2007; 27 © Pierre Bismuth/courtesy Cosmic, Paris; 28 © Musée d'Art Moderne/Roger-Viollet/© ADAGP Paris/DACS, London 2007; 29 © Photo CNAC/MNAM Dist RMN/© Philippe Migeat/© ADAGP Paris/DACS, London 2007; 30 © Photo CNAC/MNAM Dist RMN/© Philippe Migeat/© ADAGP Paris/DACS, London 2007; 31 Tiddy Rowan/© ADAGP Paris/DACS, London 2007; 32 © Photo CNAC/MNAM Dist RMN/Droits réservés/© ADAGP Paris/DACS, London 2007; 33 © Estate Brassaï - RMN; 34 © Photo CNAC/MNAM Dist RMN/© Philippe Migeat/© ADAGP Paris/DACS, London 2007; 35 Christian Sarramon; 36 Galerie Thaddaeus Ropac, courtesy Jean-Marc Bustamante; 37 Christian Sarramon/© 2008 Calder Foundation/All rights reserved/DACS, London; 38 Christian Sarramon/© ADAGP Paris/DACS, London 2007; 39 Magnum Photos/Henri Cartier-Bresson; 40 Christian Sarramon/© ADAGP Paris/DACS, London 2007; 41 © Photo RMN/© Hervé Lewandowski; 42 © Photo CNAC/MNAM Dist RMN/© Philippe Migeat/© ADAGP, Paris/DACS, London 2007; 43 Galerie Air de Paris, courtesy François Curlet; 44 © Musée d'Art Moderne/Roger-Viollet; 45 © Musée d'Art Moderne/Roger-Viollet/© ADAGP, Paris/DACS, London 2007; 46 Galerie Claude Bernard/Atelier Doisneau; 47 Christian Sarramon/© ADAGP, Paris/DACS, London 2007; 48 © Photo CNAC/MNAM Dist RMN/© Philippe Migeat/© Succession Marcel Duchamp/© ADAGP, Paris/DACS, London 2007; 49 © Photo CNAC/MNAM Dist RMN/© Droits réservés/© ADAGP, Paris/DACS, London 2007; 50 Christian Sarramon/© ADAGP, Paris/DACS, London 2007; 51 © Musée d'Art Moderne/Roger-Viollet/© ADAGP, Paris/DACS, London 2007; 52 Galerie Nelson-Freeman/Florian Kleinefenn; 53 courtesy Galerie Emmanuel Perrotin, Paris-Miami/© ADAGP, Paris/DACS, London 2007; 54 © Photo CNAC/MNAM Dist RMN/© Philippe Migeat; 55 Collection Maeght, Paris/© Photo Galerie Maeght, Paris; 56 © Photo CNAC/MNAM Dist RMN/© Droits réservés/© ADAGP, Paris/DACS, London 2007; 57 courtesy Galerie Yvon Lambert, Paris, courtesy Nan Goldin; 58 courtesy Galerie Yvon Lambert, Paris, courtesy Loris Gréaud; 59 © Musée d'Art Moderne/Roger-Viollet/© ADAGP, Paris/DACS, London 2007; 60 © Photo CNAC/MNAM Dist RMN/© Droits réservés; 61 © Thomas Hirschhorn, courtesy Galerie Chantal Crousel/Florian Kleinefenn; 62 courtesy Huang Yong Ping & Galerie Anne de Villepoix; 63 © Pierre Huyghe/Michael Vahrenwald, courtesy Marian Goodman Gallery, New York/Paris; 64 courtesy Fabrice Hyber, courtesy Galerie Jérôme de Noirmont, Paris/Marc Domage/© ADAGP, Paris/DACS, London 2007; 65 © Photo CNAC/MNAM Dist RMN/© Jacques Faujour/© ADAGP, Paris/DACS, London 2007; 66 © Photo CNAC/MNAM Dist RMN/© Philippe Migeat/© ADAGP, Paris/DACS, London 2007; 67 Galerie Xippas/© ADAGP, Paris/DACS, London 2007; 68 © Photo CNAC/MNAM Dist RMN/© Jacqueline Hyde/© ADAGP, Paris/DACS, London 2007; 69 © Musée d'Art Moderne/Roger-Viollet/© ADAGP, Paris/DACS, London 2007; 70 Christian Sarramon/© ADAGP, Paris/DACS, London 2007; 71 Galerie Yvon Lambert, Paris/The François Pinault Collection/© ADAGP, Paris/DACS, London 2007; 72 © Guillaume Leblon/François Doury, courtesy Galerie Jocelyn Woolf; 73 Galerie Almine Rech, Paris-Bruxelles; 74 © Photo CNAC/MNAM Dist RMN/© Droits réservés/© FLC/ADAGP, Paris/DACS, London 2007; 75 © Photo CNAC/MNAM Dist RMN/© Jean-François Tomasian/© ADAGP, Paris/DACS, London 2007; 76 © Claude Lévêque, courtesy Galerie Kamel Mennour, Paris; 77 © Photo CNAC/MNAM Dist RMN/© Philippe Migeat/© ADAGP, Paris/DACS, London 2007; 78 © Man Ray Trust/ADAGP, Paris/DACS, London 2007; 79 © Photo CNAC/MNAM Dist RMN/© Philippe Migeat; 80 © Photo CNAC/MNAM Dist RMN/© Jacqueline Hyde/© ADAGP, Paris/DACS, London 2007; 81 © Succession Matisse/DACS, London 2007. © Photo CNAC/MNAM Dist RMN/Philippe Migeat; 82 courtesy Galerie Chez Valentin; 83 © Photo CNAC/MNAM Dist RMN/© Philippe Migeat/© ADAGP, Paris/DACS, London 2007; 84 © Photo CNAC/MNAM Dist RMN/© Droits réservés/© ADAGP, Paris/DACS, London 2007; 85 Galerie Air de Paris/© M/M (Paris); 86 © Photo CNAC/MNAM Dist RMN/© Droits réservés/ADAGP, Paris/DACS, London 2007; 87 © Jean-Luc Moulène/courtesy Galerie Chantal Crousel; 88 courtesy Galerie Chantal Crousel; 89 Christian Sarramon/© ADAGP, Paris/DACS, London 2007; 90 © Photo CNAC/MNAM Dist RMN/© Georges Meguerditchian/© ADAGP, Paris/DACS, London 2007; 91 Galerie Air de Paris/© Anna Lena Films. Douglas Gordon & Philippe Parreno; 92 © Photo CNAC/MNAM Dist RMN/© Georges Meguerditchian/© ADAGP, Paris/DACS, London 2007; 93 © Photo RMN/© Jean-Gilles Berizzi/© Succession Picasso/DACS, London 2007; 94 © Pierre et Gilles, courtesy Galerie Jérôme de

Noirmont, Paris; 95 © Photo CNAC/MNAM Dist RMN/© Droits réservés; 96 Christian Sarramon/© ADAGP, Paris/ DACS, London 2007; 97 © Photo CNAC/MNAM Dist RMN/© Philippe Migeat/© ADAGP, Paris/DACS, London 2007; 98 © Photo RMN/© Hervé Lewandowski; 99 Christian Sarramon/© ADAGP, Paris/DACS, London 2007; 100 © Jean-Michel Sanejouand/Ludovic Sanejouand; 101 courtesy Air de Paris; 102 courtesy Galerie Karsten Greve; 103 © Photo CNAC/MNAM Dist RMN/© Philippe Migeat/© ADAGP, Paris/DACS, London 2007; 104 Christian Sarramon/© ADAGP Paris/DACS, London 2007; 105 courtesy Galerie Denise Rene/© ADAGP Paris/DACS, London 2007; 106 courtesy Marian Goodman Gallery NewYork/Paris; 107 © Tatiana Trouvé/Marc Domage/courtesy Almine Rech Gallery, Bruxelles, Galerie Emmanuel Perrotin Miami & Galerie Johann König, Berlin; 108 © Photo CNAC/ MNAM Dist RMN/© Jacques Faujour/© ADAGP, Paris/DACS, London 2007; 109 courtesy Emmanuel Perrotin/ © ADAGP, Paris/DACS, London 2007; 110 courtesy Galerie Daniel Templon/© ADAGP, Paris/DACS, London 2007; 111 courtesy Galerie Georges-Philippe & Nathalie Vallois; 112 Musée Zadkine de la Ville de Paris/© André Morin/ © ADAGP, Paris/DACS, London 2007; 150 1st column, from top: Tiddy Rowan; Galerie Air de Paris; Le Plateau/Marc Domage/© ADAGP, Paris/DACS, London 2007; Hemis.fr/Franck Guiziou; 2nd column, from top: Photononstop/ Jacques Loic; Palais de Tokyo/Daniel Moulinet; Galerie Georges-Philippe & Nathalie Vallois; Urba Images/F Vielcanet; Tiddy Rowan; 3rd column, from top: Photononstop/ Mauritius; Alamy/Robert Harding Picture Library/Roy Rainford/ © Succession Miro/ADAGP, Paris/DACS, London 2007; Galerie Chantal Crousel; Palais de Tokyo/Daniel Moulinet; inside back cover Paris Metro map © RATP.

Index of artists